跟着"我"成为创意手绘达人

MY
WONDERFUL
WORLD
OF
FASHION

FOR SAFIYA

谨以此书
献给
莎菲亚

图书在版编目（CIP）数据

跟着"我"成为创意手绘达人：最新版 /（英）妮娜·查拉巴缇著；
L.Y.T译. —— 上海：上海人民美术出版社, 2023.1
书名原文：My Wonderful World of Fashion
ISBN 978-7-5586-1914-4

Ⅰ.①跟　Ⅱ.①妮　②L　Ⅲ.①绘画技法 Ⅳ.①J21

中国版本图书馆CIP数据核字(2021)第246674号

跟着"我"成为创意手绘达人（最新版）

原版书名：My Wonderful World of Fashion

原作者名：Nina Chakrabarti

原书出版号：ISBN 978-1-85669-632-6

合同登记号：图字：09-2010-498

跟着"我"成为创意手绘达人（最新版）

著　　者：［英］尼娜·查拉巴缇

译　　者：L.Y.T

责任编辑：张维辰

版权经理：康　华

装帧设计：林　晨

技术编辑：齐秀宁

出版发行：上海人民美术出版社

　　　　　（上海市闵行区号景路159弄A座7F）

印　　刷：浙江天地海印刷有限公司

开　　本：889×1194　1/16　17印张

版　　次：2023年1月第1版

印　　次：2023年1月第1次

书　　号：ISBN 978-7-5586-1914-4

定　　价：78.00元

跟着"我"成为创意手绘达人

（最新版）

MY WONDERFUL WORLD OF FASHION

［英］尼娜·查拉巴缇 著

L.Y.T 译

一本可以涂色、创作和梦想的时尚手绘书。 A BOOK FOR DRAWING, CREATING, and DREAMING

BY Nina CHAKRABARTI

上海人民美术出版社

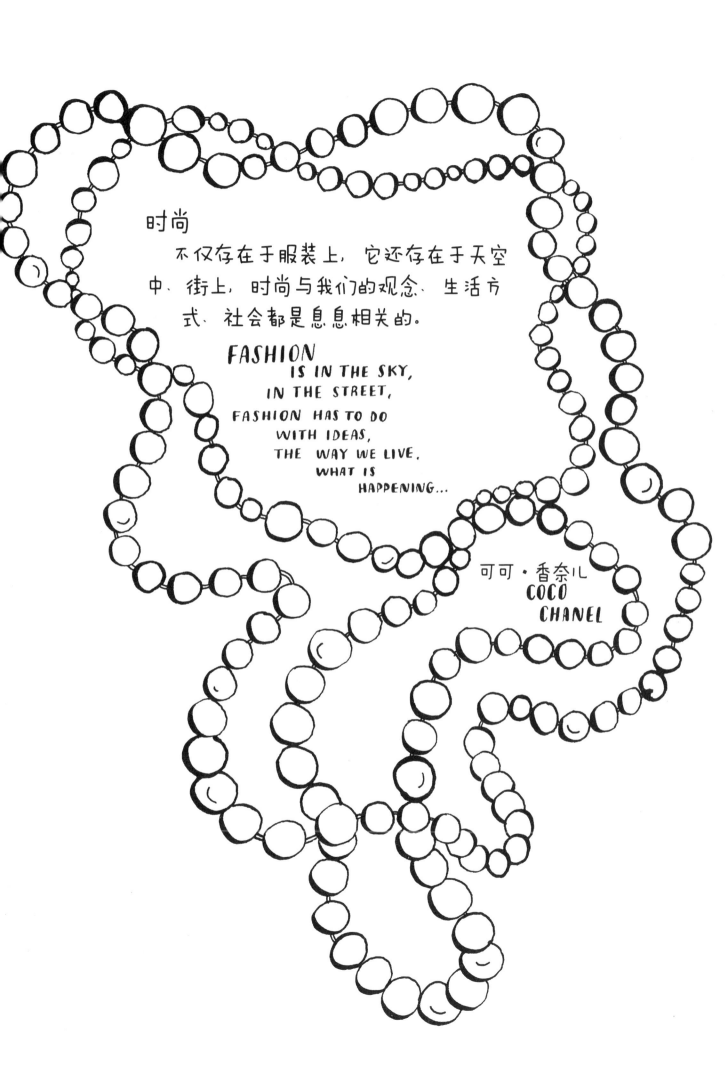

时尚

　　不仅存在于服装上，它还存在于天空中、街上，时尚与我们的观念、生活方式、社会都是息息相关的。

FASHION
IS IN THE SKY,
IN THE STREET,
FASHION HAS TO DO
WITH IDEAS,
THE WAY WE LIVE.
WHAT IS
HAPPENING...

可可·香奈儿
COCO
CHANEL

下图中呈现的发饰是
埃及艳后戴过的。
THIS HEADDRESS WAS
ONCE WORN BY AN
EGYPTIAN QUEEN

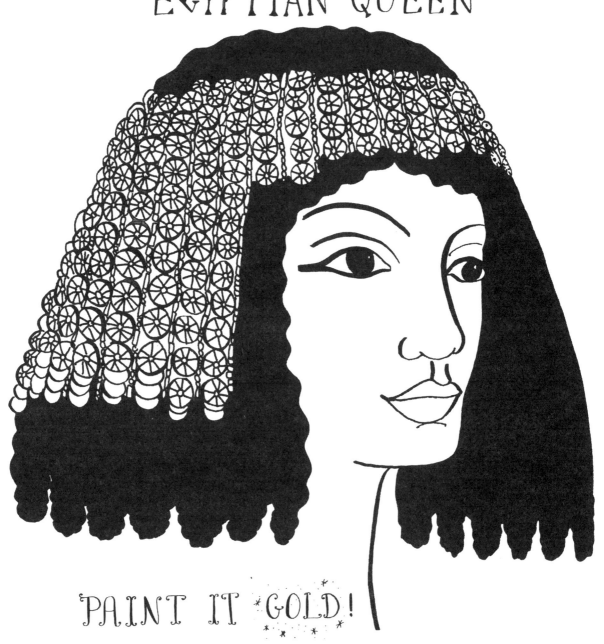

PAINT IT GOLD!

请先将它涂上 金色。

若戴在你的头上会是什么样的呢?
WHAT WOULD IT LOOK LIKE ON YOU?

好奇的话, 就将自己的样貌画上去吧! ……
DRAW YOUR FACE HERE and see …

按照图上顺序将其连成线……
JOIN THE DOTS..

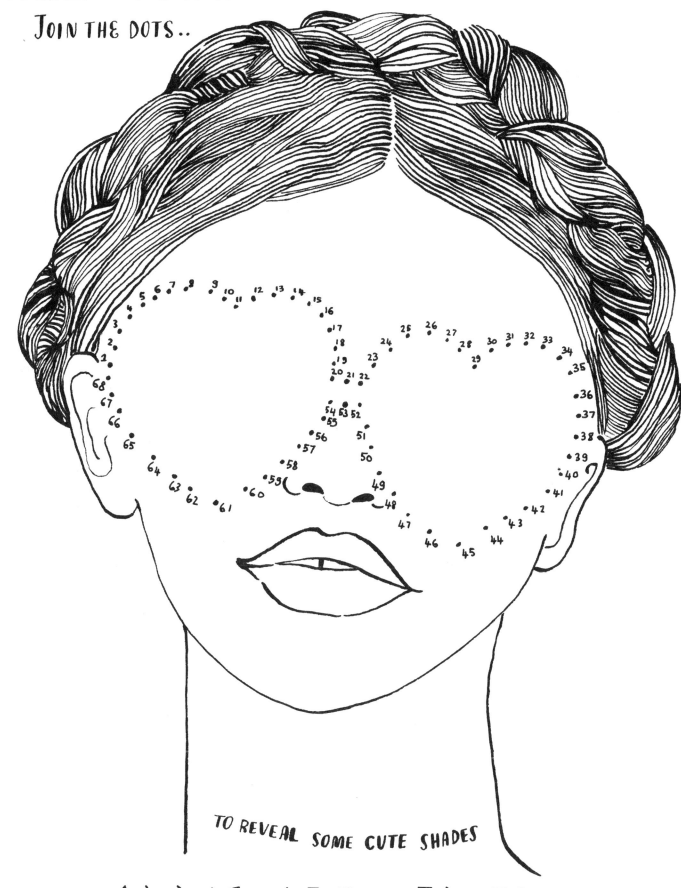

TO REVEAL SOME CUTE SHADES

全部完成后，会呈现一个漂亮的图形。

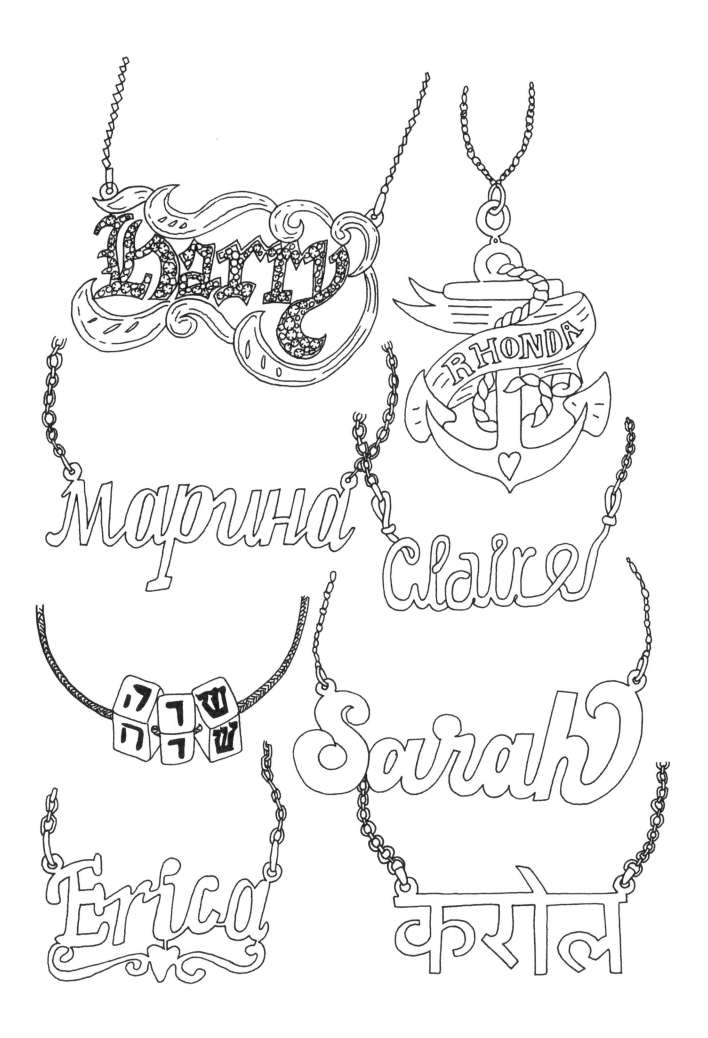

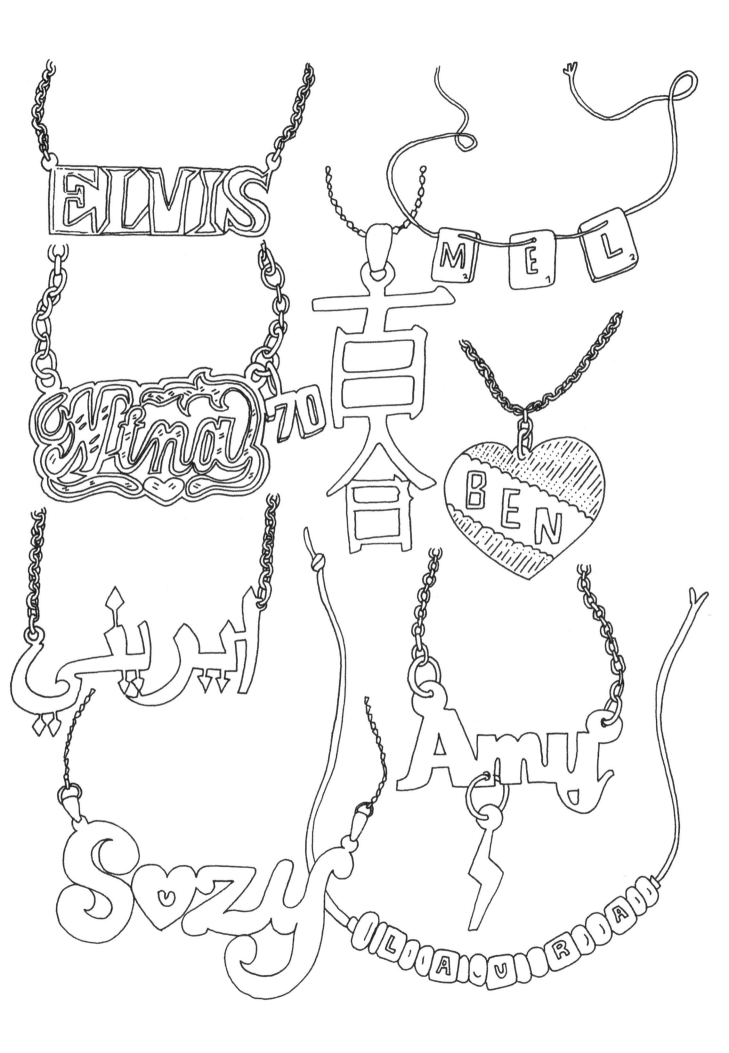

CREATE

... A NECKLACE FOR YOUR NAME

尝试使用自己的名字来
制作一条项链吧！

how ABOUT SOME FOR YOUR FRIENDS ?

给自己的朋友也制作几条项链吧。

如何使用身边常见的纽扣
来制作项链呢?

材料:

各种样式的纽扣

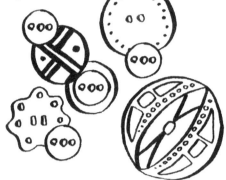

再准备一根长度可以戴在你脖子上的线。

线的长度一定要能保证可以
戴在你的脖子上。

①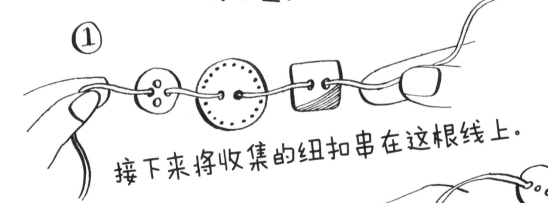

接下来将收集的纽扣串在这根线上。

②

最后,在最上方将
线的两头打结。

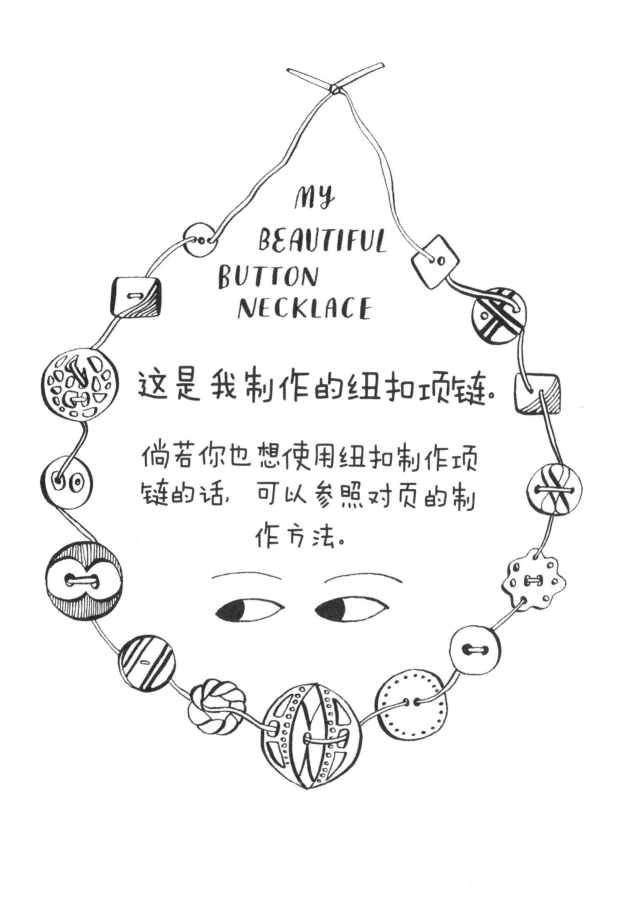

这些都是好看的纽扣，

LOOK at all the pretty buttons

你能把它们一一配对吗?

Can you find a matching pair?

使用纽扣、亮片以及贝壳在一件
旧夹克衫上进行设计创作。

Customize

AN OLD JACKET WITH PATCHES, BUTTONS and SHELLS
AND CREATE SOMETHING ONE OF A KIND

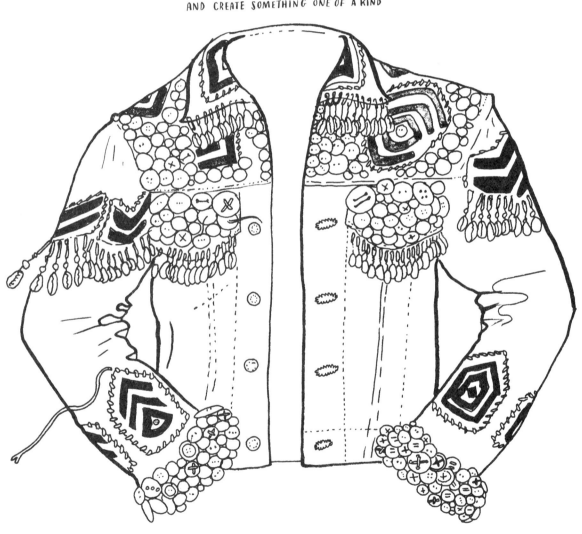

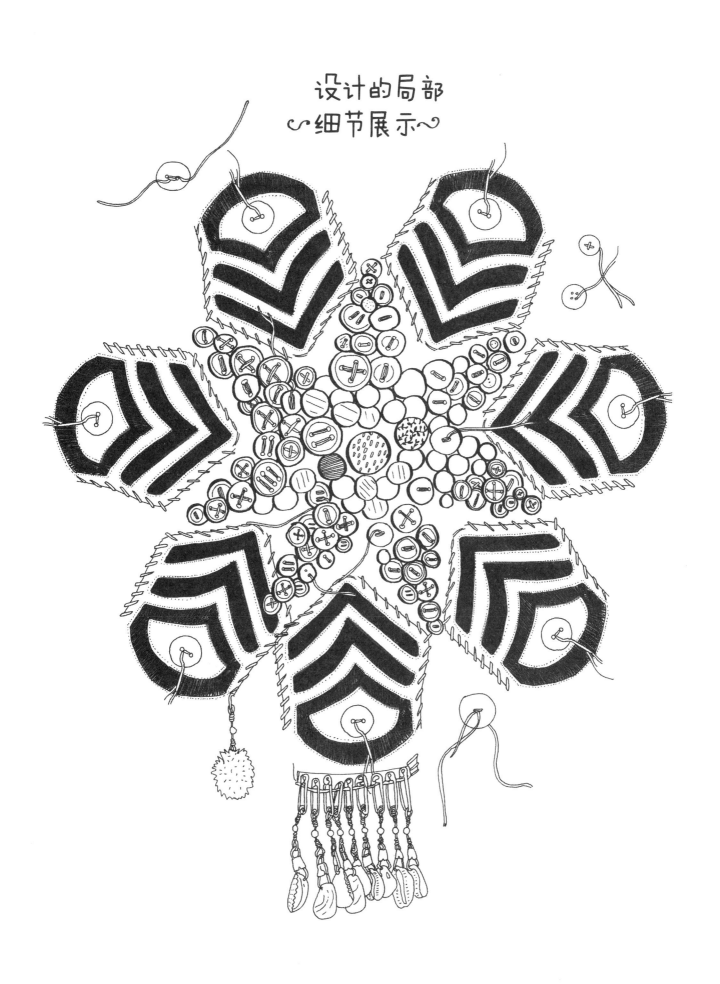

设计的局部
～细节展示～

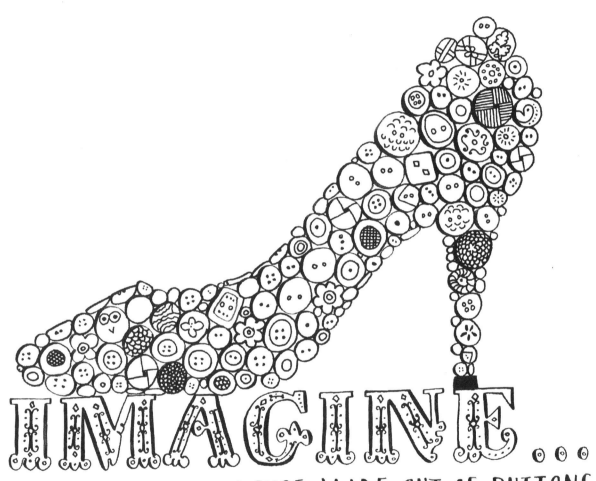

IMAGINE...

A SHOE MADE OUT OF BUTTONS

看得出来是使用纽扣制
作的高跟鞋吗?

CREATE

YOUR OWN SHOE FROM
AS MANY DIFFERENT BUTTONS
AS YOU LIKE

自己也来尝试使用纽扣设计一双鞋，不限制纽扣的使用数量。

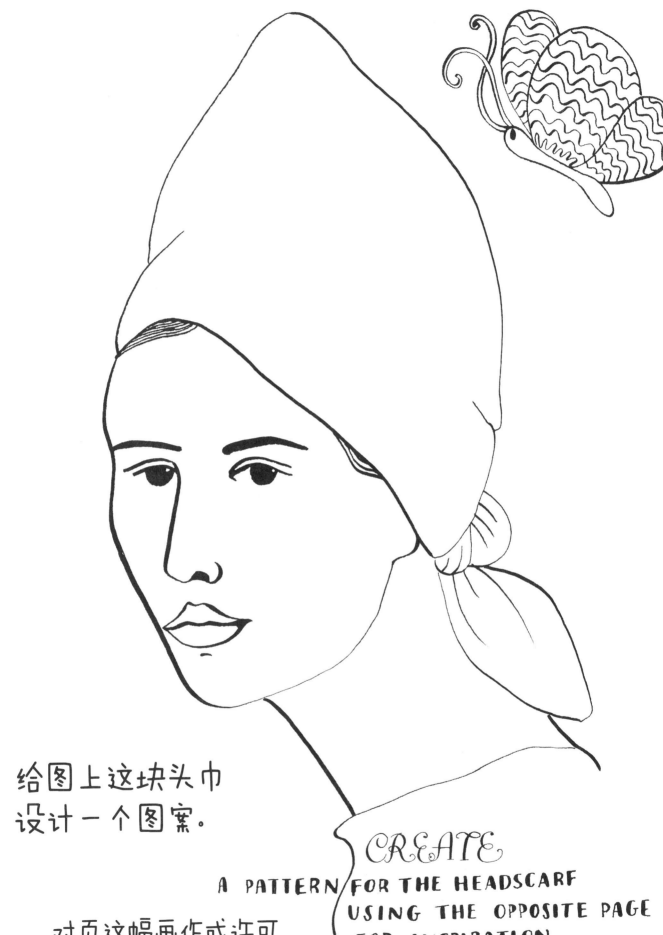

给图上这块头巾
设计一个图案。

对页这幅画作或许可
以给你带来灵感。

CREATE
A PATTERN FOR THE HEADSCARF
USING THE OPPOSITE PAGE
FOR INSPIRATION

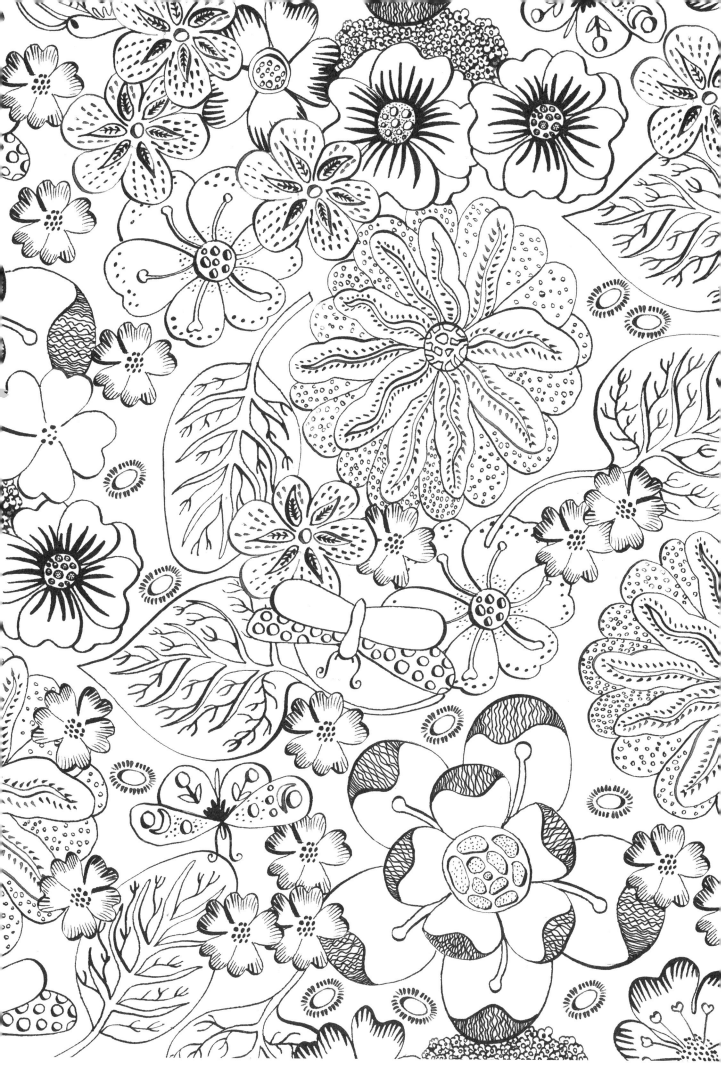

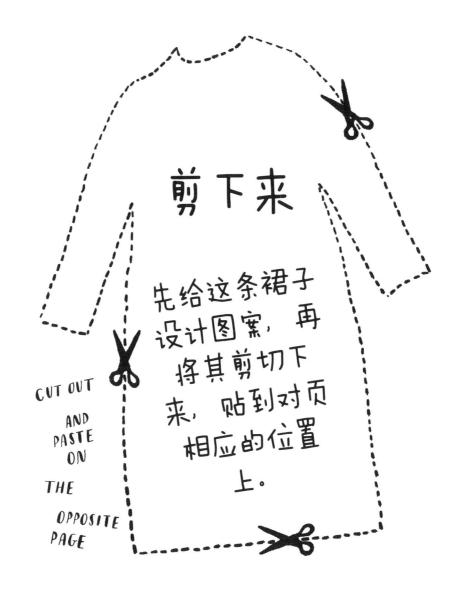

剪下来

先给这条裙子
设计图案，再
将其剪切下
来，贴到对页
相应的位置
上。

CUT OUT

AND

PASTE

ON

THE

OPPOSITE

PAGE

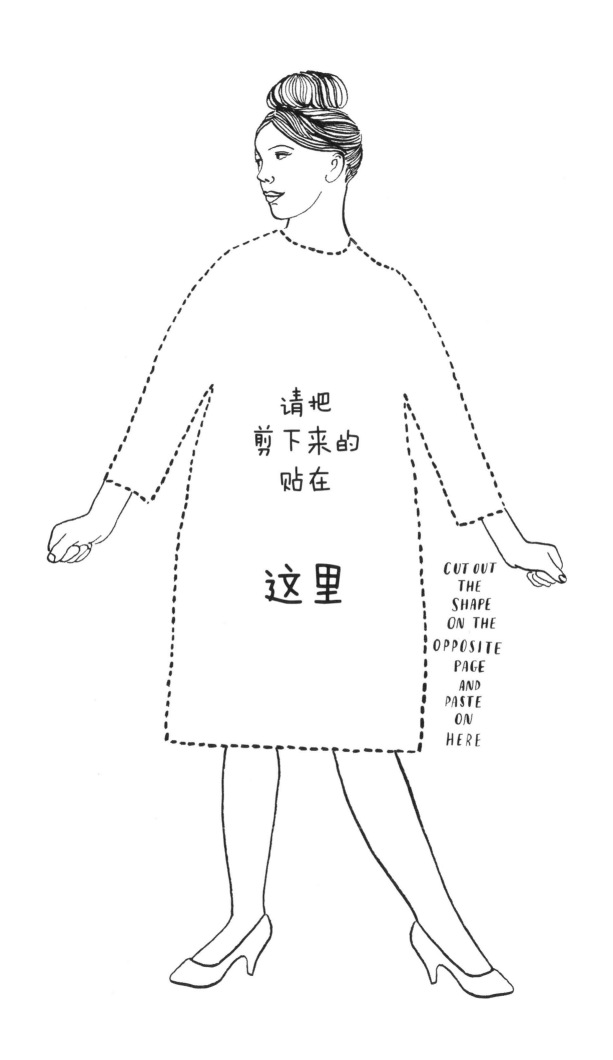

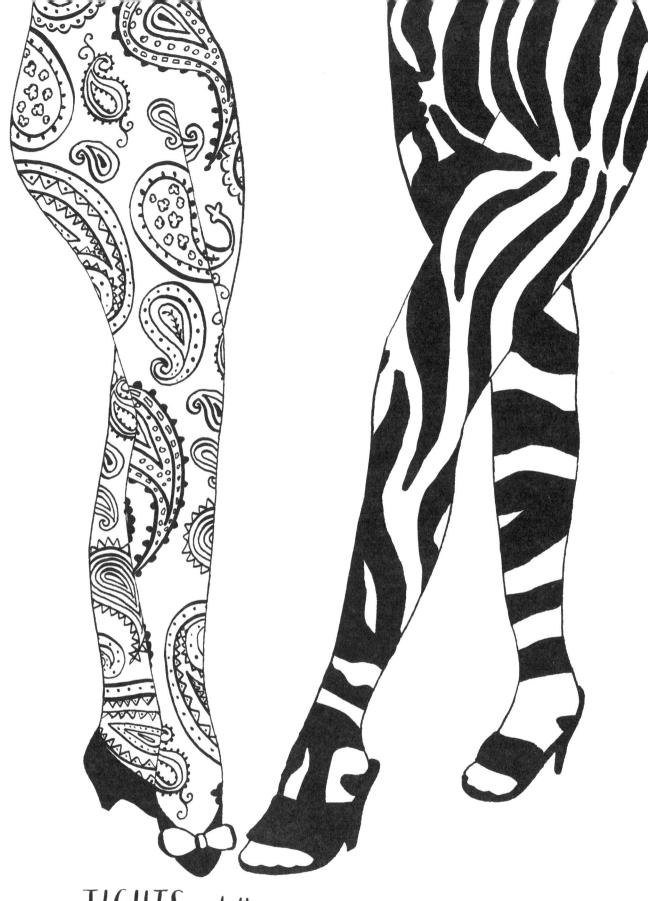

TIGHTS maketh

THE OUTFIT

这些紧身裤是否与你日常所见的不太一样。

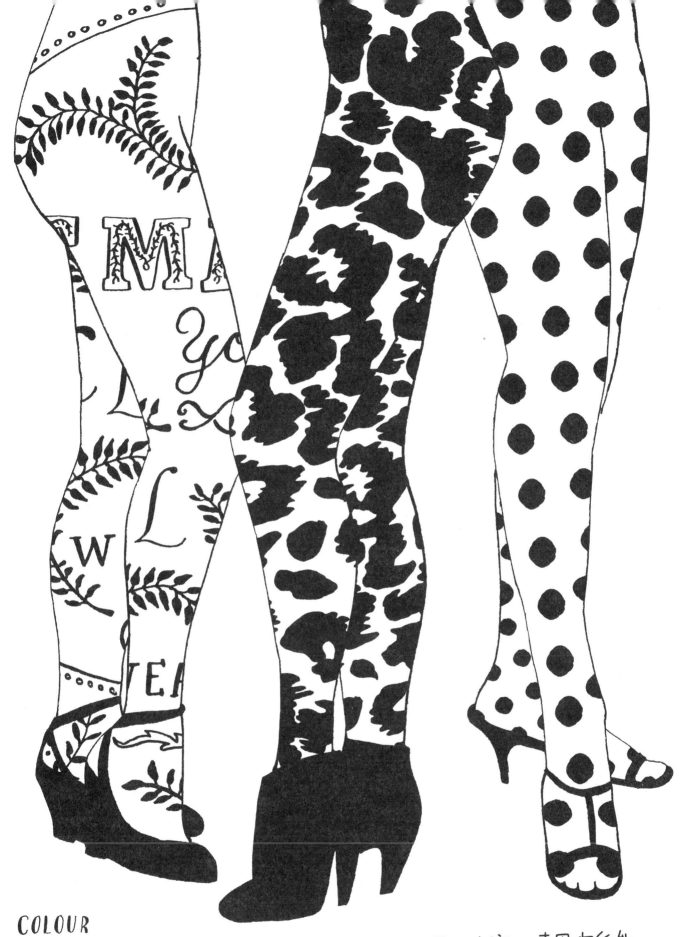

COLOUR
THESE IN USING YOUR BRIGHTEST
COLOURS 为使其更加丰富，使用你所能
想到的艳丽色彩为其着色吧。

ONE SIZE

FANCY STOCKINGS
MARY QUANT

Made in U.S.A.

SIZE: A PEARL

Hanes nude heel

ultra sheer panty hose

SIZE: A SEE SIZE CHART ON BACK NUDE HEEL · REINFORCED HEEL ONE
 FOR CORRECT FIT PAIR

Hanes ®

KNEE HIGHS by REGENCY Black STYLE No H PS

KNEE HIGHS s-t-r-e-t-c-h RUN RESIST

with SPECIAL TOP

100% NYLON MADE IN ENGLAND

在尝试给紧身裤上色后，我们再来试着给紧身裤和长袜的包装涂上色彩。

PACKETS OF TIGHTS and
STOCKINGS

Shoes, glorious shoes!

目光所及之处皆是各式各样的鞋子。尝试给这些鞋子涂上色彩、设计图案或是使用珠宝点缀，将其改造成新颖、时尚的样式。

COLOUR IN, MAKE PATTERNS FOR,
DRAW IN THE STITCHING, EMBELLISH
WITH JEWELS...

TRANSFORM THESE SHOES

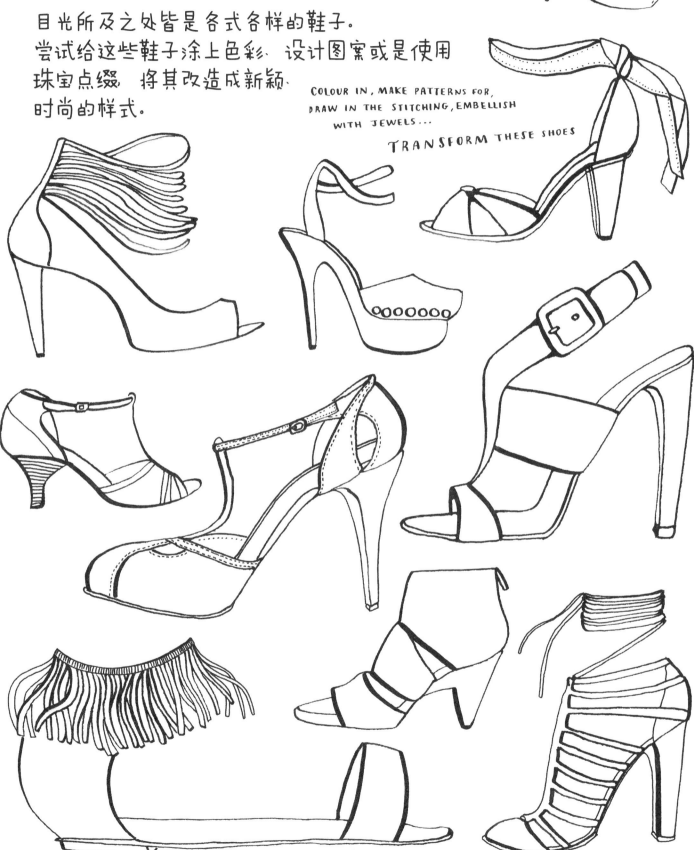

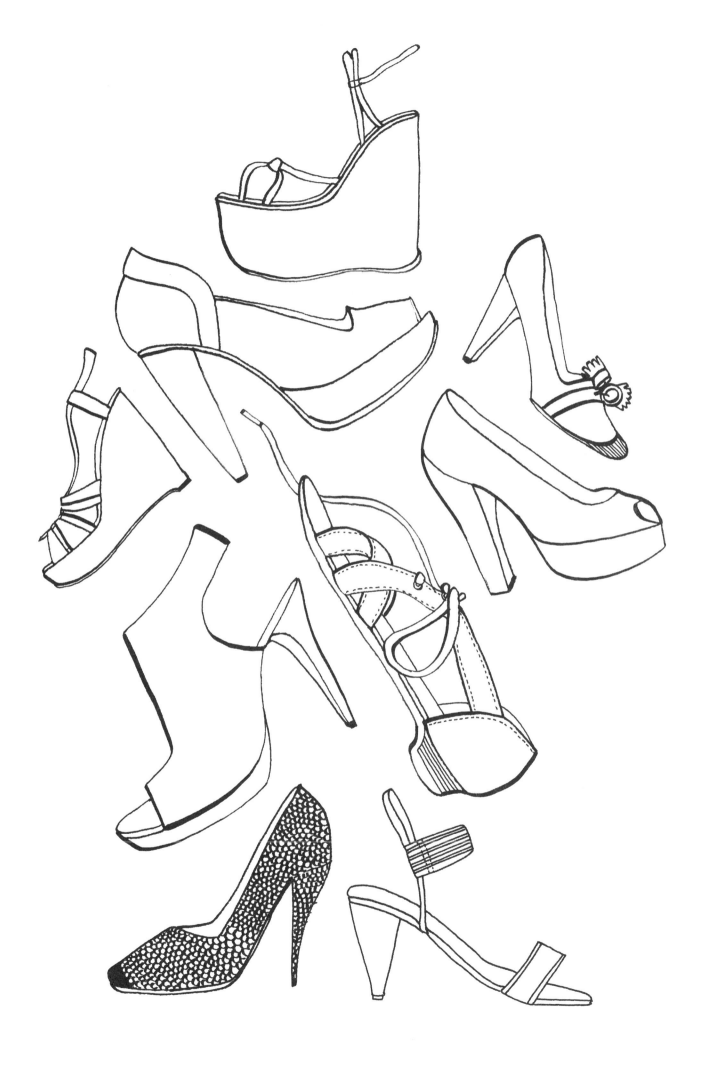

LE BERET
IS A HAT WORN
BY MEN, WOMEN, BOYS
AND GIRLS and SOMETIMES
POODLES

贝雷帽是一款男女老少皆宜, 乃至贵宾犬也能戴的帽子。

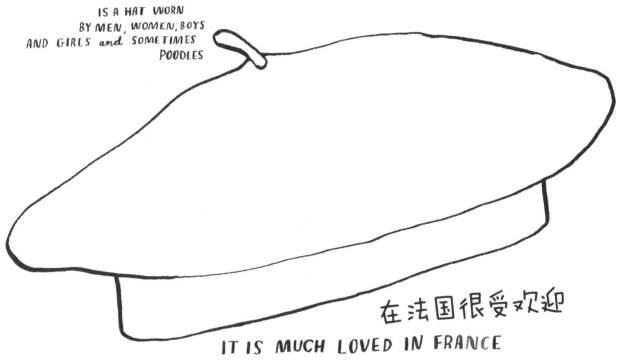

在法国很受欢迎

IT IS MUCH LOVED IN FRANCE

COVER
WITH
SPARKLING
SEQUINS and BEADS

同样使用亮闪闪的珠子和亮片来装饰上面这顶贝雷帽。

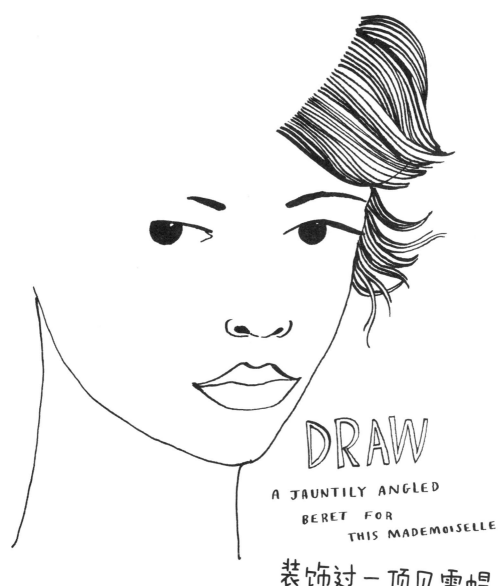

DRAW

A JAUNTILY ANGLED

BERET FOR

THIS MADEMOISELLE

装饰过一顶贝雷帽
后，再来尝试给这位
小姐画上一顶自己设
计的贝雷帽吧。

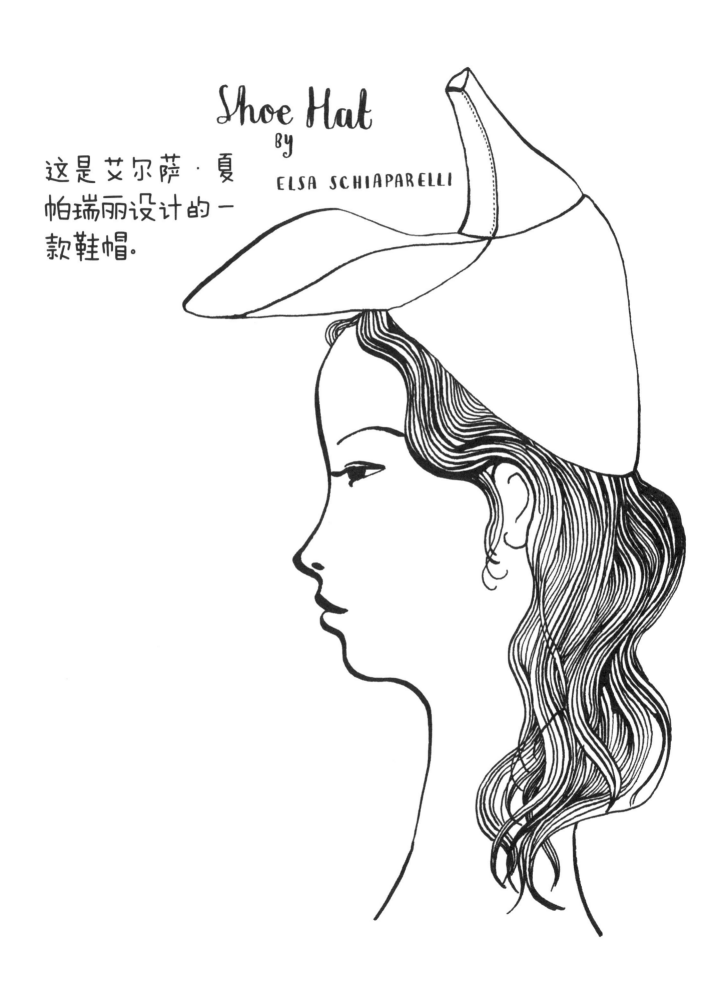

Shoe Hat

BY

ELSA SCHIAPARELLI

这是艾尔萨·夏帕瑞丽设计的一款鞋帽。

DESIGN

A HAT INSPIRED BY
YOUR FAVOURITE SHOE

在空白处，
以你最喜欢的鞋的样式，
结合所学帽子形式，
设计一款属于你自己的鞋帽。

时尚档案

DRESS BY
FINNISH COMPANY
MARIMEKKO

这是芬兰 marimekko 公
司出品的一款时装。

奇怪的是，
该时装没有任何图案。

BUT ...

WHERE IS THE PATTERN?

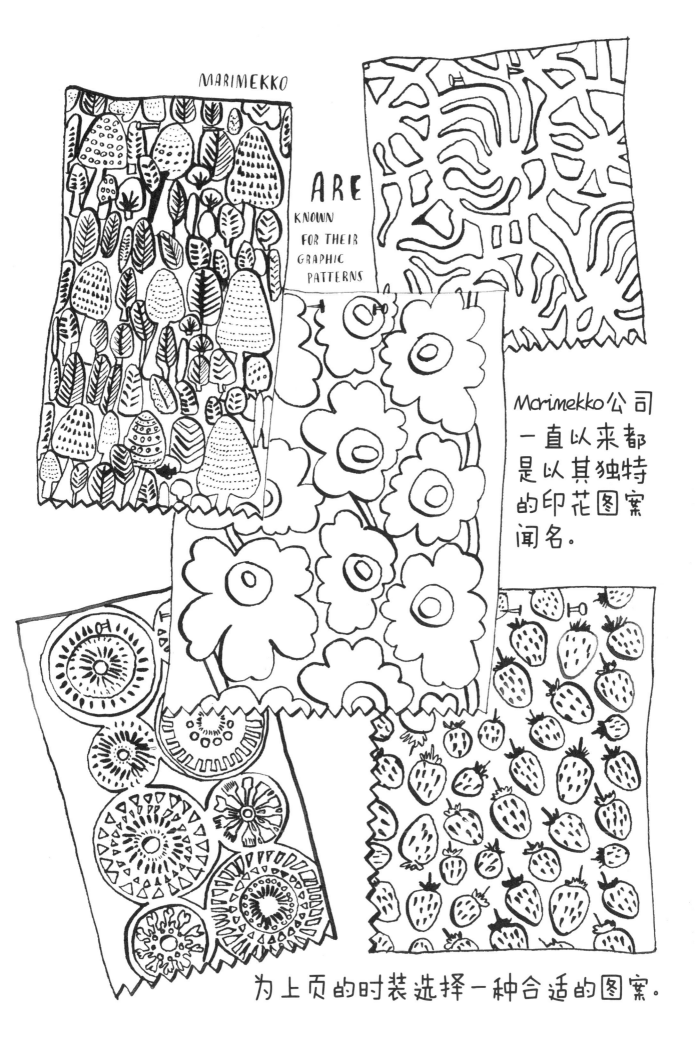

MARIMEKKO

ARE
KNOWN
FOR THEIR
GRAPHIC
PATTERNS

Marimekko公司
一直以来都
是以其独特
的印花图案
闻名。

为上页的时装选择一种合适的图案。

给这双手画上一副连
指手套，并给戴上。

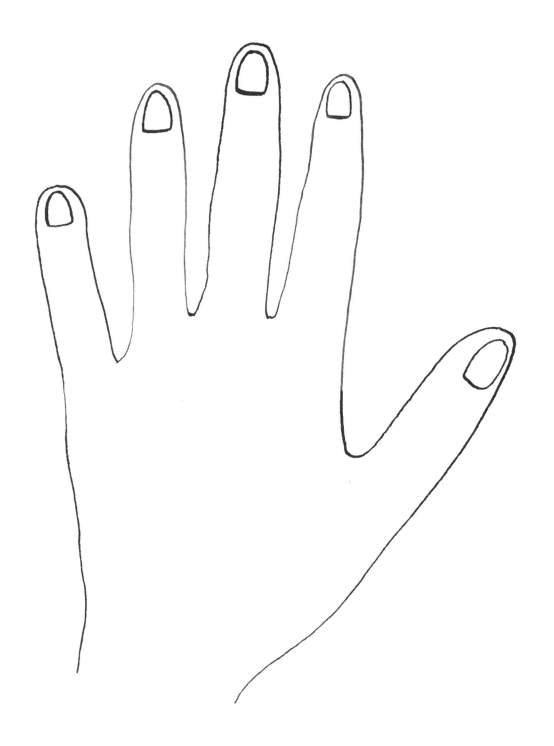

onto these hands
戴在这双手上。

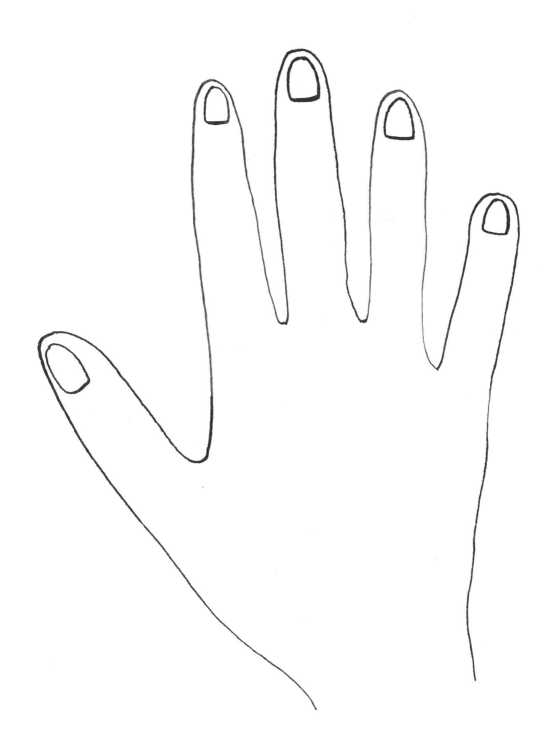

此处陈列各式各样的美甲图案，需要大家为其涂色，使它们更加艳丽。

The NAIL ART GALLERY

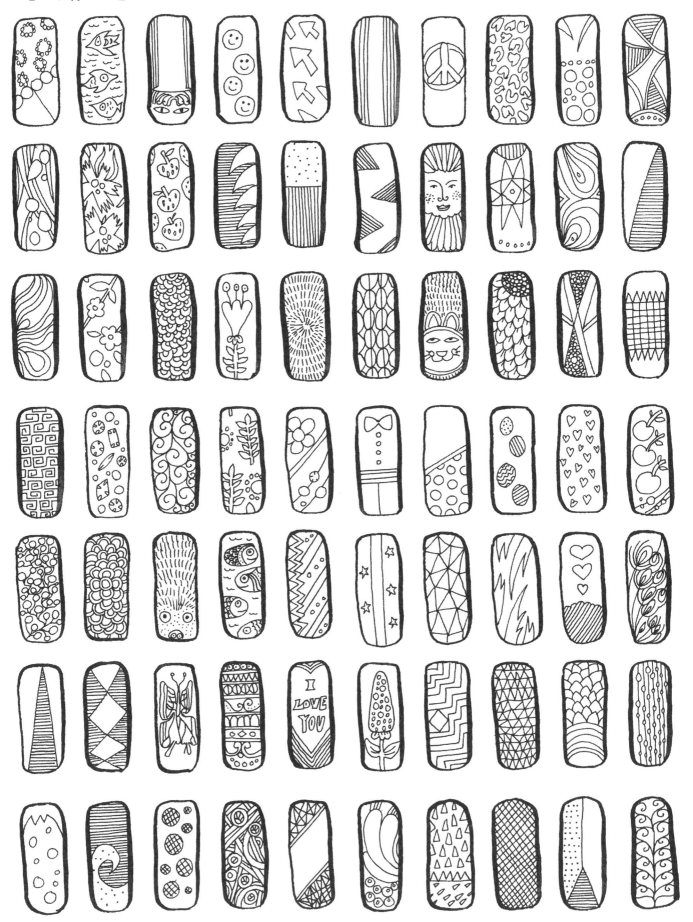

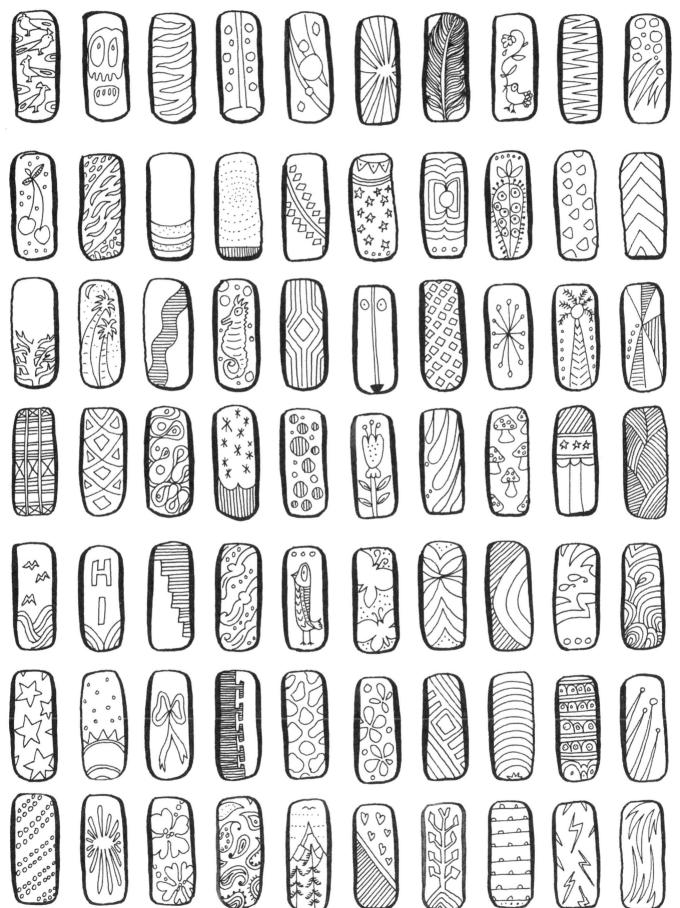

先在此处设计绘制你自己喜欢
的美甲图案，之后剪切下来。 CUT OUT THE NAIL ART YOU LIKE THE BEST

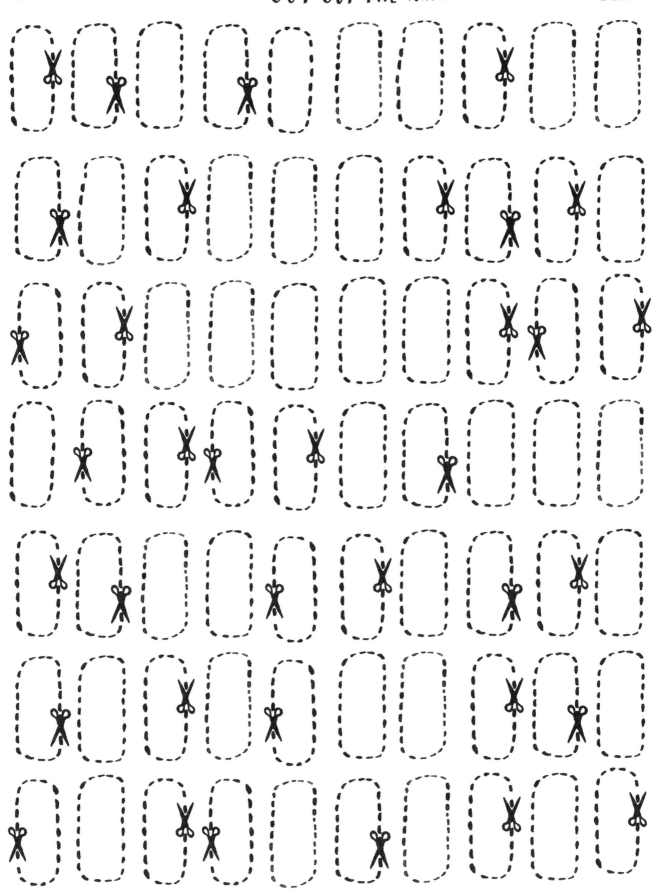

PUT 在空白处画出手的轮廓，
　　　　　并将刚剪切的美甲图案贴上。

YOUR HAND ON THE PAGE,

TAKE A PEN and DRAW AROUND IT.

现在，
把你剪下来的美甲图案贴上去。

and now ...

STICK ON THE NAILS YOU'VE
CUT OUT

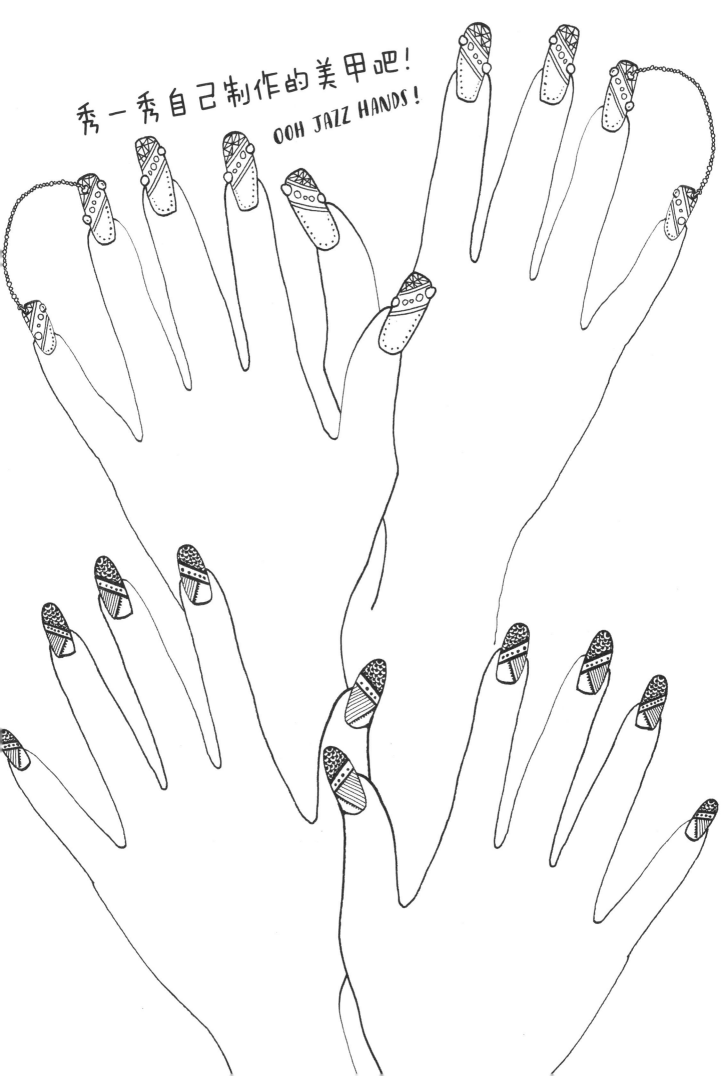

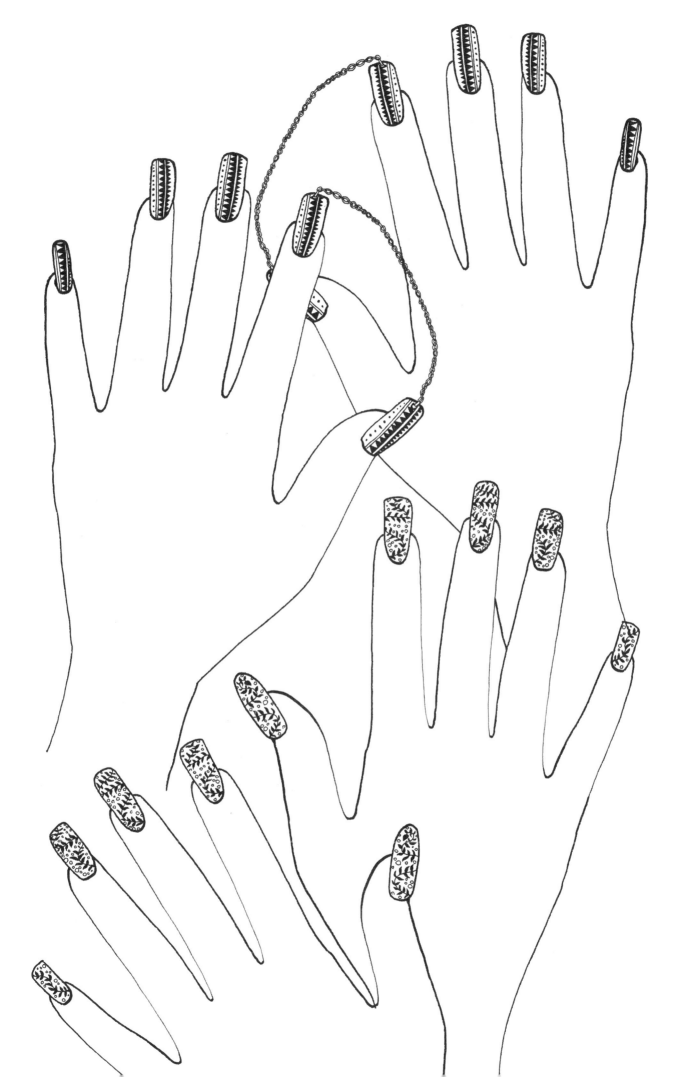

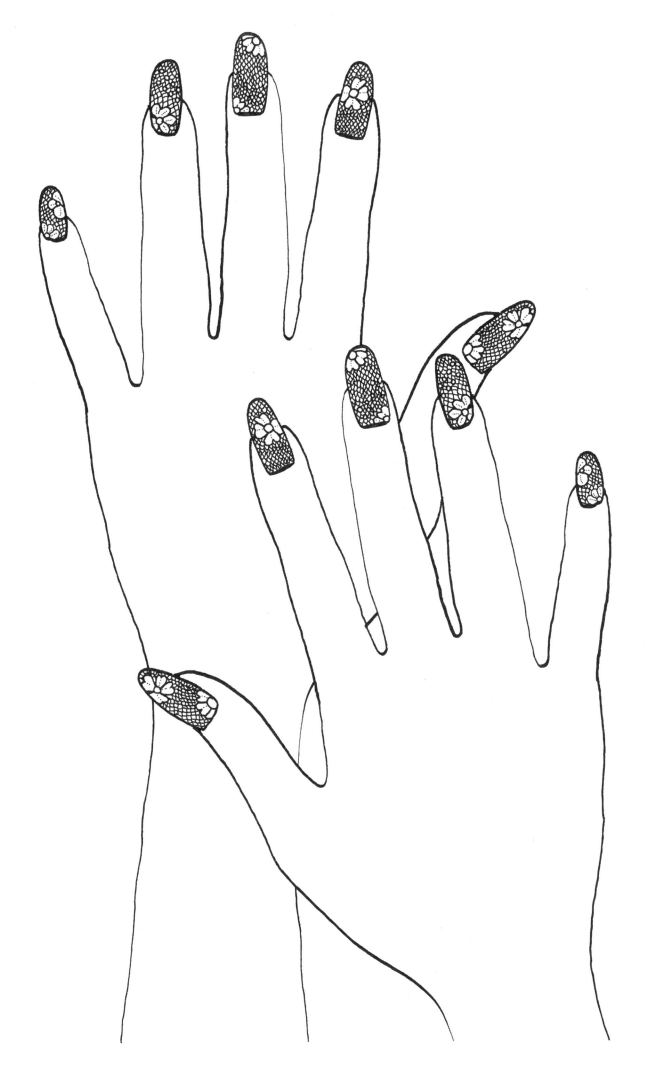

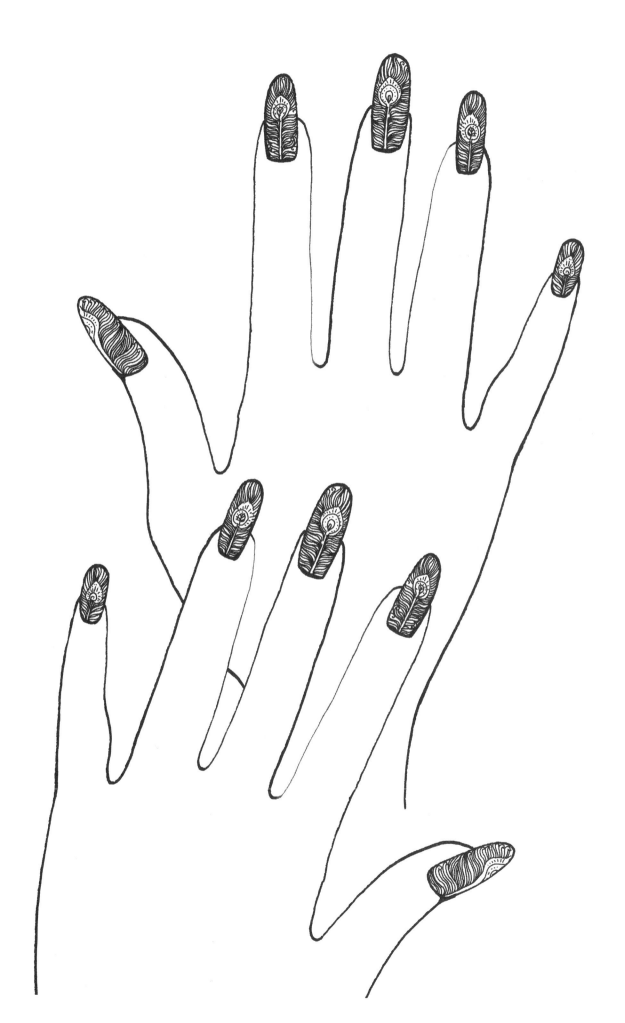

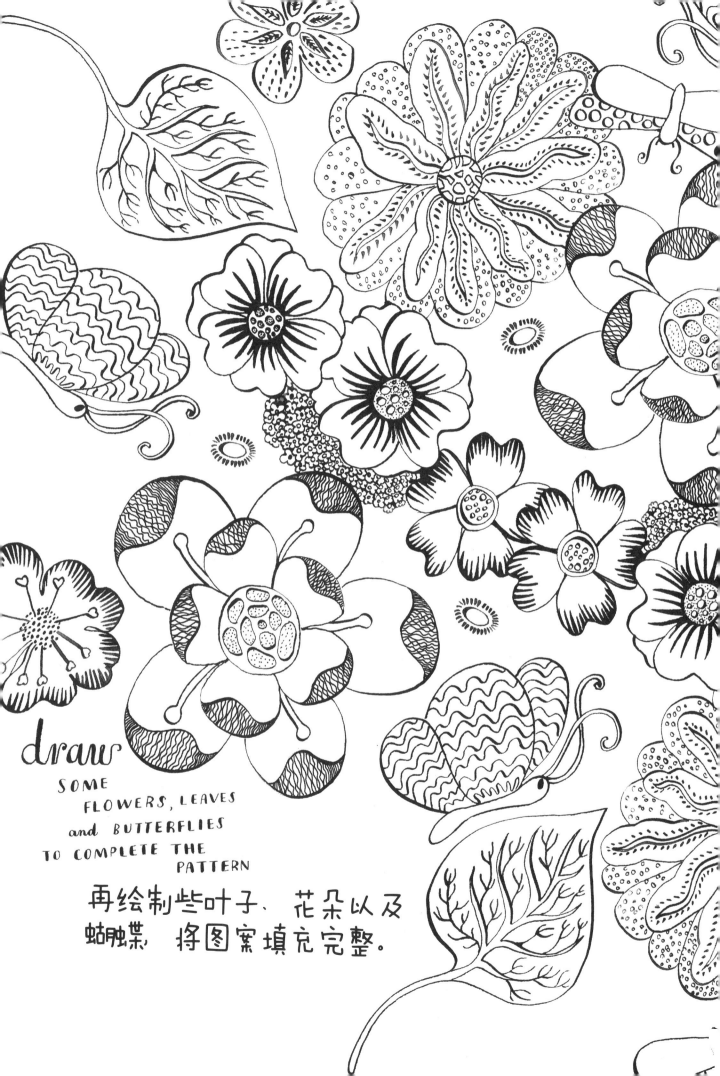

draw
SOME
FLOWERS, LEAVES
and BUTTERFLIES
TO COMPLETE THE
PATTERN

再绘制些叶子、花朵以及
蝴蝶，将图案填充完整。

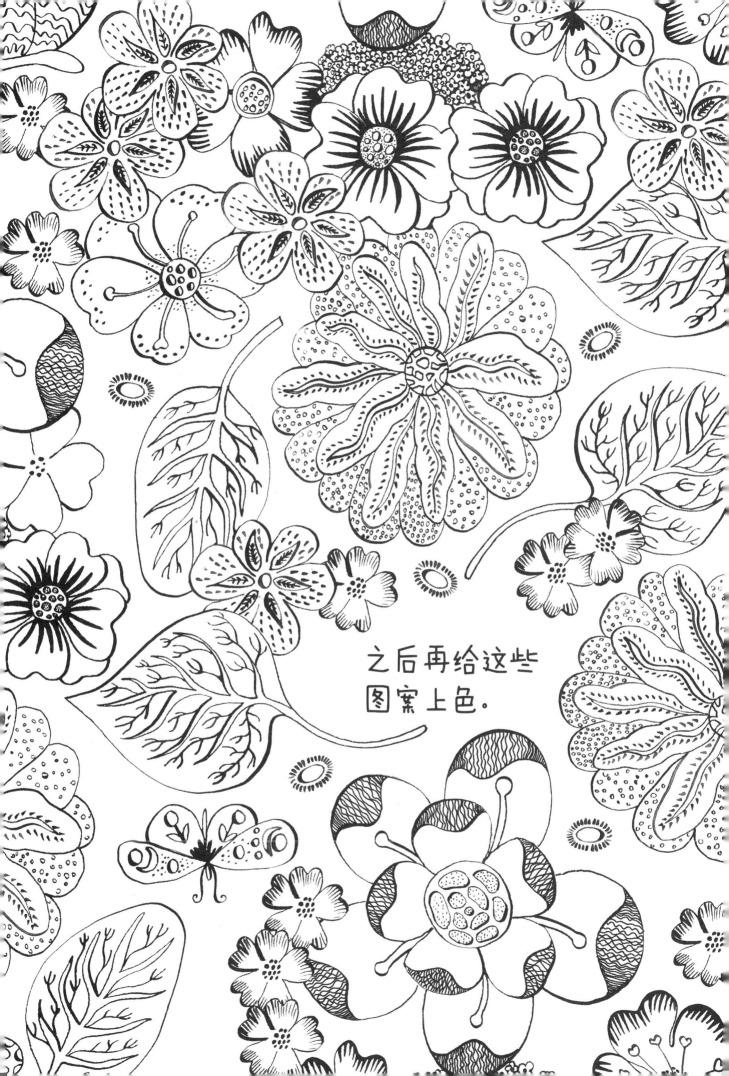

之后再给这些
图案上色。

使用长蕾丝布制作一副面具，先在布条上挖两个洞，给眼睛留下空间。防止磨损皮肤，记得缲边。

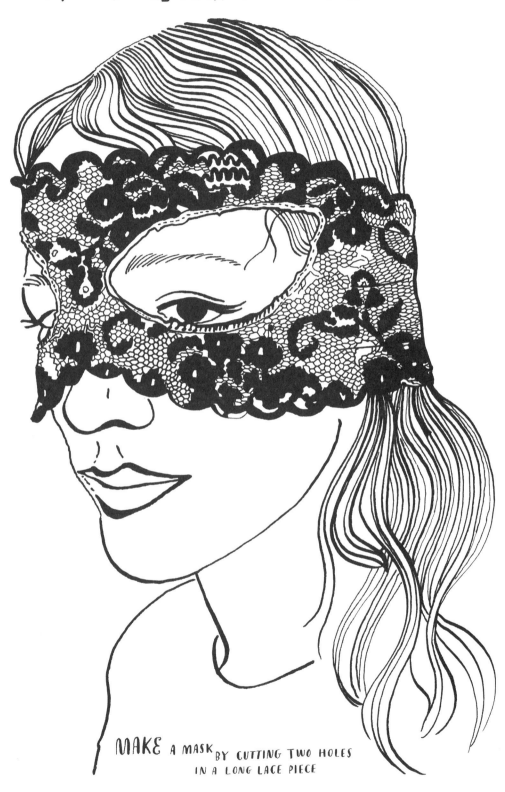

MAKE A MASK BY CUTTING TWO HOLES IN A LONG LACE PIECE

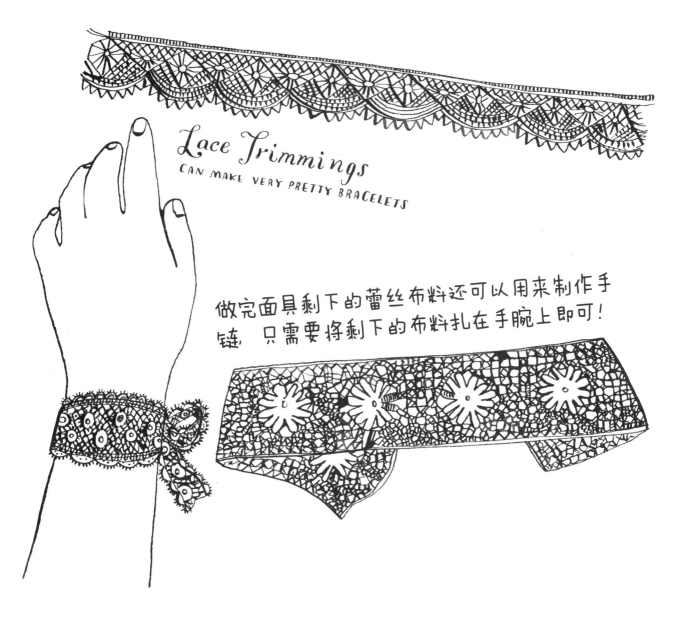

Lace Trimmings
CAN MAKE VERY PRETTY BRACELETS

做完面具剩下的蕾丝布料还可以用来制作手链，只需要将剩下的布料扎在手腕上即可！

只需要把一条（或者一些）边角料扎在你的手腕上。

很简单！

还可以选择一条古典的蕾丝布料，用别针加固在你的衣服领子上。

SAFETY PIN AN
ANTIQUE LACE
COLLAR TO YOUR T-SHIRT

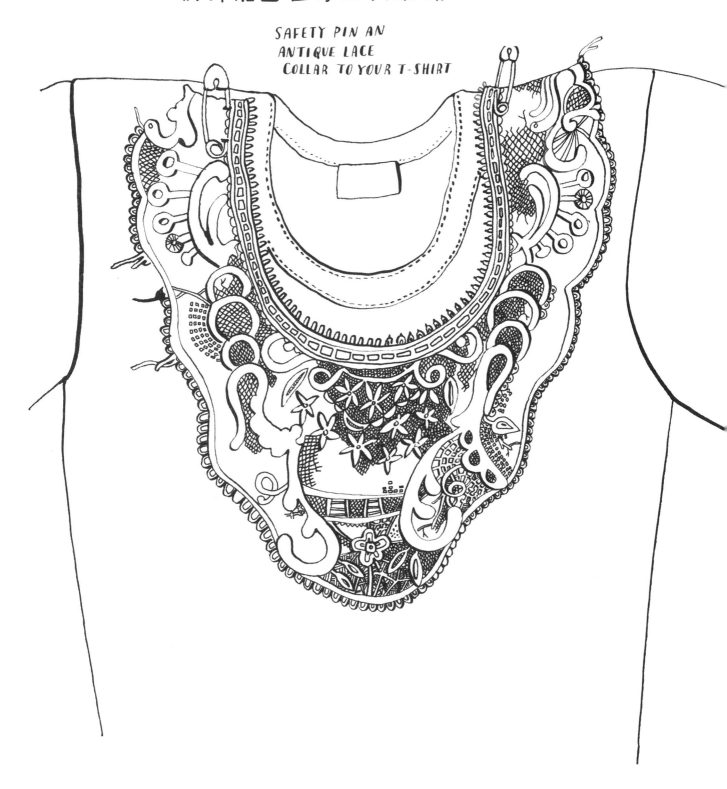

除此之外，这些蕾丝布料还可以
当作发带，直接扎在头上即可。
YOU CAN USE LACE TRIMMINGS
TO MAKE A HEADBAND

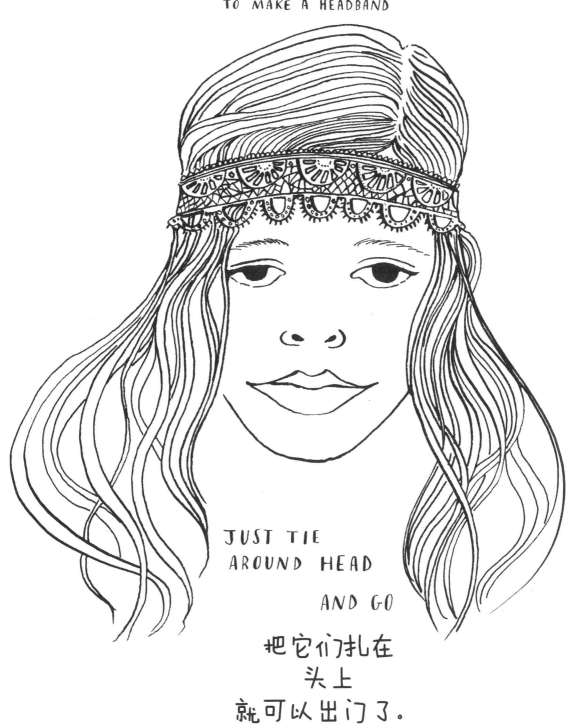

JUST TIE
AROUND HEAD

AND GO

把它们扎在
头上
就可以出门了。

试试看，
将这双手套变成
带有花边的式样。

Can you
TURN
THESE INTO LACY GLOVES?

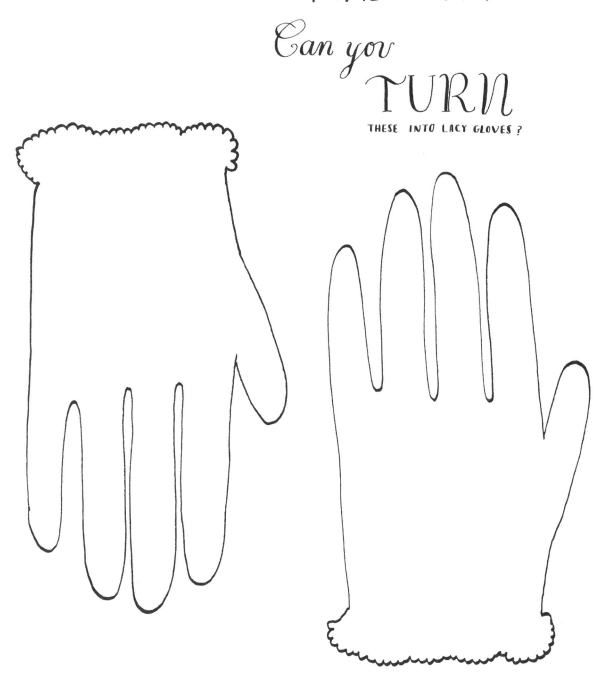

变废为宝,
将旧的蕾丝布料
制成染色模板。

第一步,将蕾丝布料放在你想要染色的衣服上。

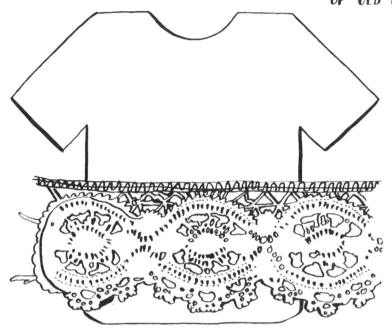

第二步,运用可喷
在布料上的喷漆进
行喷涂。

喷涂!

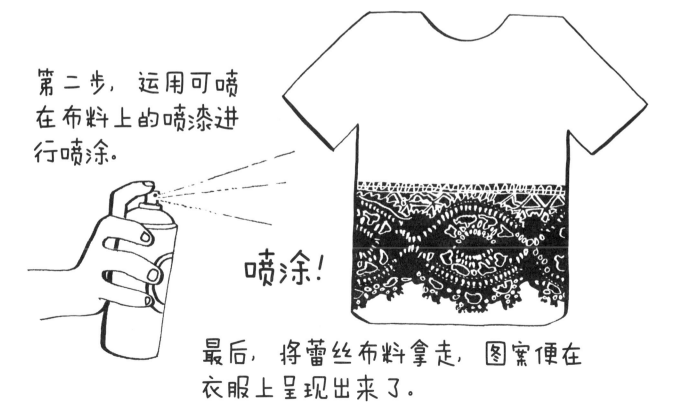

最后,将蕾丝布料拿走,图案便在
衣服上呈现出来了。

试着给这套比基尼绘制一个 INVENT A SUNNY PATTERN
充满夏日色彩的图案吧。　FOR THIS BIKINI

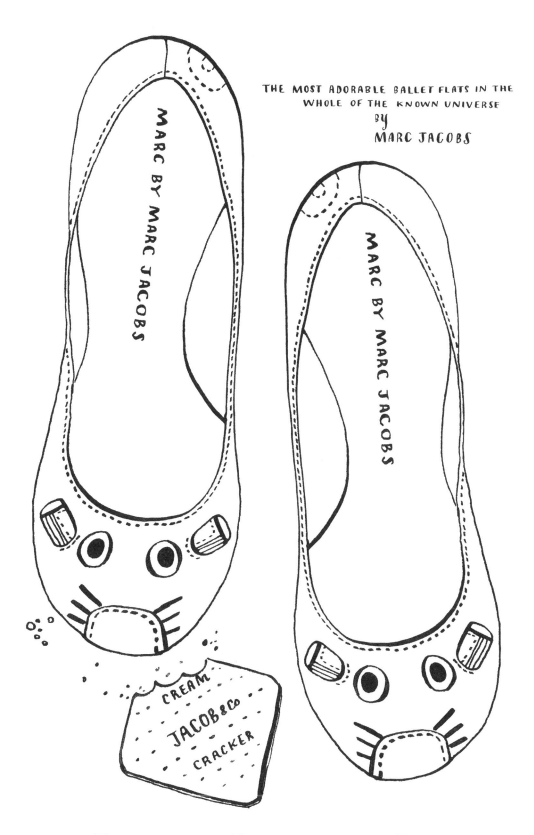

THE MOST ADORABLE BALLET FLATS IN THE
WHOLE OF THE KNOWN UNIVERSE
BY
MARC JACOBS

这是Marc Jacobs设计的一款世界上
最可爱的芭蕾舞鞋。

DESIGN
YOUR OWN HANDBAG

在空白处

设计绘制一个属于自己的手提袋。

并设计一双与之
搭配的鞋如何？
how about...
DRAWING SOME SHOES
TO GO WITH IT

在墨西哥，
为了躲避骄阳，
会将帽子的帽檐
设计得很宽大。

THE SOMBRERO
WAS DESIGNED
WITH AN EXTRA WIDE BRIM
TO GIVE SHELTER
FROM THE FIERCE MEXICAN SUN

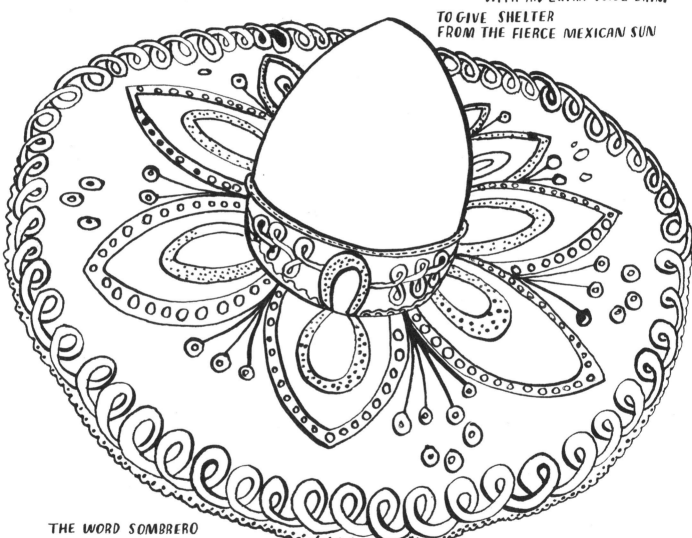

THE WORD SOMBRERO
COMES FROM THE SPANISH WORD
SOMBRA
WHICH MEANS
'SHADE' OR 'SHADOW'

"墨西哥帽" 一词
来自西班牙语sombra，
原意是 "遮掩" 或是 "影子"

DRAW A FANTASTIC WIDE BRIMMED
HAT FOR THIS LOVELY SEÑORITA

为这位女士也画上一顶
拥有宽帽檐的遮阳帽。

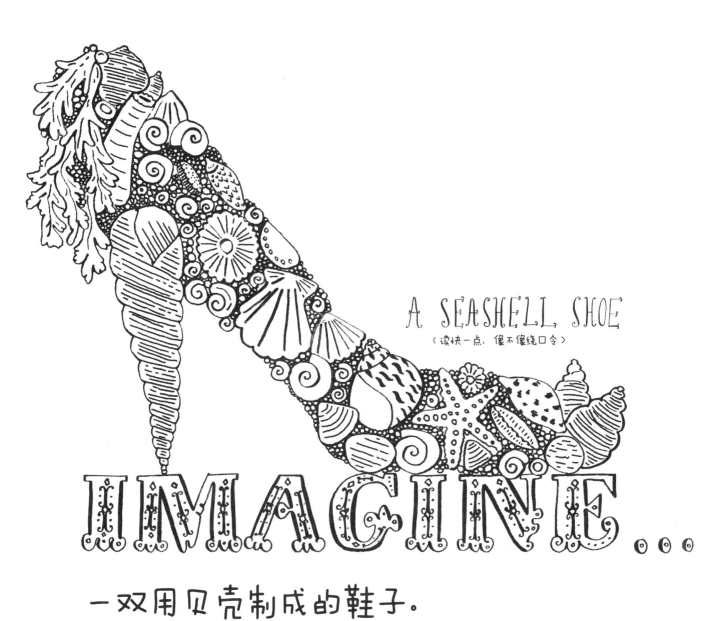

A SEASHELL SHOE
（读快一点，像不像绕口令）

IMAGINE...

一双用贝壳制成的鞋子。

想象一下，画出你自己的创意想法。
NOW DRAW
YOUR OWN

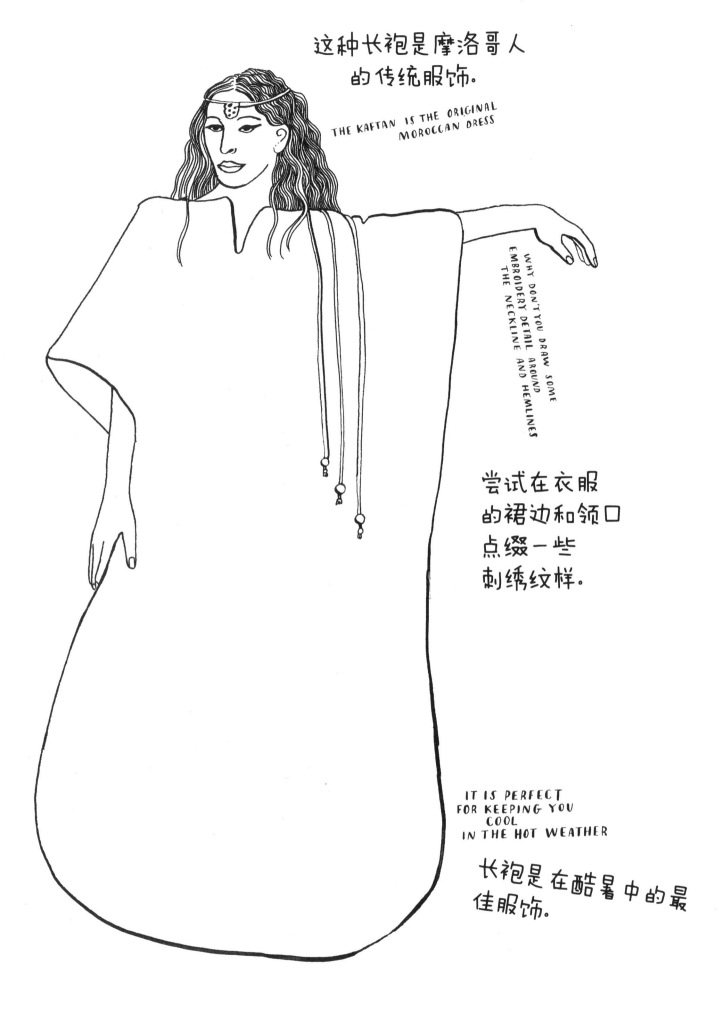

这种长袍是摩洛哥人
的传统服饰。

THE KAFTAN IS THE ORIGINAL
MOROCCAN DRESS

WHY DON'T YOU DRAW SOME
EMBROIDERY DETAIL AROUND
THE NECKLINE AND HEMLINES

尝试在衣服
的裙边和领口
点缀一些
刺绣纹样。

IT IS PERFECT
FOR KEEPING YOU
COOL
IN THE HOT WEATHER

长袍是在酷暑中的最
佳服饰。

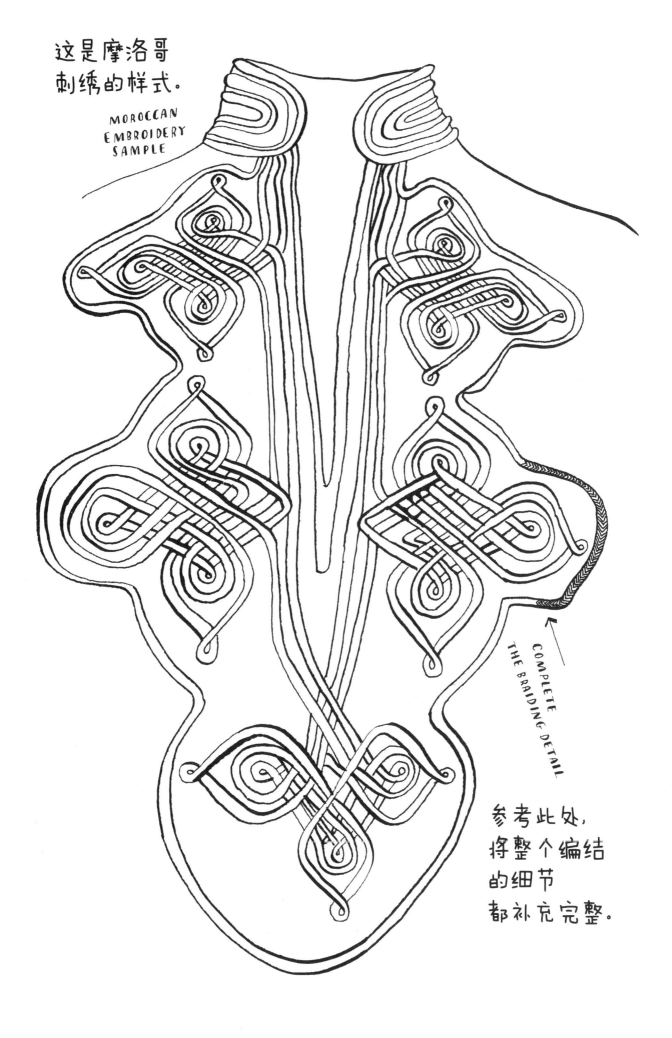

这是摩洛哥
刺绣的样式。

MOROCCAN
EMBROIDERY
SAMPLE

COMPLETE
THE BRAIDING DETAIL

参考此处,
将整个编结
的细节
都补充完整。

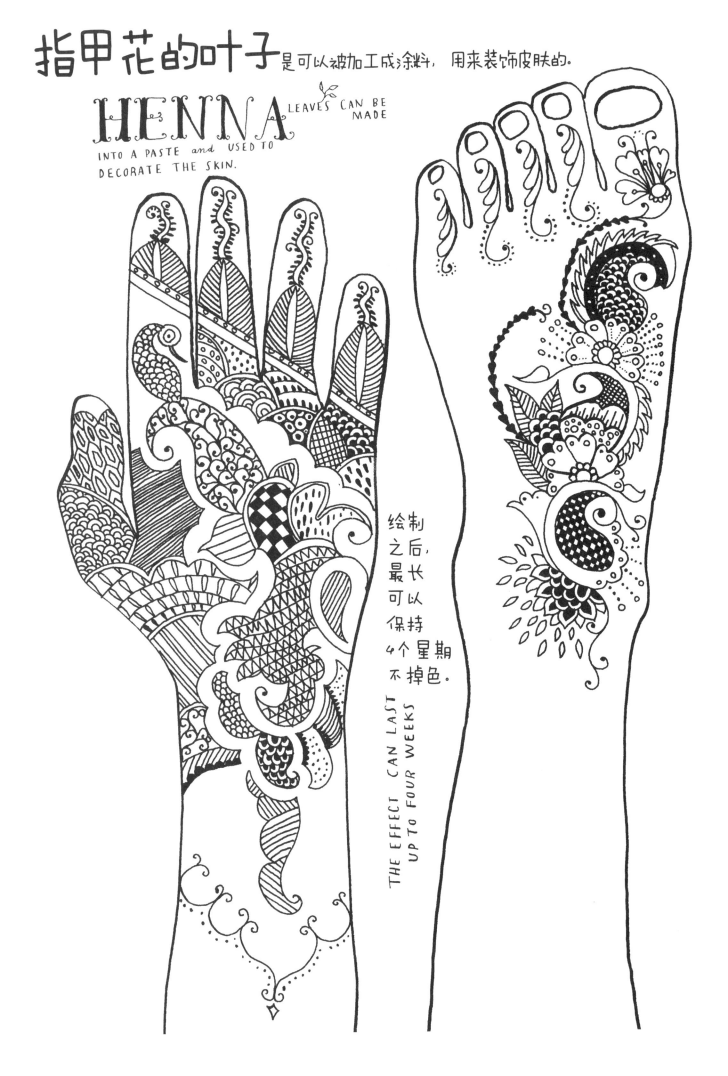

指甲花传统上在 **南亚**和**北非地区**盛行。

Henna is traditionally used in South Asia and North Africa.

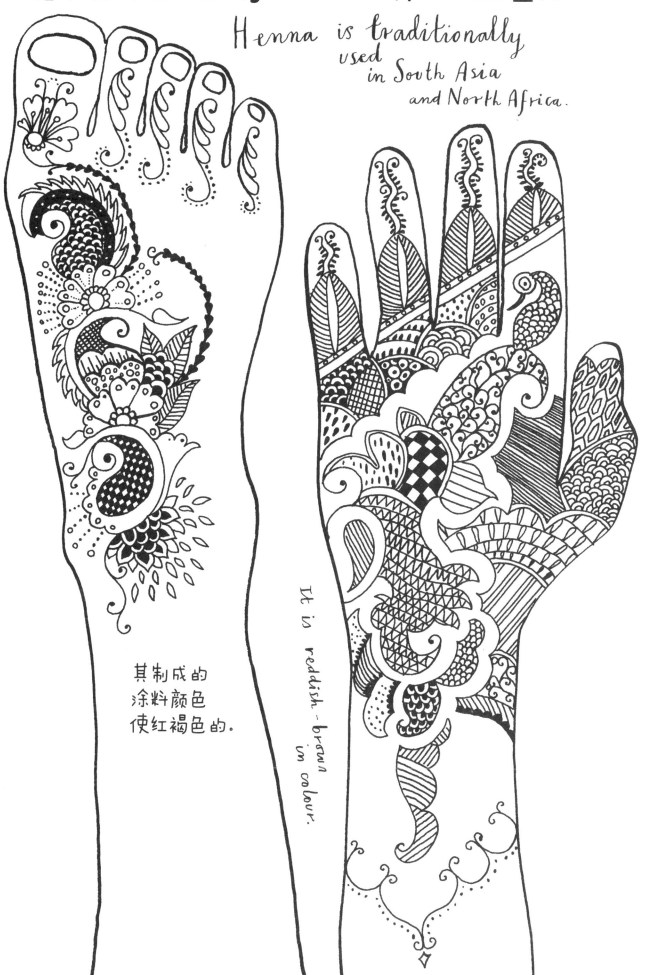

其制成的涂料颜色使红褐色的。

It is reddish-brown in colour.

试着绘制
属于你自己的指甲花涂画图案。

CREATE
your own
HENNA DESIGN.

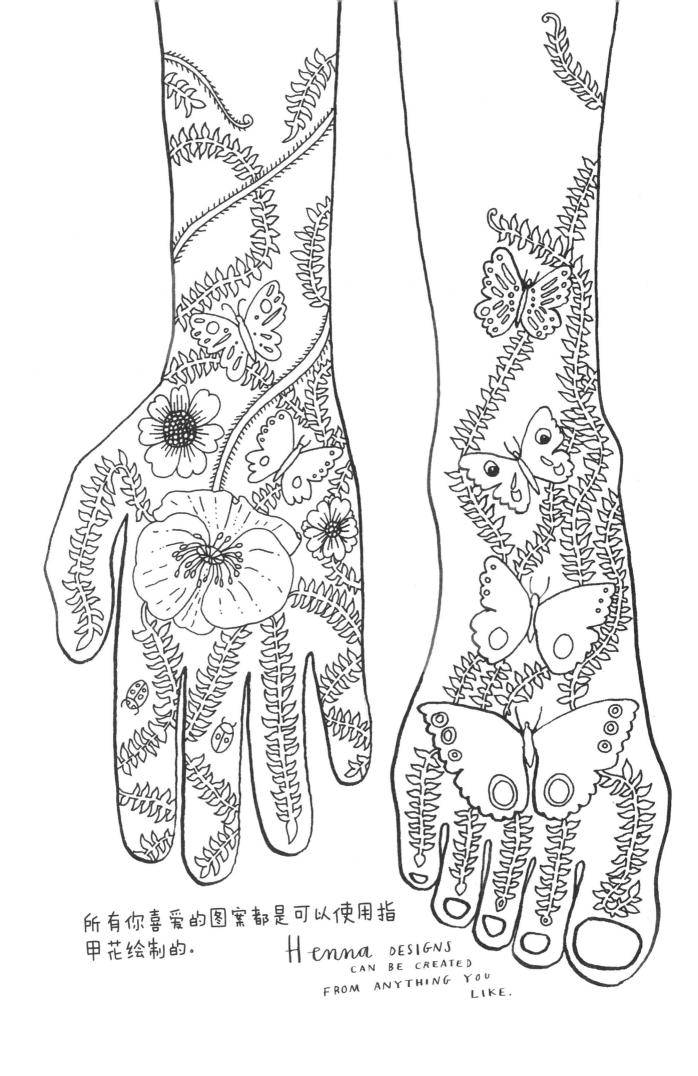

所有你喜爱的图案都是可以使用指
甲花绘制的。

Henna DESIGNS
CAN BE CREATED
FROM ANYTHING YOU
LIKE.

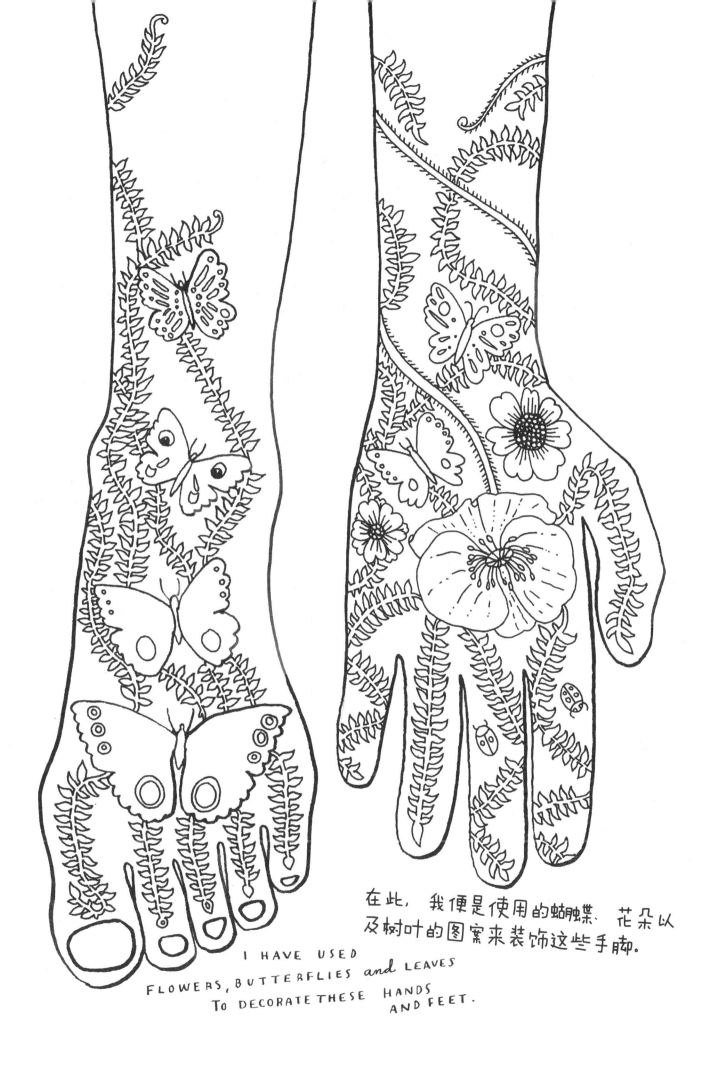

在此，我便是使用的蝴蝶、花朵以及树叶的图案来装饰这些手脚。

I HAVE USED
FLOWERS, BUTTERFLIES and LEAVES
TO DECORATE THESE HANDS
AND FEET.

CREATE
SOME MORE HENNA DESIGNS

绘制
更多的指甲花涂绘图案。

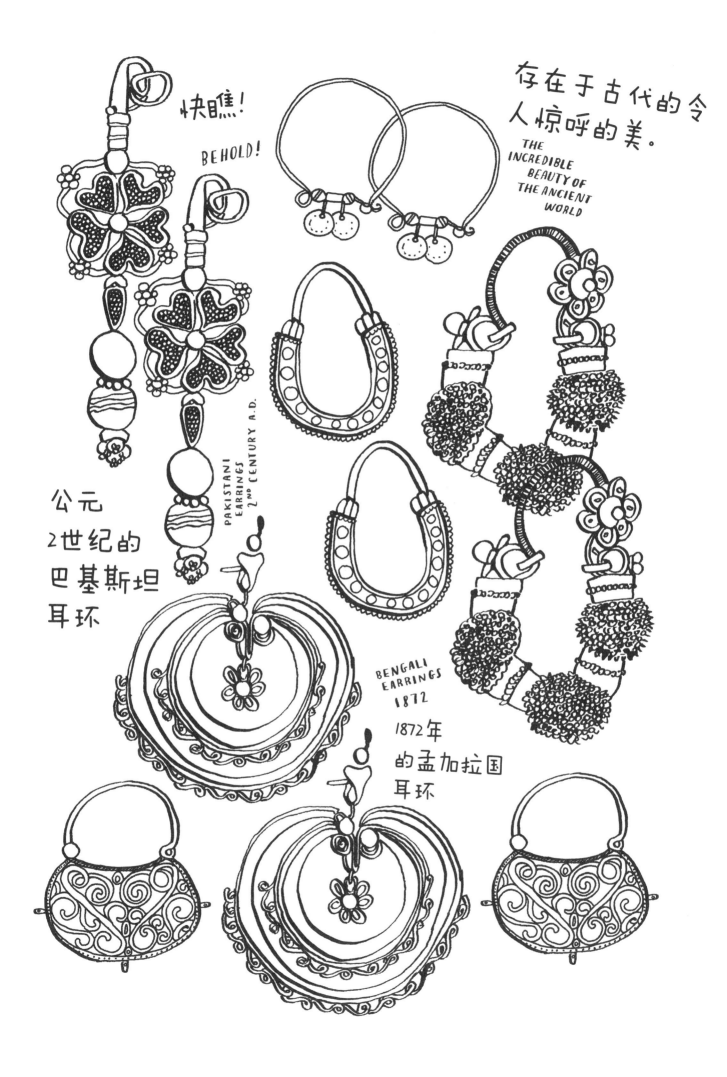

快瞧!

BEHOLD!

存在于古代的令
人惊呼的美。

THE
INCREDIBLE
BEAUTY
OF
THE ANCIENT
WORLD

PAKISTANI EARRINGS
2ⁿᵈ CENTURY A.D.

公元
2世纪的
巴基斯坦
耳环

BENGALI
EARRINGS
1872

1872年
的孟加拉国
耳环

看了那么多漂亮耳环，
也想象一下属于自己的耳环是何模样？
draw 将它绘制出来
SOME BEAUTIFUL EARRINGS
THAT YOU CAN
IMAGINE WEARING

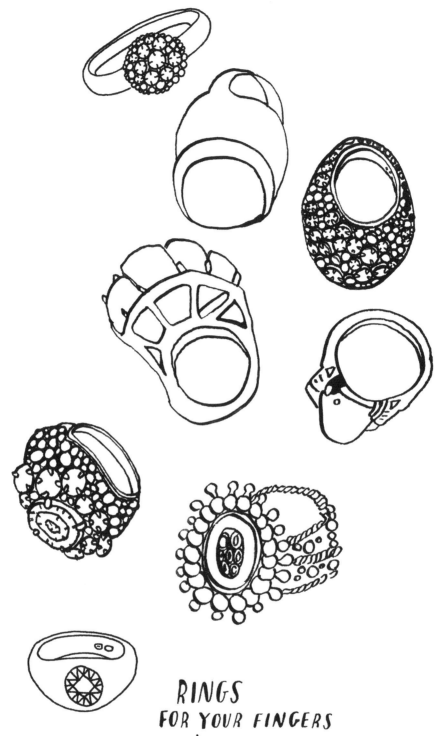

RINGS
FOR YOUR FINGERS
and
MAYBE SOME FOR YOUR TOES

这里有许多漂亮的戒指,
　　还包括了戴在脚趾上的。

在空白处画上你手和脚的轮廓，
　　之后在对页中
选择你喜欢
　　的样式 DRAW
ROUND YOUR
HANDS
AND YOUR FEET
THEN CHOOSE FROM
THE RINGS ON
THE OPPOSITE PAGE
OR MAKE UP YOUR OWN

　　给手脚都佩戴上，
或是自己来设计
新的戒指佩戴。

别针如何做成手镯?
你需要的工具有: 别针、小
串珠、适合你手臂长度的松
紧带, 以及一双灵巧的手。

HOW TO...
MAKE A SAFETY PIN BRACELET

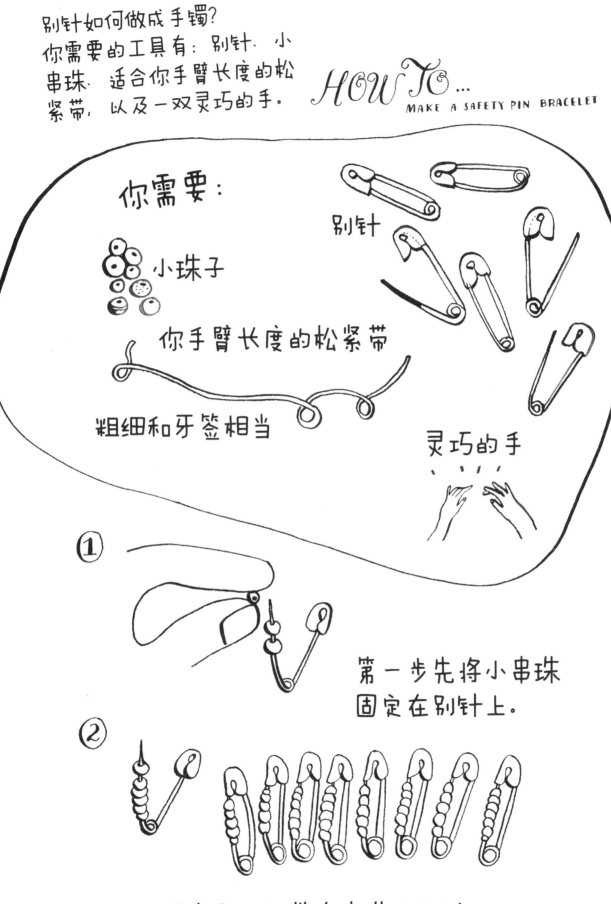

你需要:

小珠子

别针

你手臂长度的松紧带

粗细和牙签相当

灵巧的手

① 第一步先将小串珠
固定在别针上。

② 并多做一些带有串珠的别针。

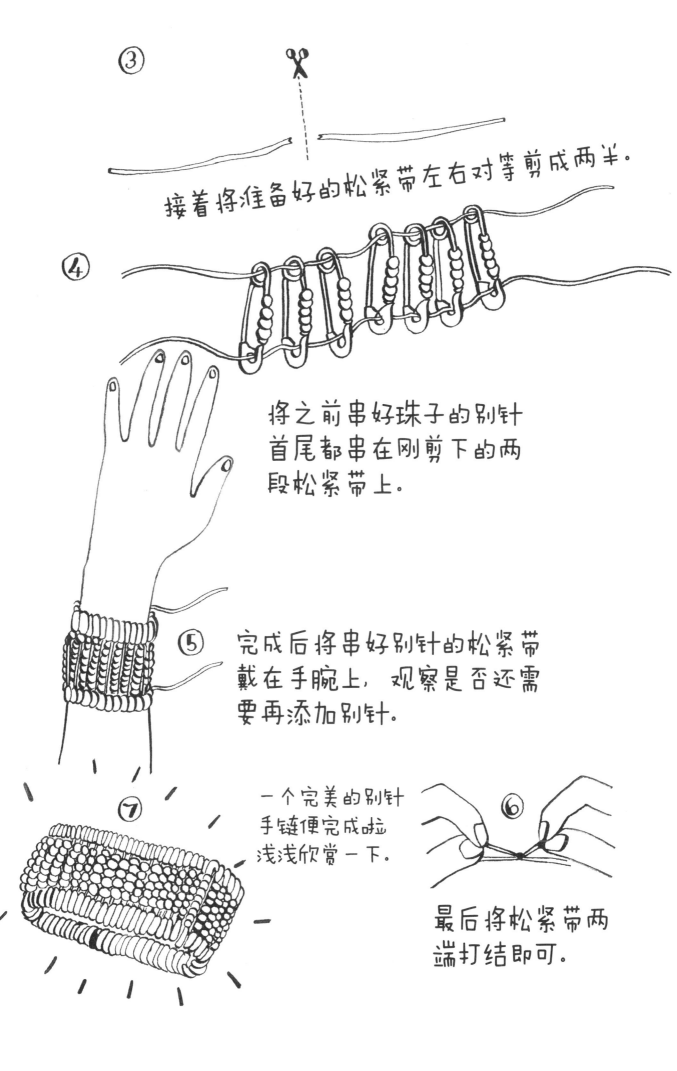

③

接着将准备好的松紧带左右对等剪成两半。

④

将之前串好珠子的别针
首尾都串在刚剪下的两
段松紧带上。

⑤

完成后将串好别针的松紧带
戴在手腕上，观察是否还需
要再添加别针。

⑦

一个完美的别针
手链便完成啦
浅浅欣赏一下。

⑥

最后将松紧带两
端打结即可。

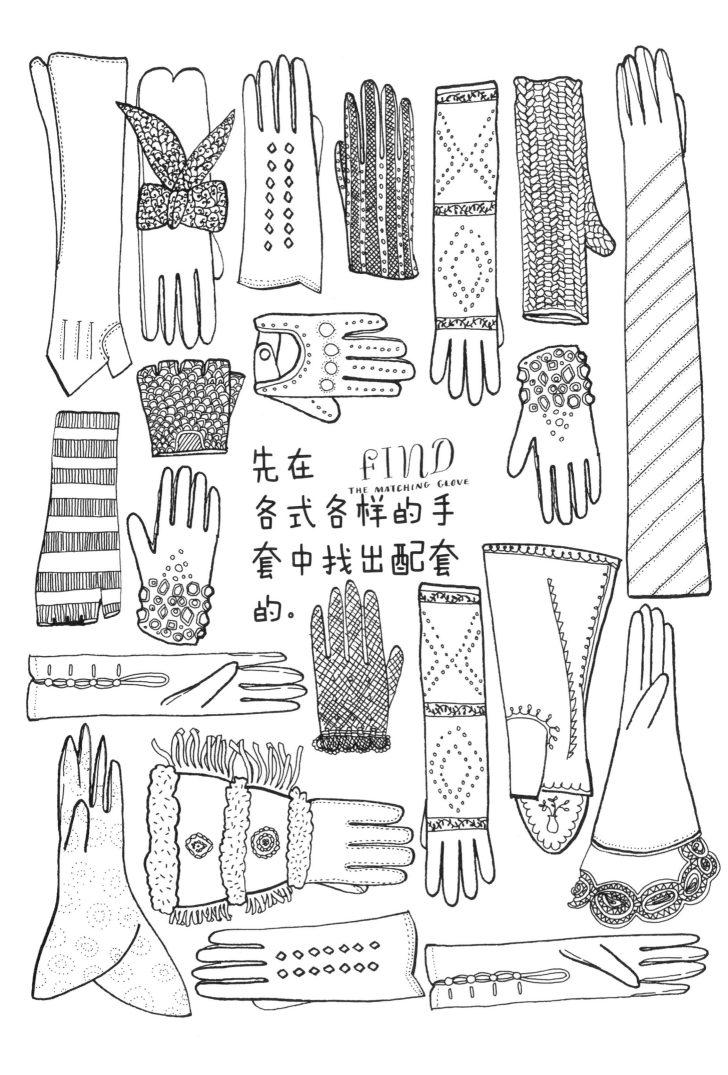

先在各式各样的手套中找出配套的。

FIND
THE MATCHING GLOVE

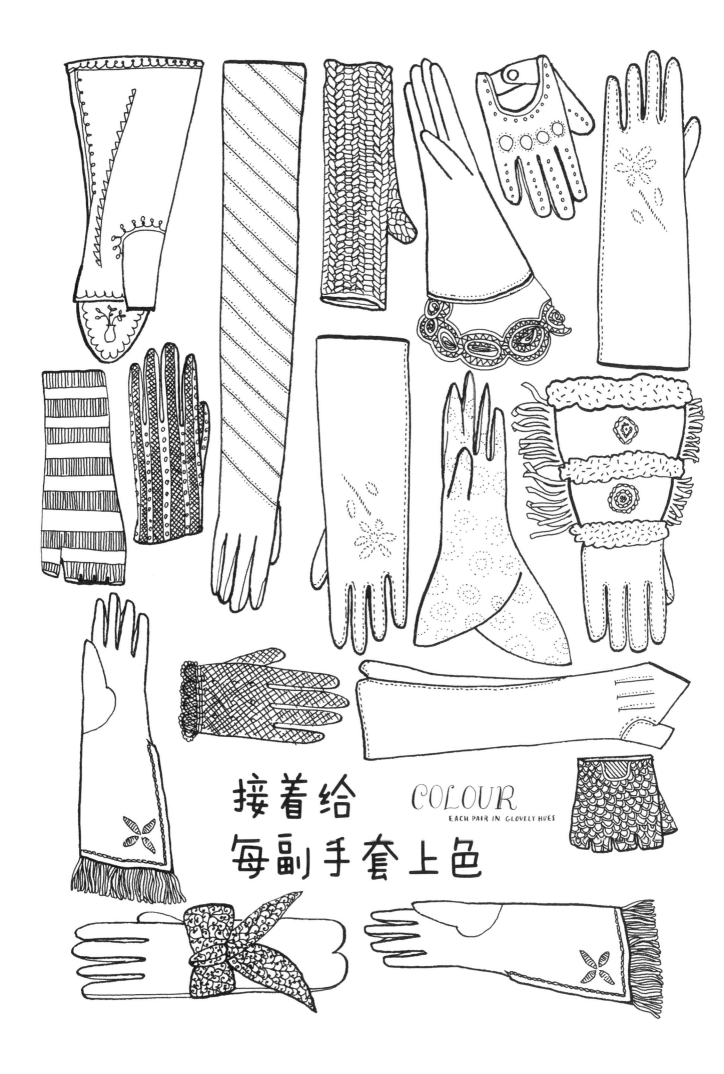

接着给
每副手套上色

COLOUR
EACH PAIR IN GLOVELY HUES

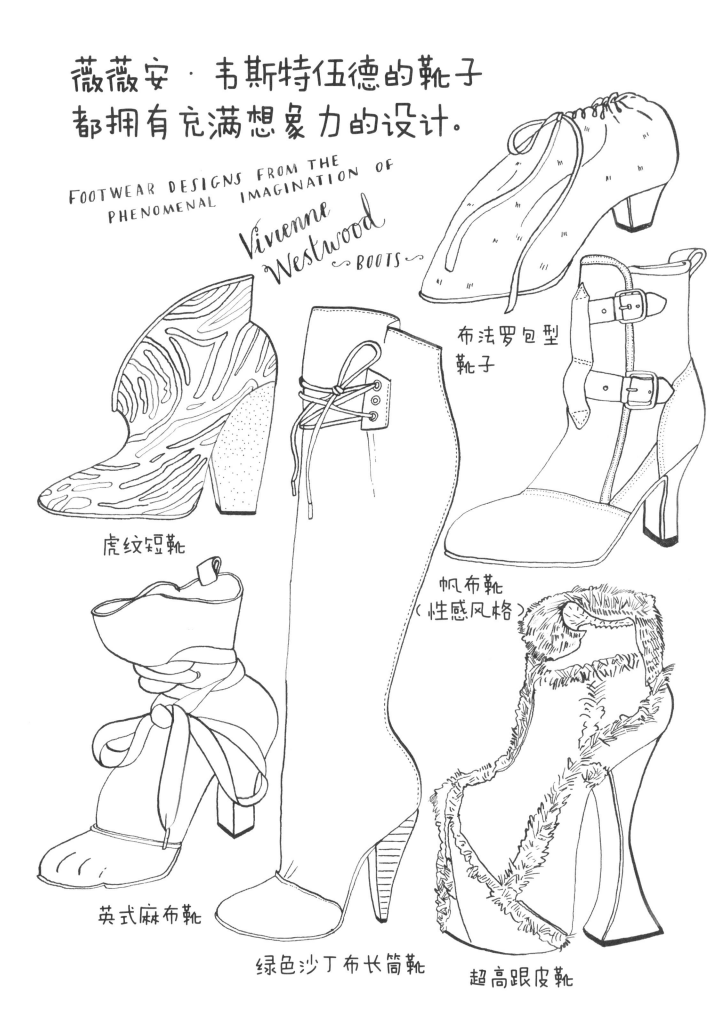

薇薇安·韦斯特伍德的靴子
都拥有充满想象力的设计。

FOOTWEAR DESIGNS FROM THE PHENOMENAL IMAGINATION OF

Vivienne Westwood ~BOOTS~

布法罗包型靴子

虎纹短靴

帆布靴（性感风格）

英式麻布靴

绿色沙丁布长筒靴

超高跟皮靴

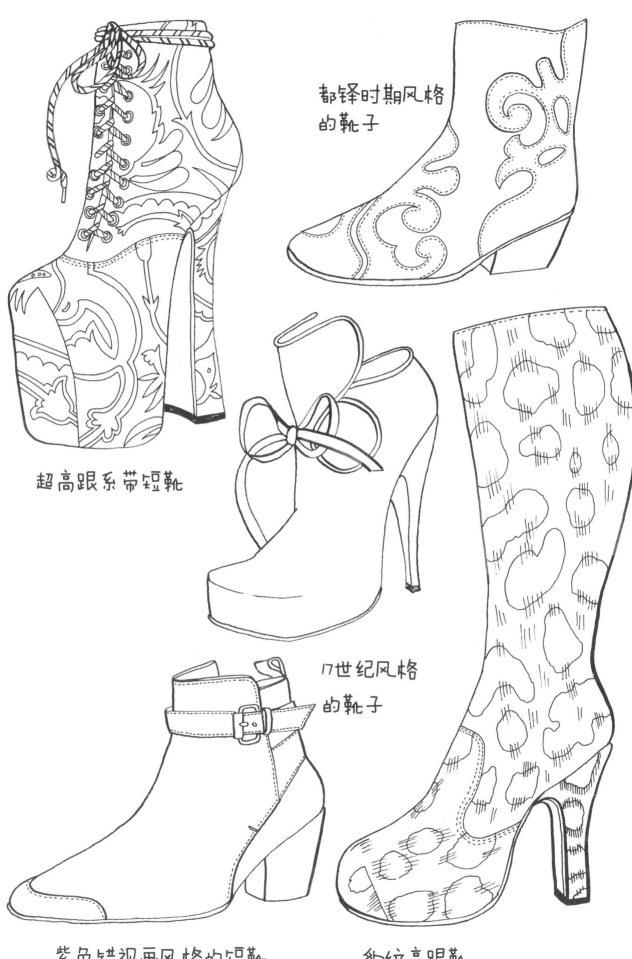

都铎时期风格
的靴子

超高跟系带短靴

17世纪风格
的靴子

紫色错视画风格的短靴　　豹纹高跟靴

欣赏了如此多 FILL
的非凡设计的鞋子, THESE PAGES...

现在需要你自己也设计出充满创意的
鞋子，数量不限，
试着将画纸填满吧。 ...WITH PHENOMENAL
FOOTWEAR DESIGNS
OF YOUR OWN

再欣赏一些
薇薇安·韦斯特伍德
设计的鞋子。

MORE
Vivienne
Westwood
~SHOES~
and
~SANDALS~

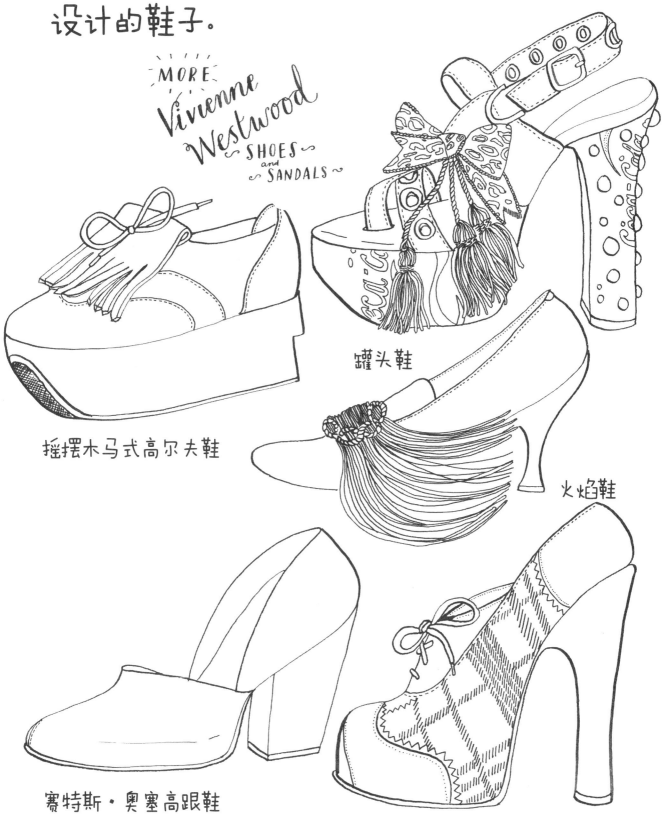

罐头鞋

摇摆木马式高尔夫鞋

火焰鞋

赛特斯·奥塞高跟鞋

苏格兰格子呢系带高跟鞋

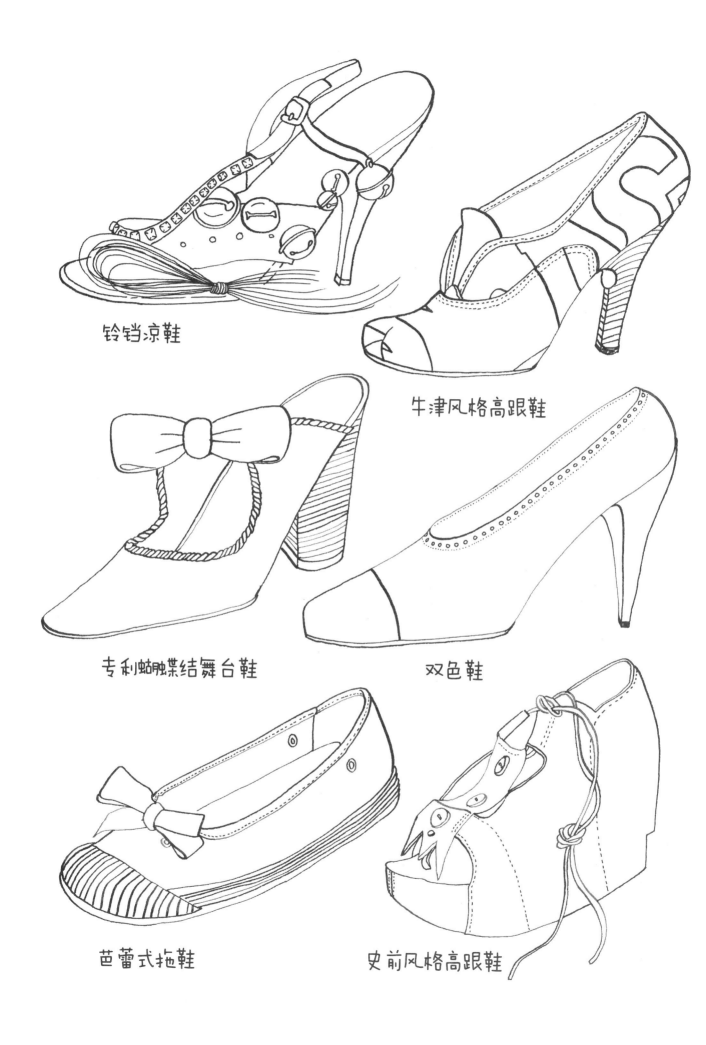

铃铛凉鞋

牛津风格高跟鞋

专利蝴蝶结舞台鞋

双色鞋

芭蕾式拖鞋

史前风格高跟鞋

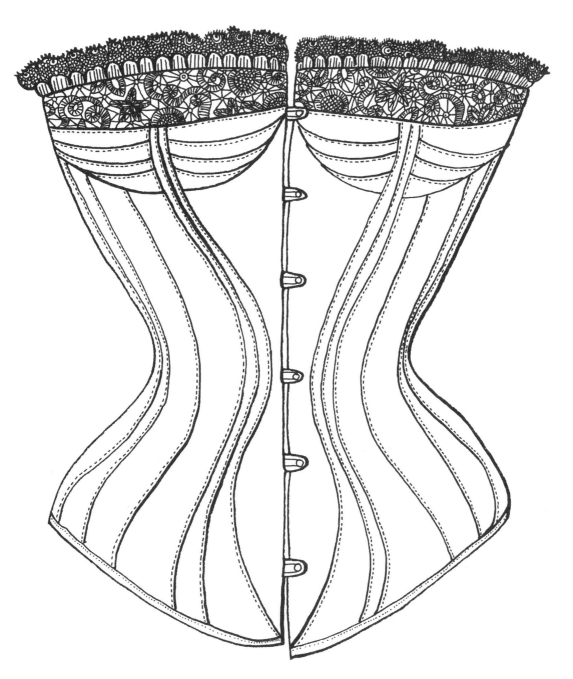

1884年的束腹衣，
使用沙丁布、
钢丝和兽骨制作。

CORSET
1884
SATIN, STEEL and BONE

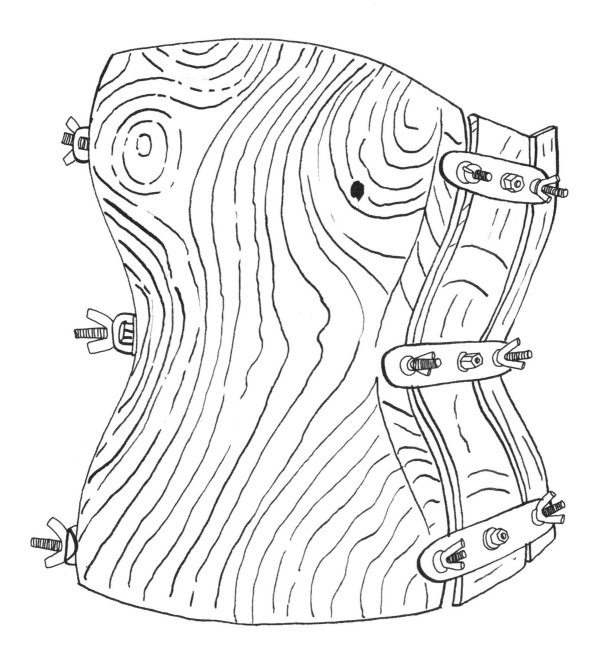

1995年的侯赛因·卡拉扬束腹,
由木材和金属制作而成。

HUSSEIN CHALAYAN

CORSET 1995

WOOD and METAL

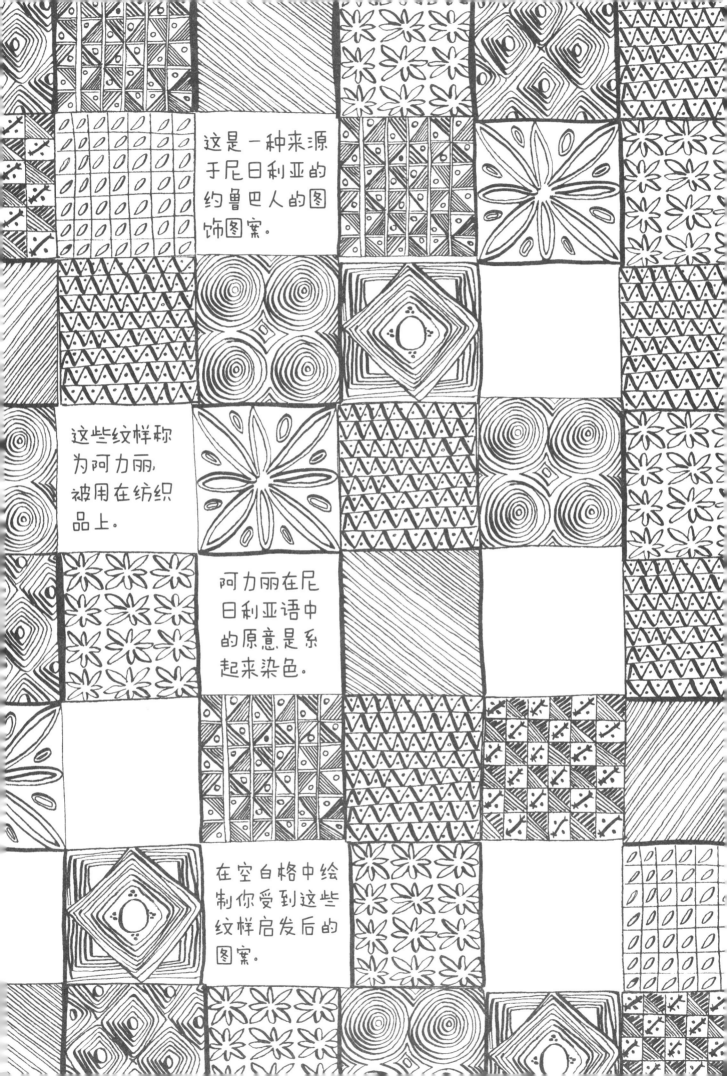

这是一种来源于尼日利亚的约鲁巴人的图饰图案。

这些纹样称为阿力丽,被用在纺织品上。

阿力丽在尼日利亚语中的原意是系起来染色。

在空白格中绘制你受到这些纹样启发后的图案。

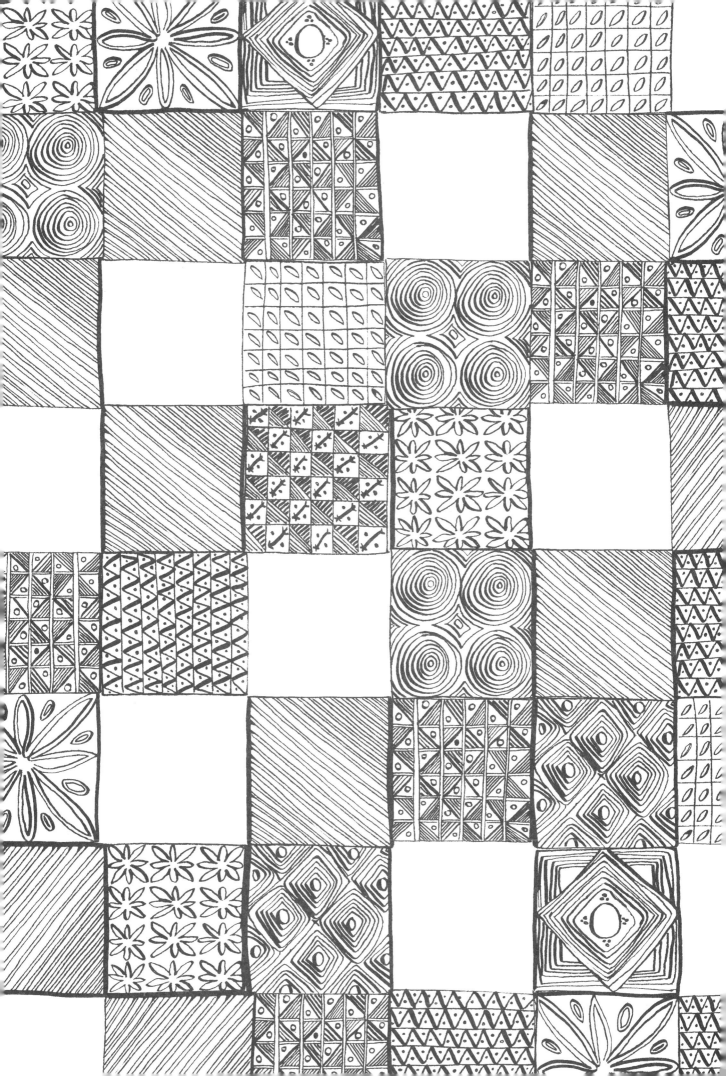

运用对页的装饰品来改造这件夹克衫。

CUSTOMIZE

THIS JACKET USING ANY OF THE

TRIMMINGS OPPOSITE →

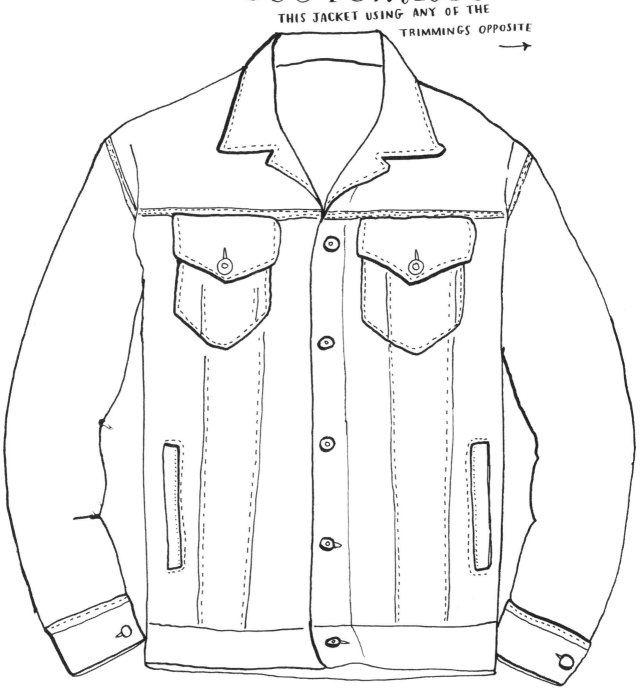

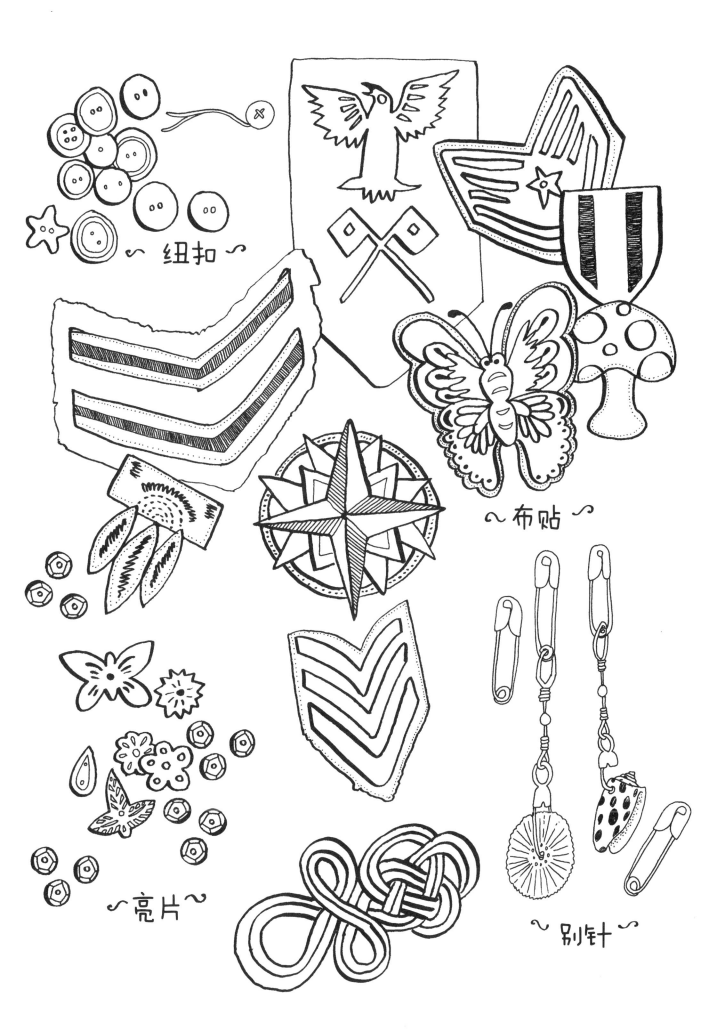

~ 纽扣 ~

~ 布贴 ~

~ 亮片 ~

~ 别针 ~

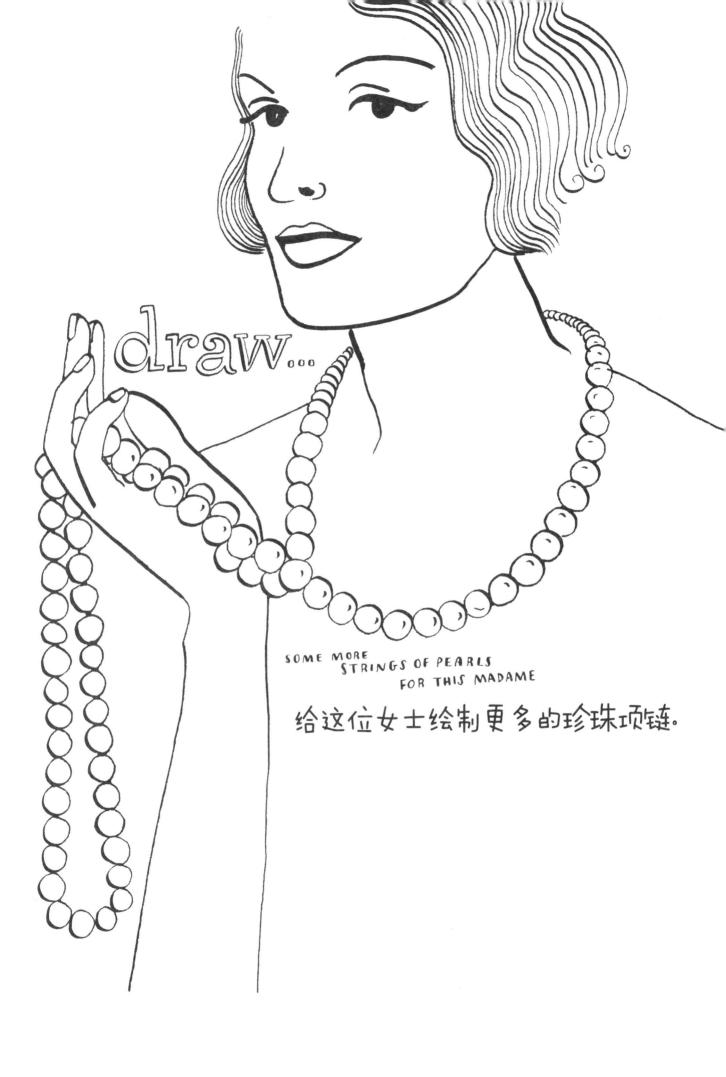

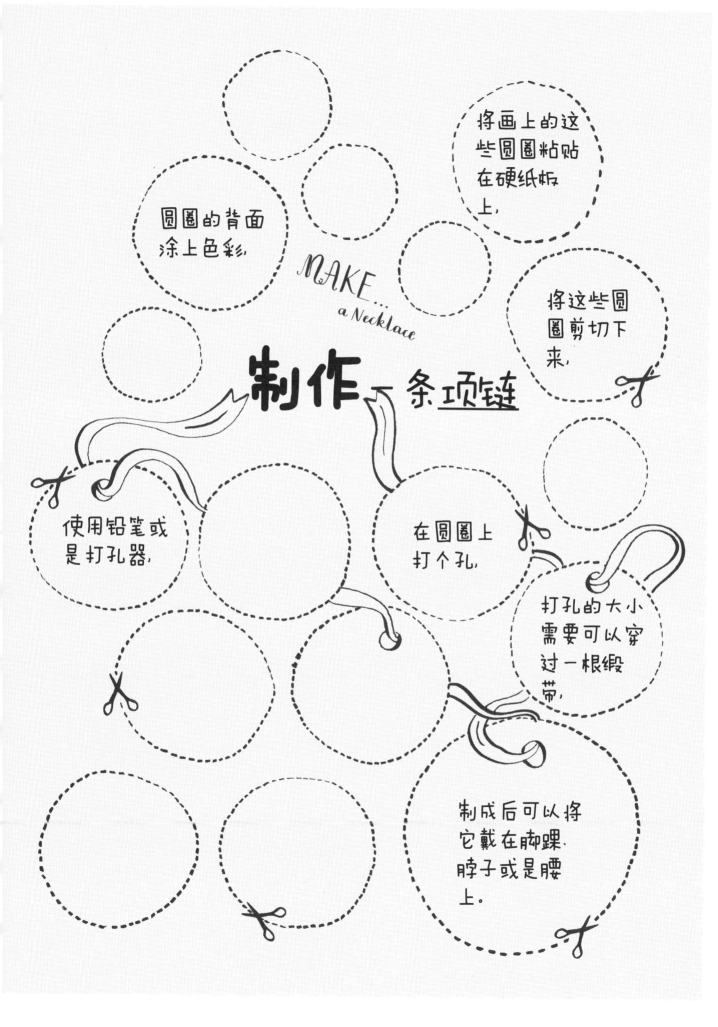

将画上的这些圆圈粘贴在硬纸板上。

圆圈的背面涂上色彩。

MAKE...
a Necklace

将这些圆圈剪切下来。

制作一条项链

使用铅笔或是打孔器。

在圆圈上打个孔。

打孔的大小需要可以穿过一根缎带。

制成后可以将它戴在脚踝、脖子或是腰上。

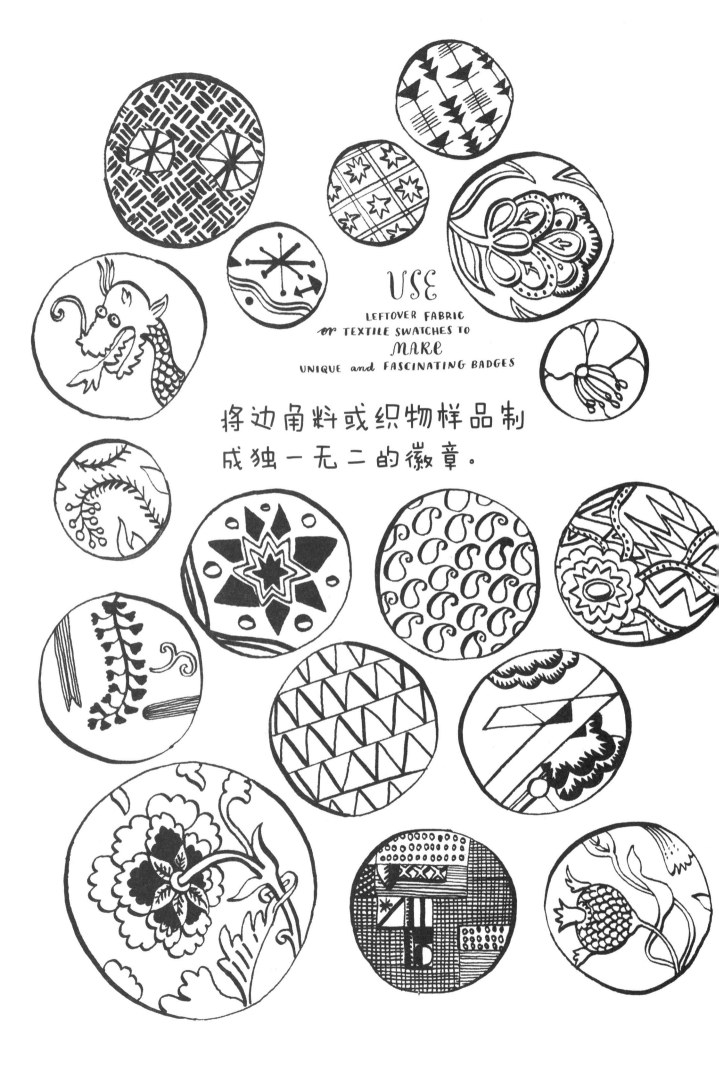

USE
LEFTOVER FABRIC
or TEXTILE SWATCHES TO
MAKE
UNIQUE and FASCINATING BADGES

将边角料或织物样品制
成独一无二的徽章。

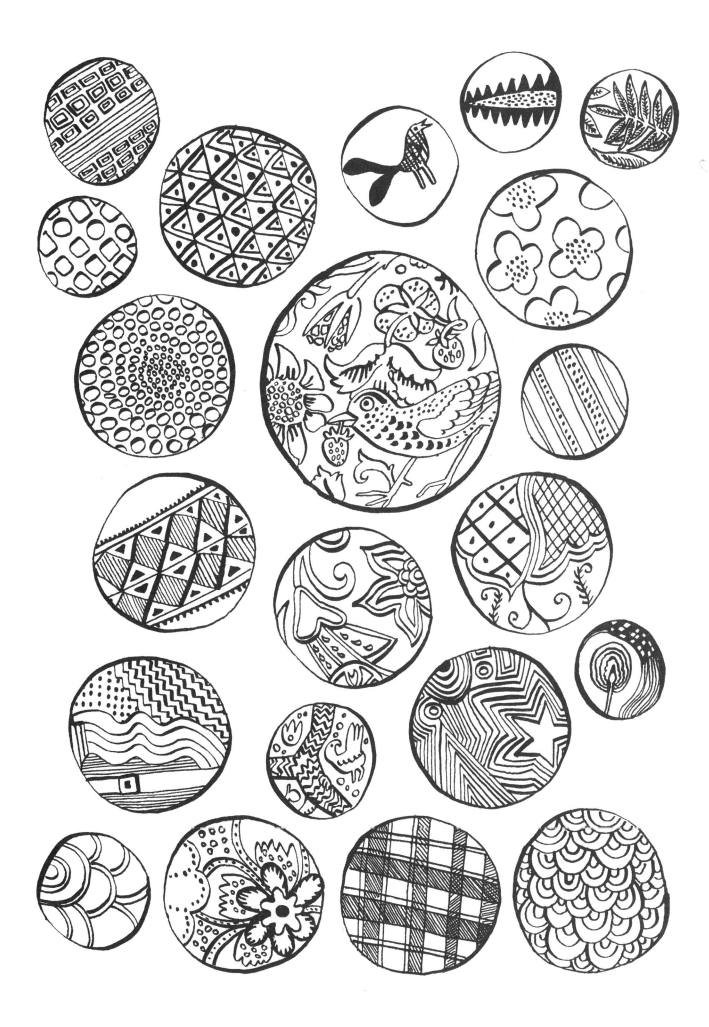

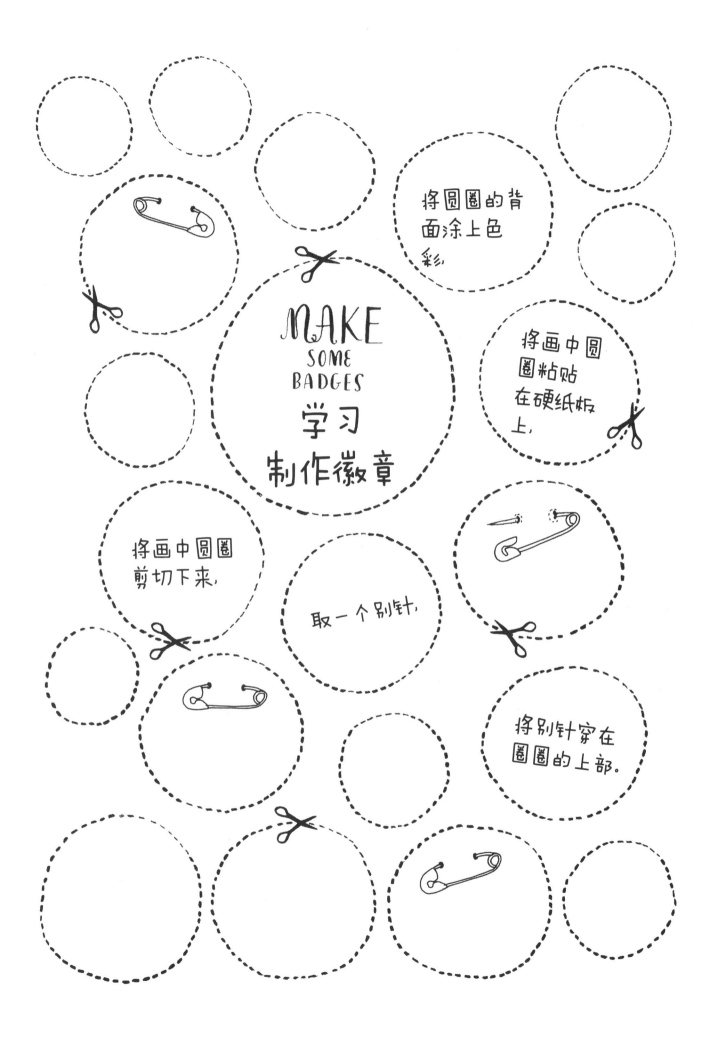

使用回形针制作项链

MAKE
A NECKLACE FROM PAPERCLIPS

你需要:

你需要的工具有
缎带和回形针.

回形针

① 首先将回形针
串在一起,
串成两串.

②

③ 最后将缎带穿过两串
回形针即可.

最后的成品是这样的。→

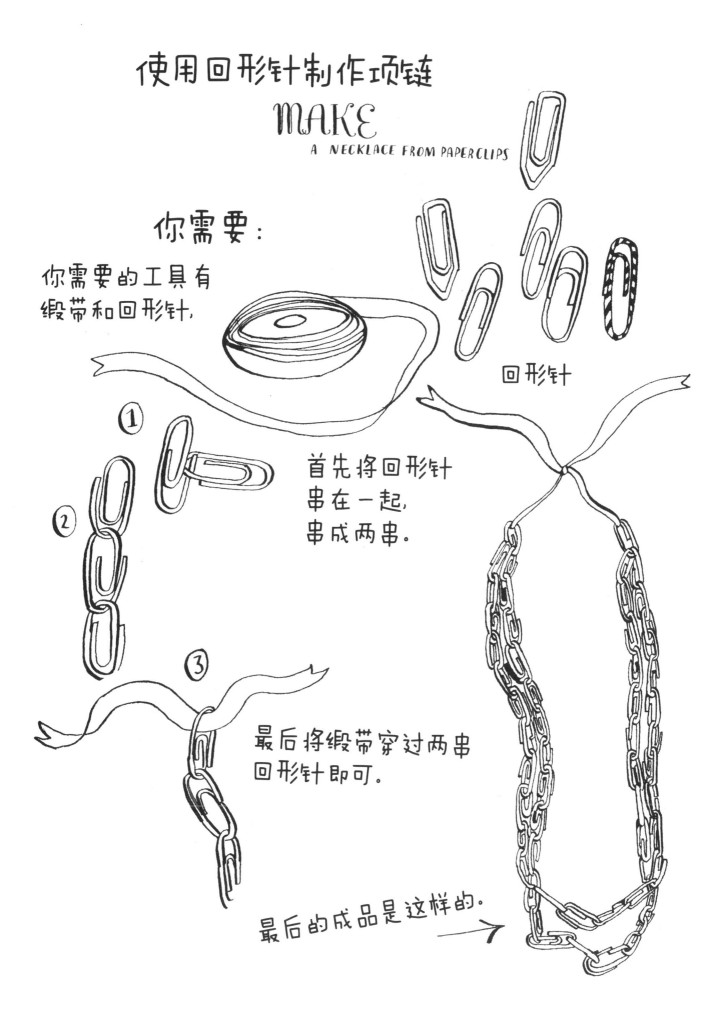

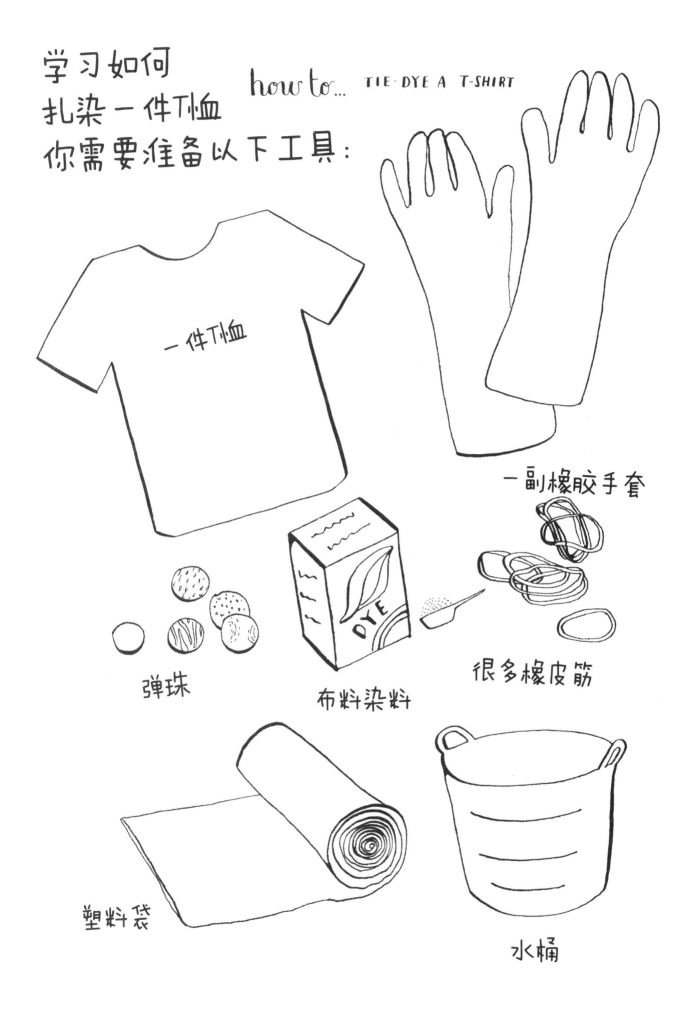

学习如何
扎染一件T恤
你需要准备以下工具：

how to... TIE-DYE A T-SHIRT

一件T恤

一副橡胶手套

弹珠

布料染料

很多橡皮筋

塑料袋

水桶

① 在桌上铺好塑料袋，并给自己戴上橡胶手套。

② 接下来将T恤揉紧并用橡皮筋扎起来。

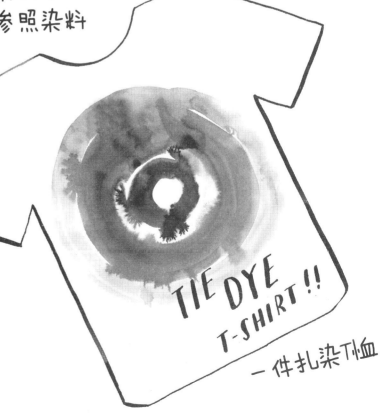

③ 倘若你有准备弹珠，可以用橡皮筋把弹珠扎在衣服里。

④ 提前将染料放在水桶中以溶解。

⑤ 之后将之前扎好的衣服浸泡在溶解的染料中，浸泡时间长短参照染料使用说明。

⑥ 时间到后就将衣服取出，使其自然风干。

⑦ 风干后，拆开所有橡皮筋，亲手制作的扎染衣服便自然呈现。

TIE DYE T-SHIRT!!

一件扎染T恤

尝试为这位女士的上
衣设计纹样 CREATE

A DESIGN
FOR THIS
GIRL'S
T-SHIRT

再试着给这条素净
的裤子设计让人眼
前一亮的图案。 DESIGN

AN EYE-BOGGLING
PATTERN FOR THESE
LEGGINGS

DRAW YOUR FAVOURITE OUTFIT

在空白处绘制出你自己最喜爱的一身服饰。

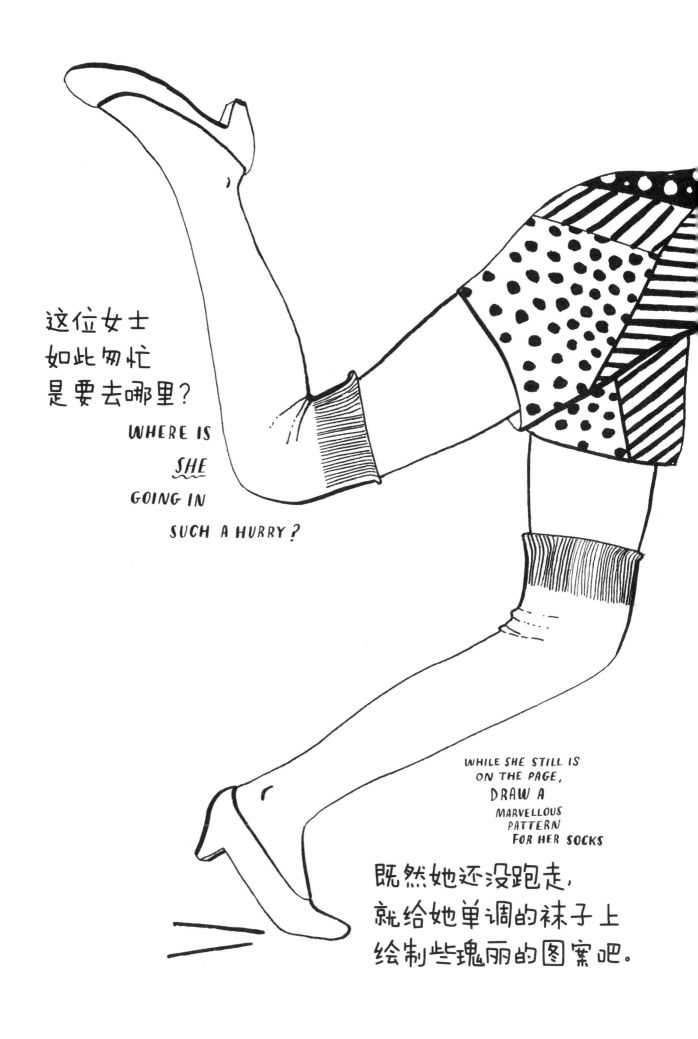

这位女士
如此匆忙
是要去哪里？

WHERE IS
SHE
GOING IN

SUCH A HURRY?

WHILE SHE STILL IS
ON THE PAGE,
DRAW A
MARVELLOUS
PATTERN
FOR HER SOCKS

既然她还没跑走，
就给她单调的袜子上
绘制些瑰丽的图案吧。

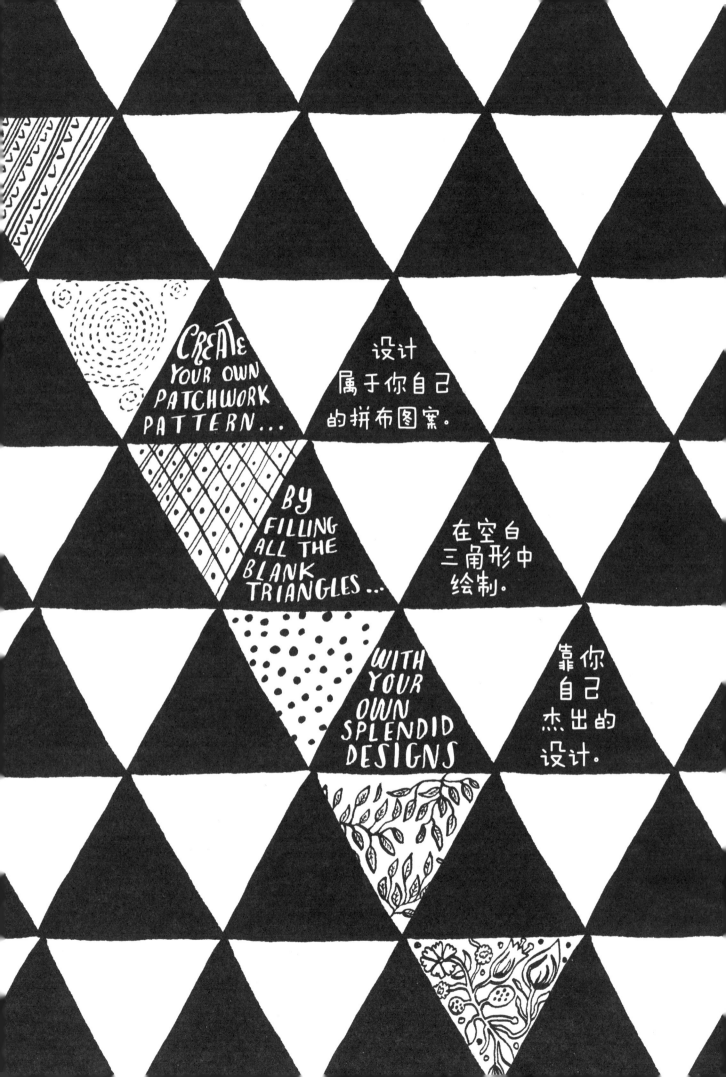

CREATE YOUR OWN PATCHWORK PATTERN...

设计属于你自己的拼布图案。

BY FILLING ALL THE BLANK TRIANGLES...

在空白三角形中绘制。

WITH YOUR OWN SPLENDID DESIGNS

靠你自己杰出的设计。

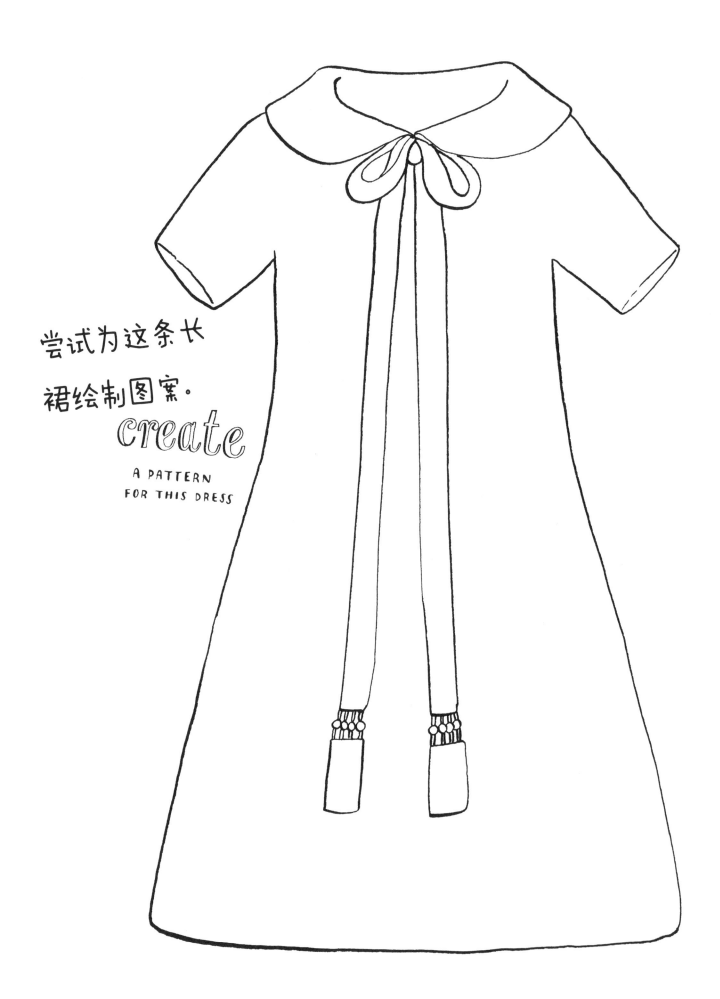

尝试为这条长
裙绘制图案。
create
A PATTERN
FOR THIS DRESS

并设计一个手提袋与之搭配。

DESIGN

A HANDBAG TO GO WITH THIS DRESS

draw... LOTS MORE POLKA DOTS

在此基础上画出更多的圆点。

在绘制带有节奏的圆点的同时，
何不一起来听波尔卡舞曲？

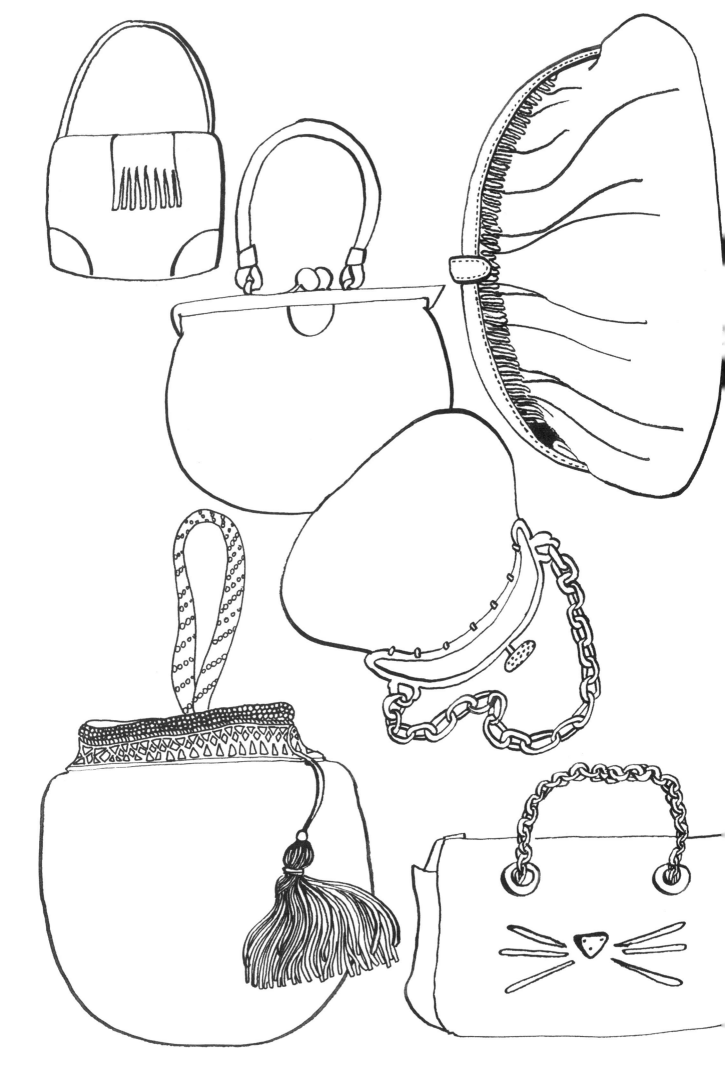

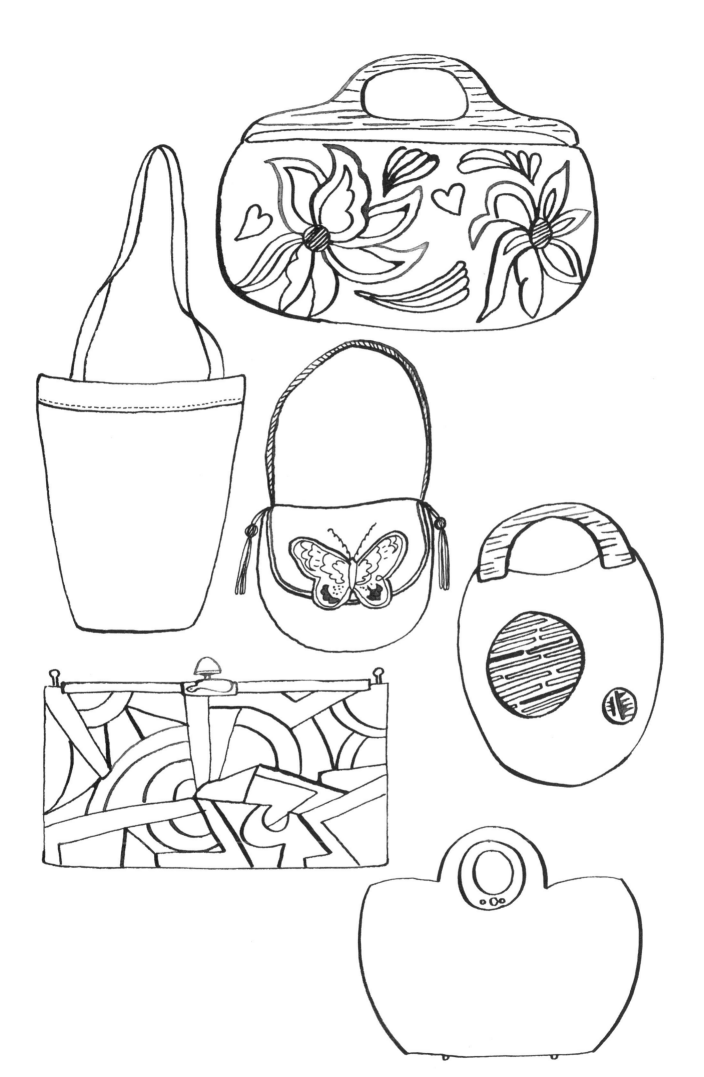

一些影响着艺术
的时尚。

THE FASHION
THAT INSPIRES ART

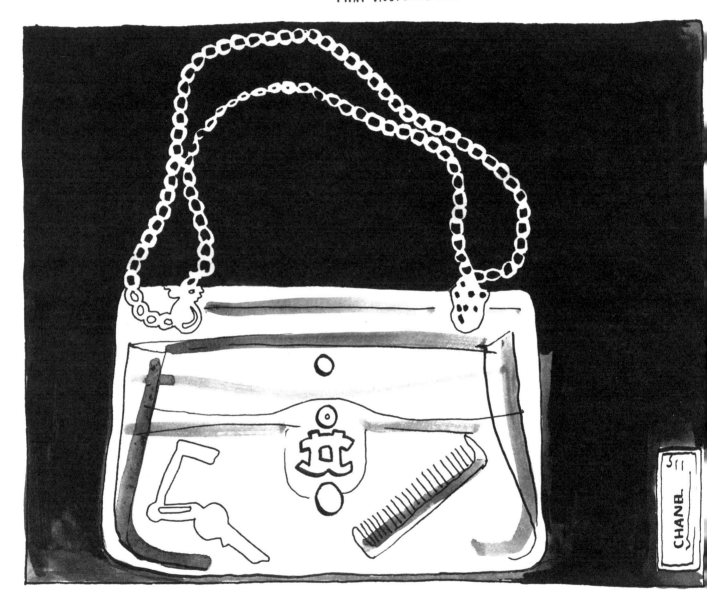

这件艺术作品名为"我妈妈手提包的X光照片"，
是美国著名蓝调摇滚艺术家史蒂夫·米勒的作品。

MY MOTHER'S PURSE
X-RAY PHOTOGRAPH
BY
STEVE MILLER

倘若有人
也使用X光来扫描
WHAT 你的包包，
WOULD SOMEONE
FIND IF THEY WERE
TO X-RAY YOUR BAG?　呢？尝试画出来吧。

绘制一张巨型笑脸在包上。

A BIG SMILING FACE ON THIS BAG

设计一个独特的商标，并附在此凉鞋上。

CREATE a label
for these delicate sandals

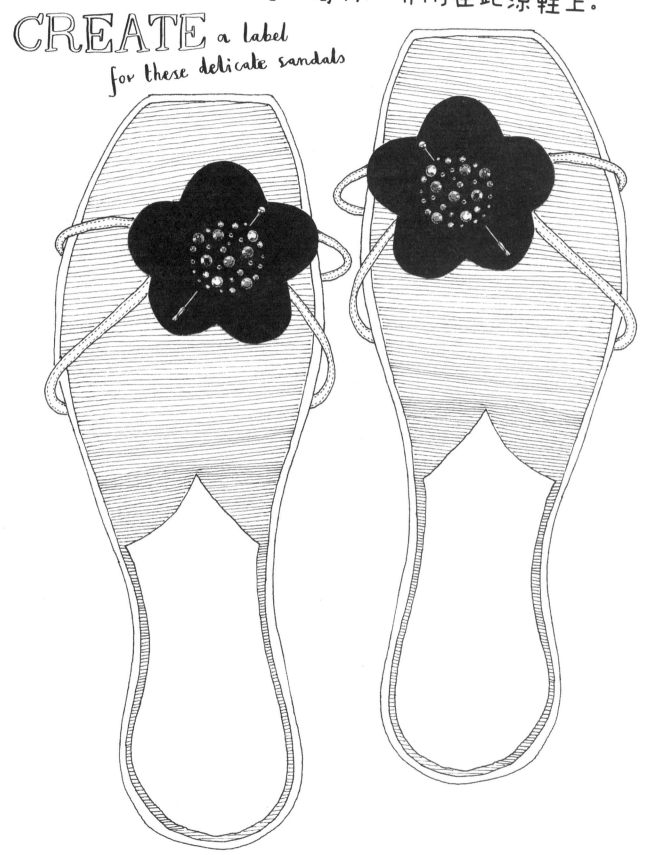

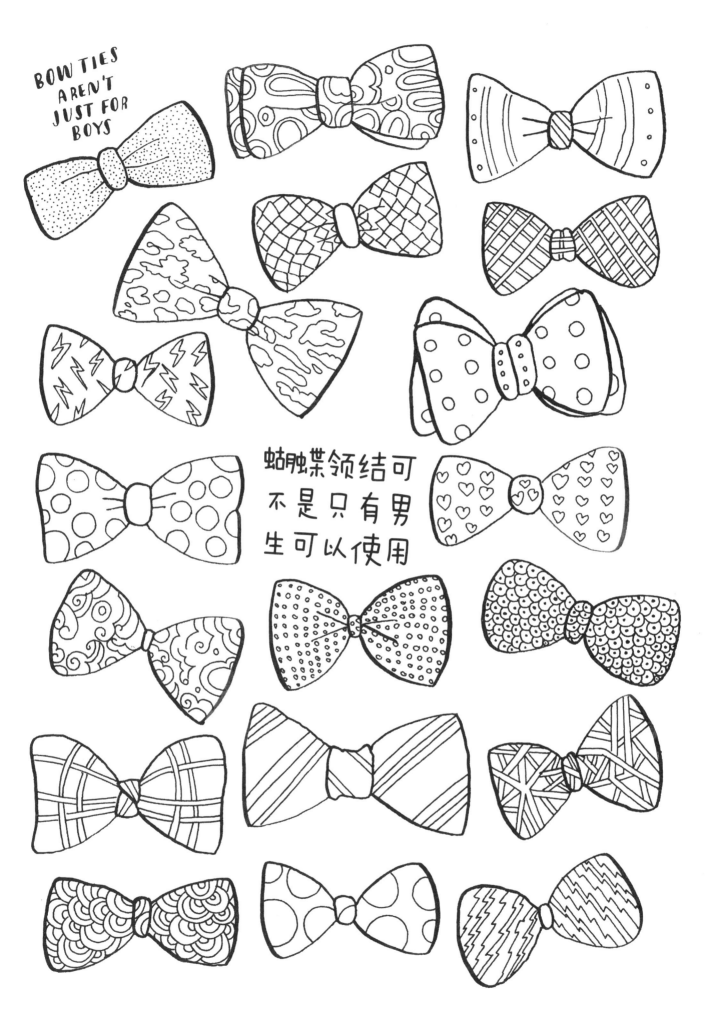

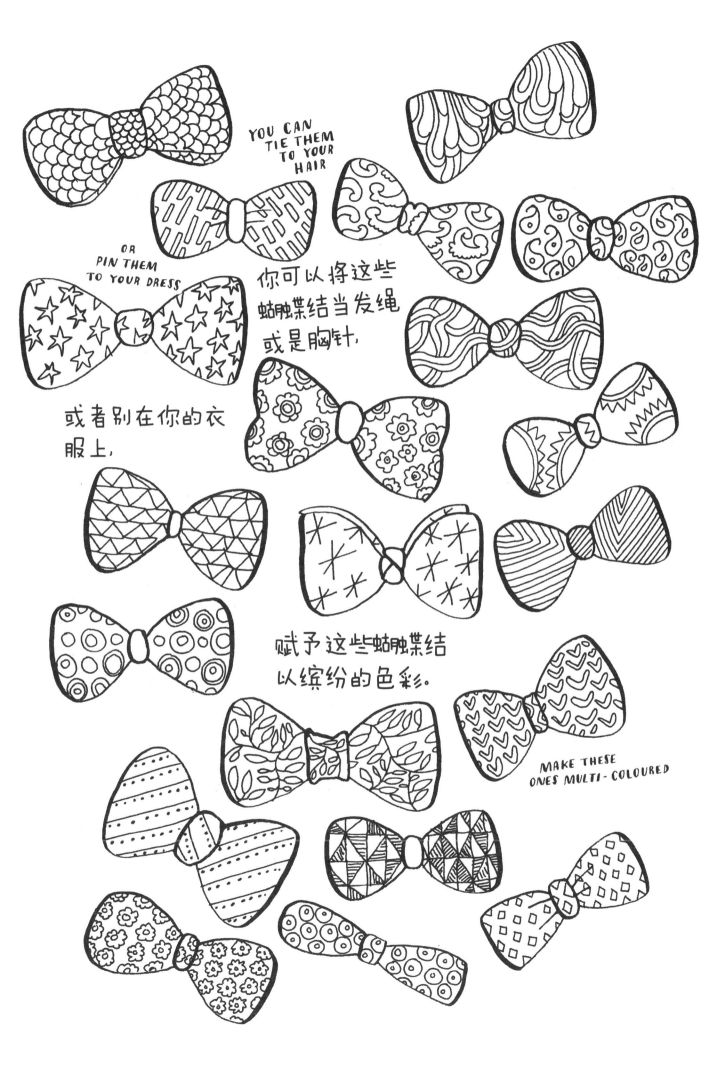

YOU CAN TIE THEM TO YOUR HAIR

OR PIN THEM TO YOUR DRESS

你可以将这些
蝴蝶结当发绳
或是胸针,

或者别在你的衣
服上,

赋予这些蝴蝶结
以缤纷的色彩。

MAKE THESE ONES MULTI-COLOURED

将下面每个蝴蝶结都绘制上不一样的图案。

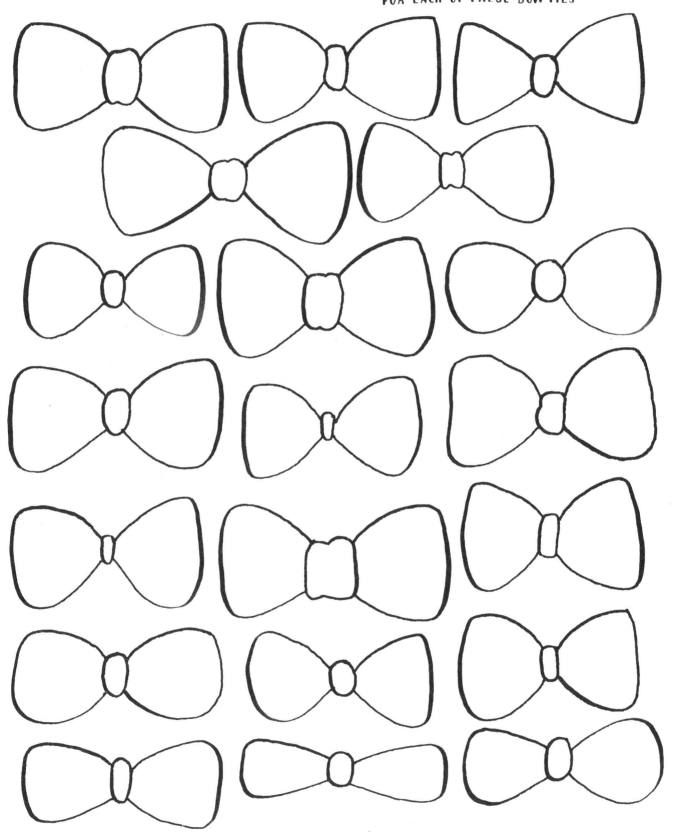

使得每个蝴蝶结都是独一无二的。

MAKE EACH ONE SPECIAL and UNIQUE

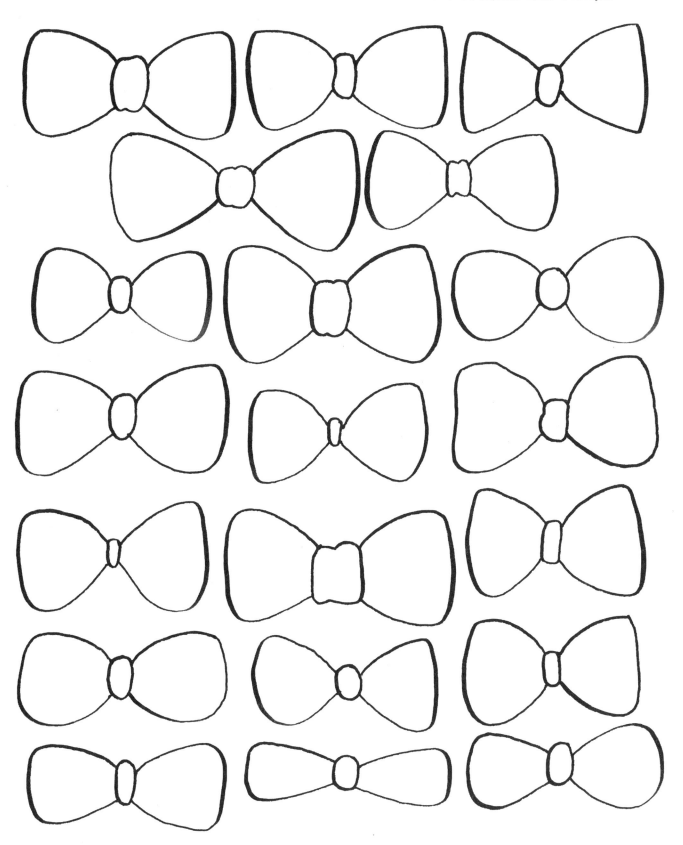

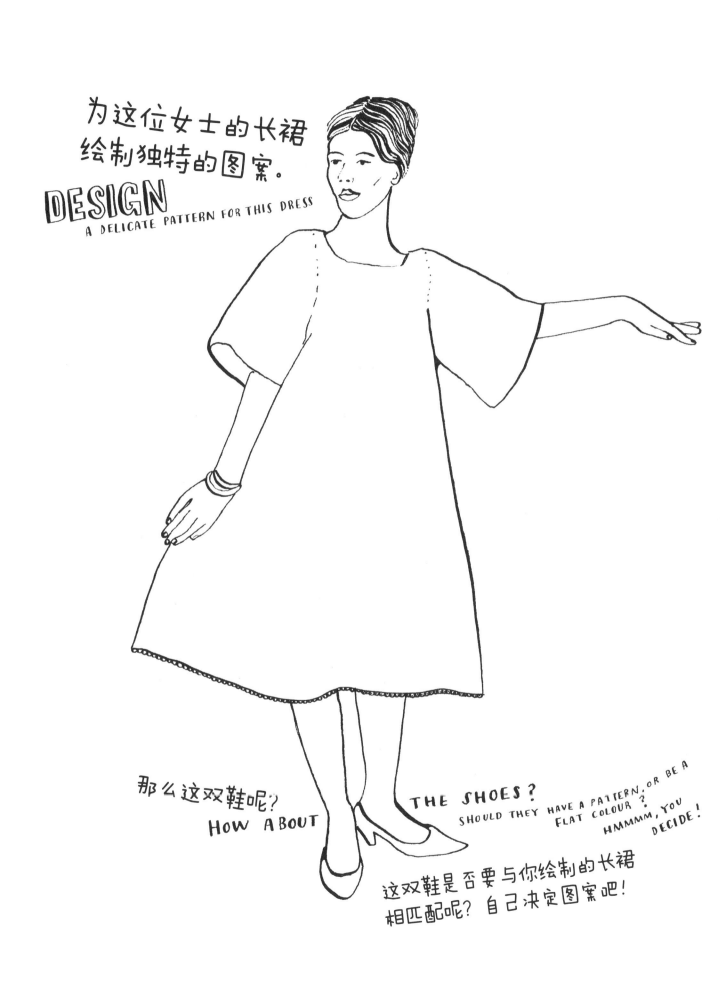

CREATE

A PATTERN FOR THESE TIGHTS.

给这条紧身裤
绘制上你喜爱的图案。

在这本书中，有一页是给此图准备的，一起找出来！……

SOMEWHERE IN THIS BOOK IS A PAGE THAT THIS SHAPE IS MADE FOR... find it!

找出来！

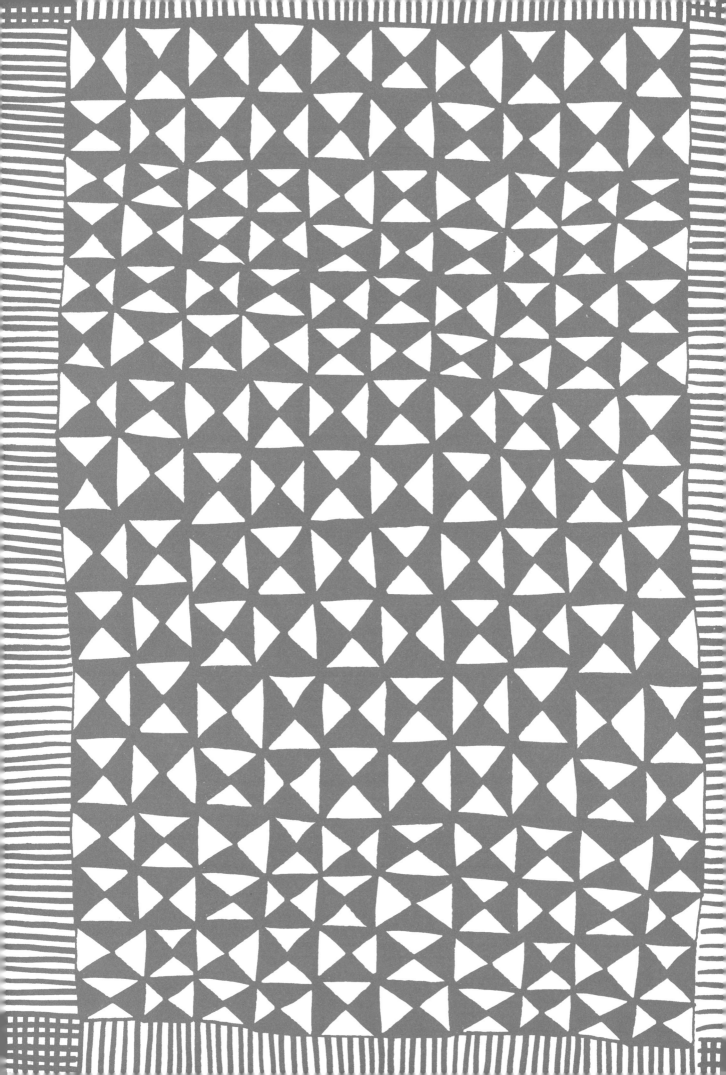

苏格兰语中
格子布意为
毛毯。

PLAID is
A SCOTS
WORD
MEANING
BLANKET

PLAID OR
TARTAN
IS MADE
FROM
WOVEN
WOOL

格子布是
使用羊毛
编织的。

THERE ARE HUNDREDS OF TYPES OF TARTAN

一块格子布上有着上百种不同的样式。

A KILT IS A TARTAN SKIRT WORN BY MEN IN SCOTLAND

苏格兰男子常穿的短裙便是用格子布制作的。

在此页中空白处绘
制完整的图案。

COLOUR IN
AND COMPLETE
THE PATTERN IN
ANY GAPS THAT
YOU SEE

好运披肩 the cape of good hope

the cape of good hope 本身原意为非洲好望角，但此处 cape 也有披肩的意思，此处有一语双关之妙。

SOMEWHERE IN THIS BOOK IS A PAGE WITH A SHAPE THAT NEEDS CUTTING OUT and STICKING ON... HERE!

在这本书中有一页有一图形与之匹配，找到它剪切下来贴在此处。

给这双靴子绘制别具一格的图案。

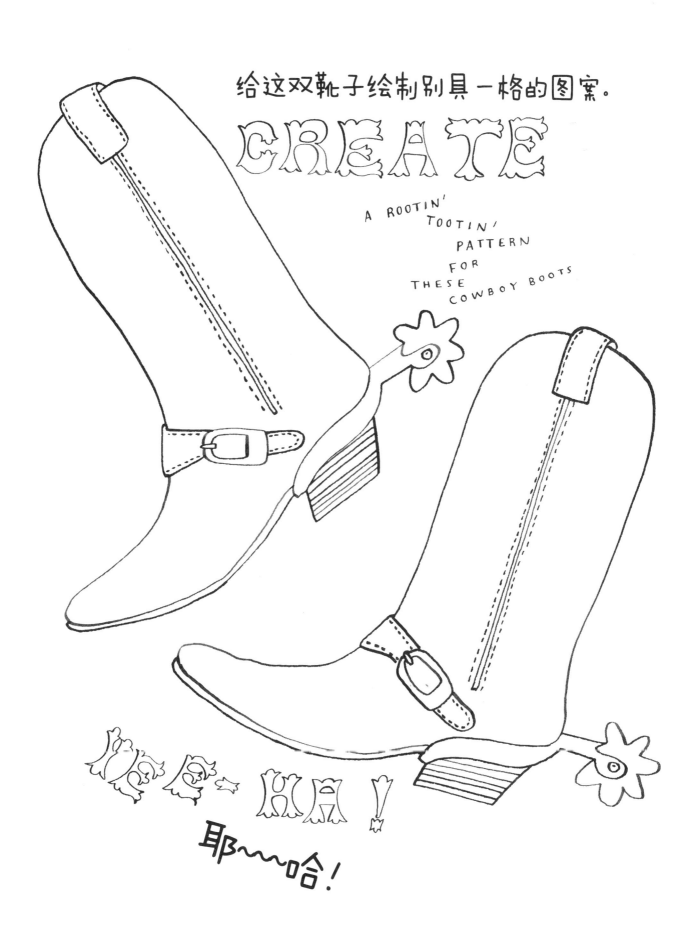

来自公元前2000年的 **夹脚拖鞋。**

FLIP-FLOPS
2000 B.C.

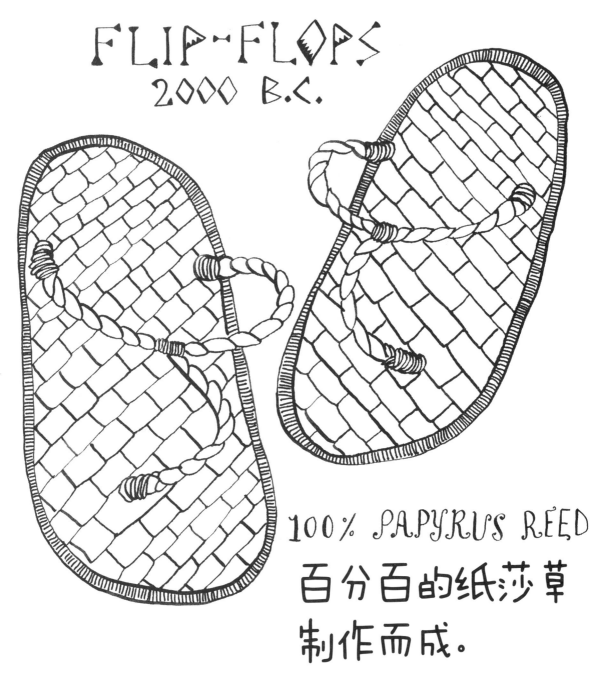

100% PAPYRUS REED
百分百的纸莎草
制作而成。

来自公元前2000年的 **夹脚拖鞋。**

FLIP, FLOPS
2000 A.D.

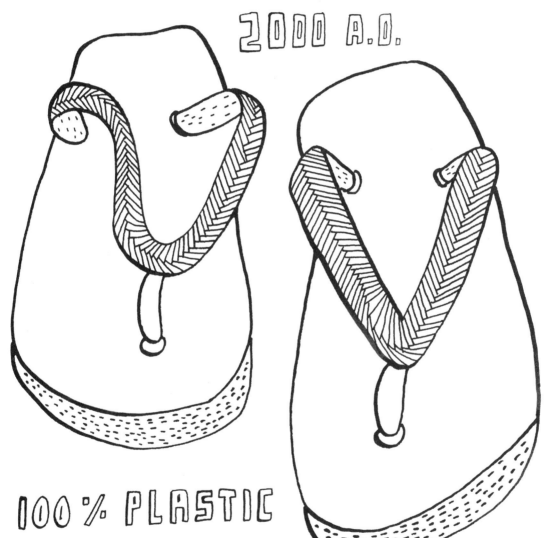

100 % PLASTIC

已经完全是塑料制成的了。

DRAW

在此画出一个过去的时尚单品。

A FASHION ITEM
FROM THE PAST

你选择如何改善这件单品呢？

HOW...

WOULD YOU MODERNISE IT?

为下面这件和服绘制瑰丽的图案。

Create

A FANTASTIC PATTERN FOR THIS KIMONO

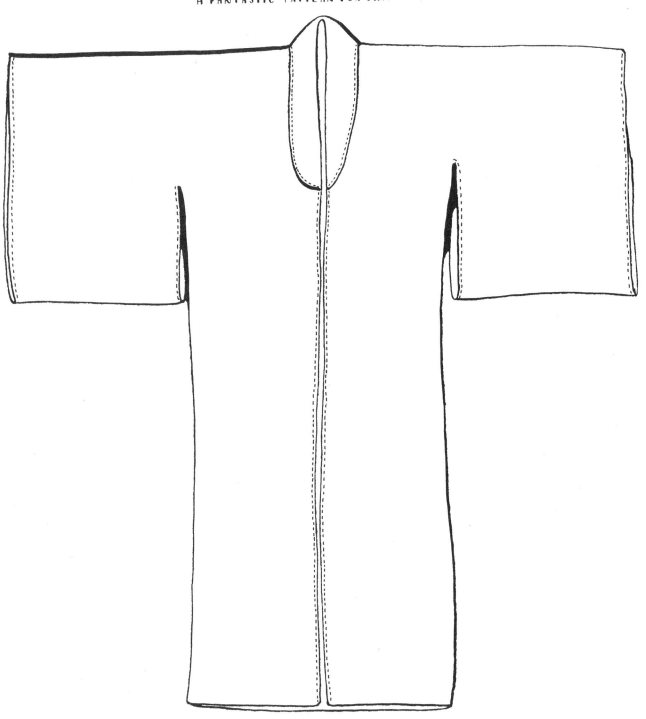

绘制之前不妨先来欣赏些
日本布料的样品，
或许可以带来灵感。

HERE ARE SOME SWATCHES
OF JAPANESE FABRIC
TO GET YOU INSPIRED

这是一款日式的**松糕鞋。**

JAPANESE

PLATFORM

SHOES

THE BEAUTIFUL and
HARD TO
WALK IN GETA SHOES

这种日式松糕鞋也称木屐，
装饰华丽，很是漂亮，但穿上行走比较困难。

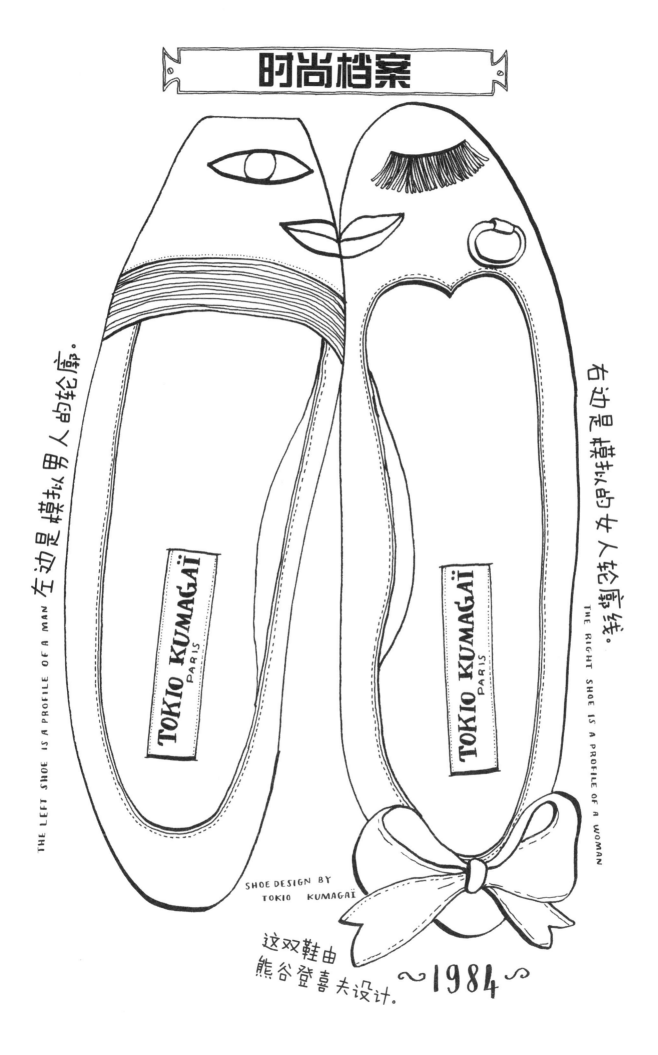

时尚档案

左边是模拟男人的轮廓。
THE LEFT SHOE IS A PROFILE OF A MAN

右边是模拟的女人轮廓线。
THE RIGHT SHOE IS A PROFILE OF A WOMAN

TOKIO KUMAGAÏ PARIS

TOKIO KUMAGAÏ PARIS

SHOE DESIGN BY TOKIO KUMAGAÏ

这双鞋由熊谷登喜夫设计。 ～1984～

这是一间只卖过去时尚用品的店铺
试着为这间店铺设计一款手提袋。

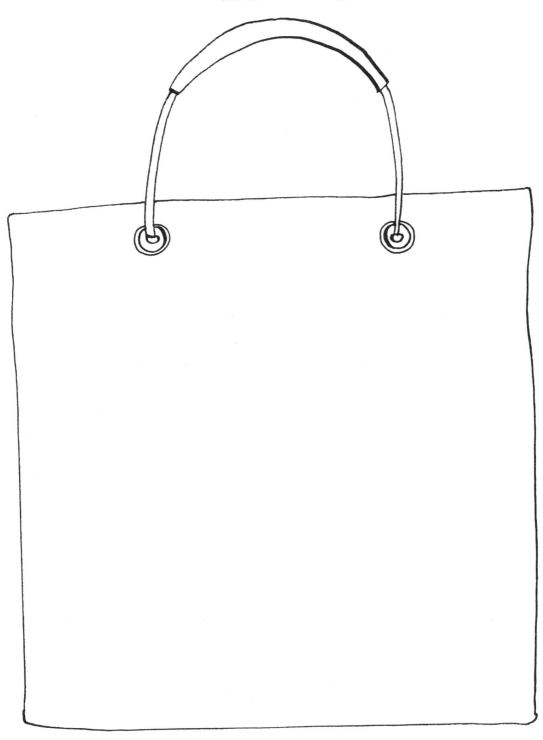

与之相反，这是一间只卖未
来时尚用品的店铺，也尝试
为这间店铺设计一款手袋。

DESIGN A BAG FOR A SHOP
THAT ONLY
SELLS FASHIONS FROM THE FUTURE

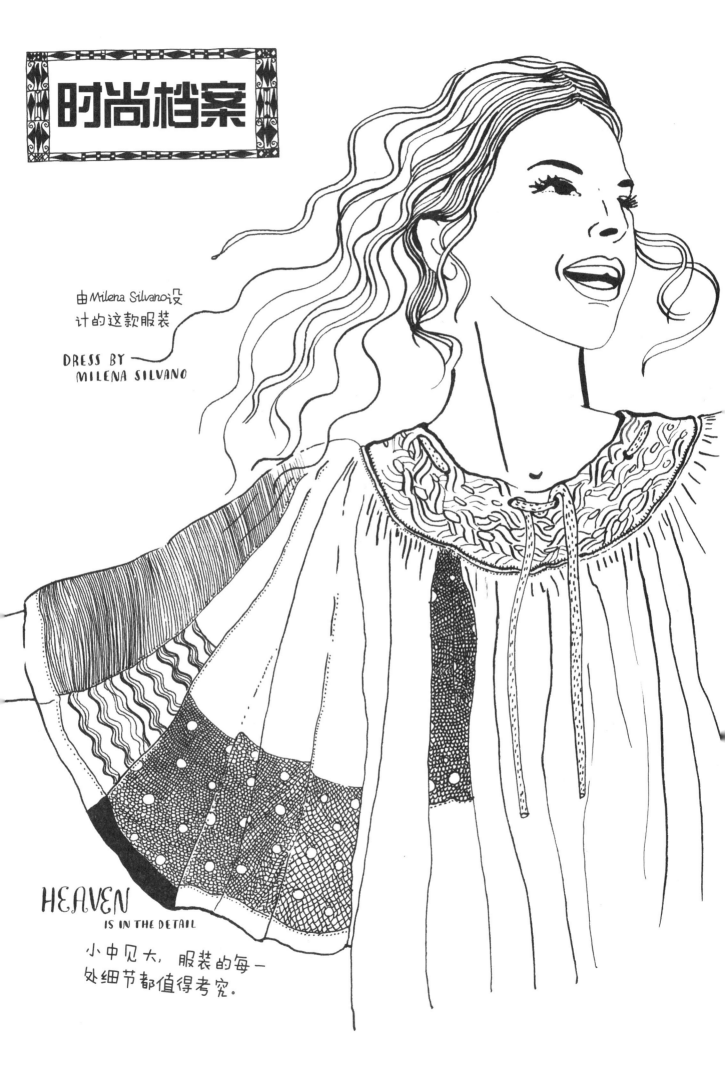

时尚档案

由Milena Silvano设
计的这款服装

DRESS BY
MILENA SILVANO

HEAVEN
IS IN THE DETAIL

小中见大，服装的每一
处细节都值得考究。

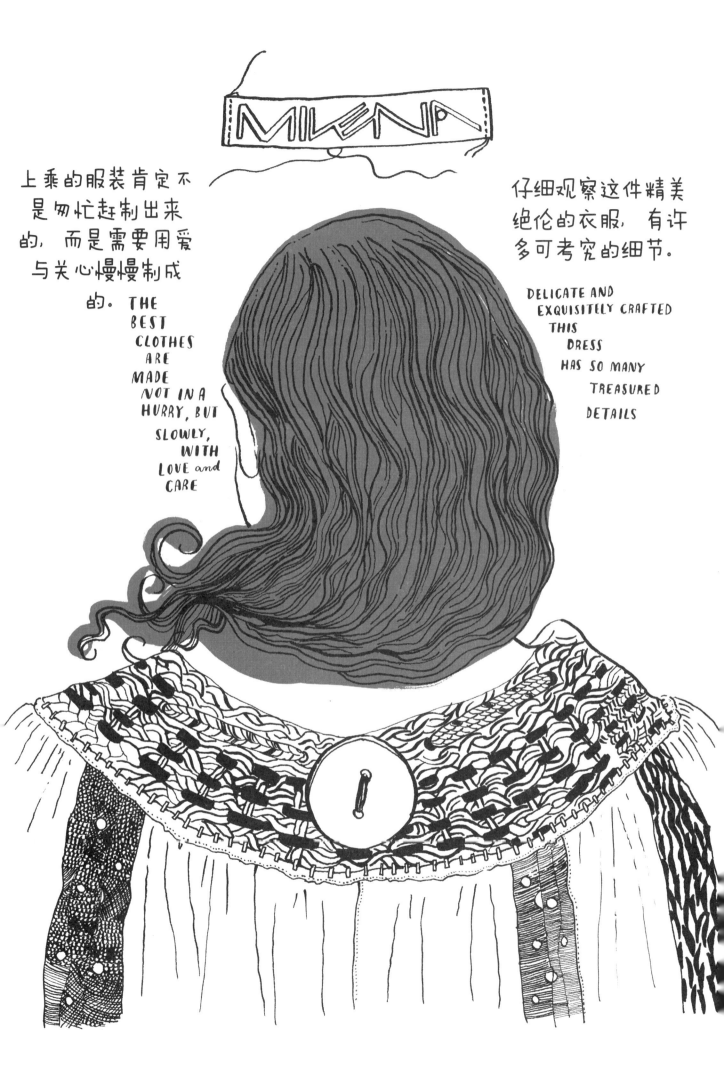

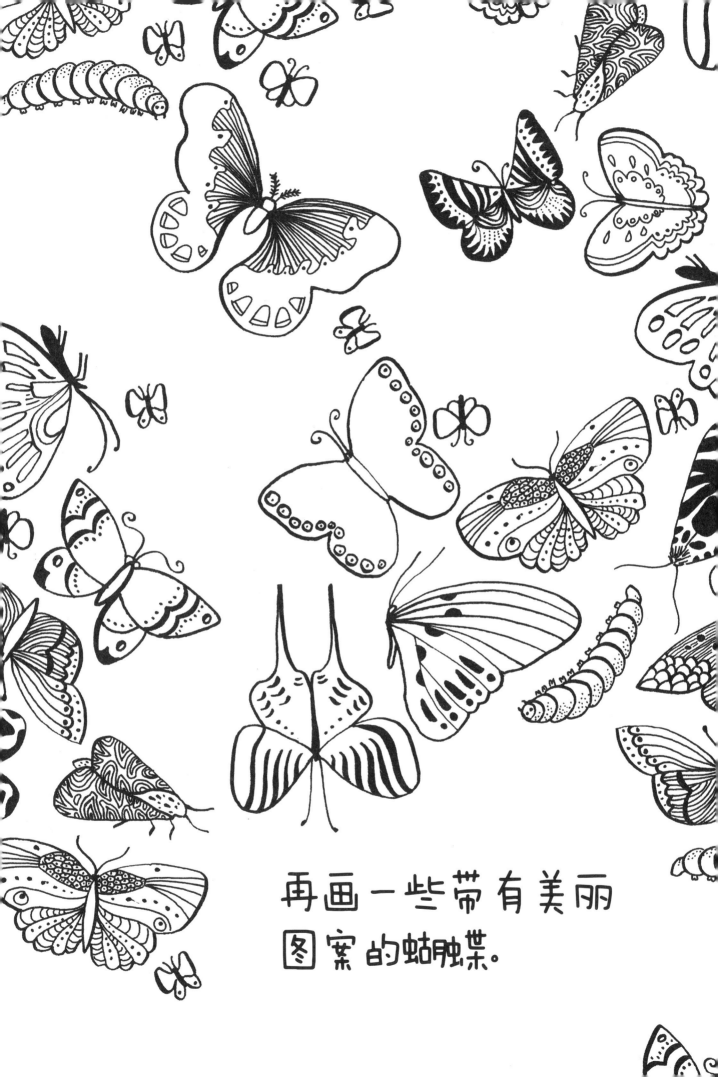

再画一些带有美丽
图案的蝴蝶。

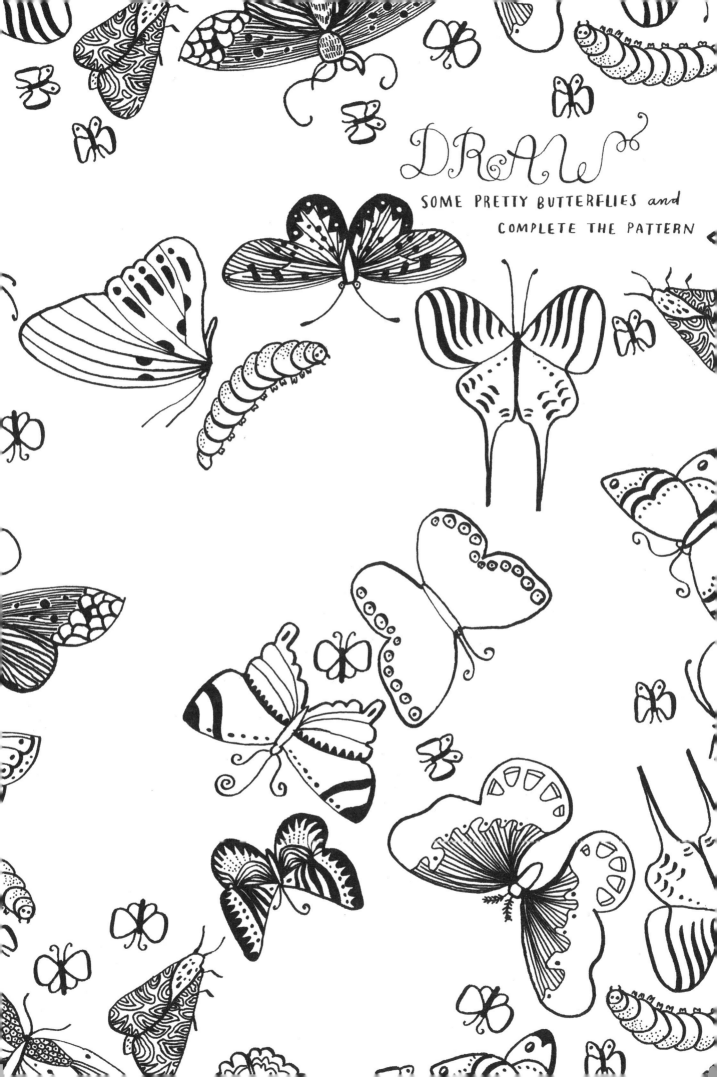

DRAW

SOME PRETTY BUTTERFLIES and
COMPLETE THE PATTERN

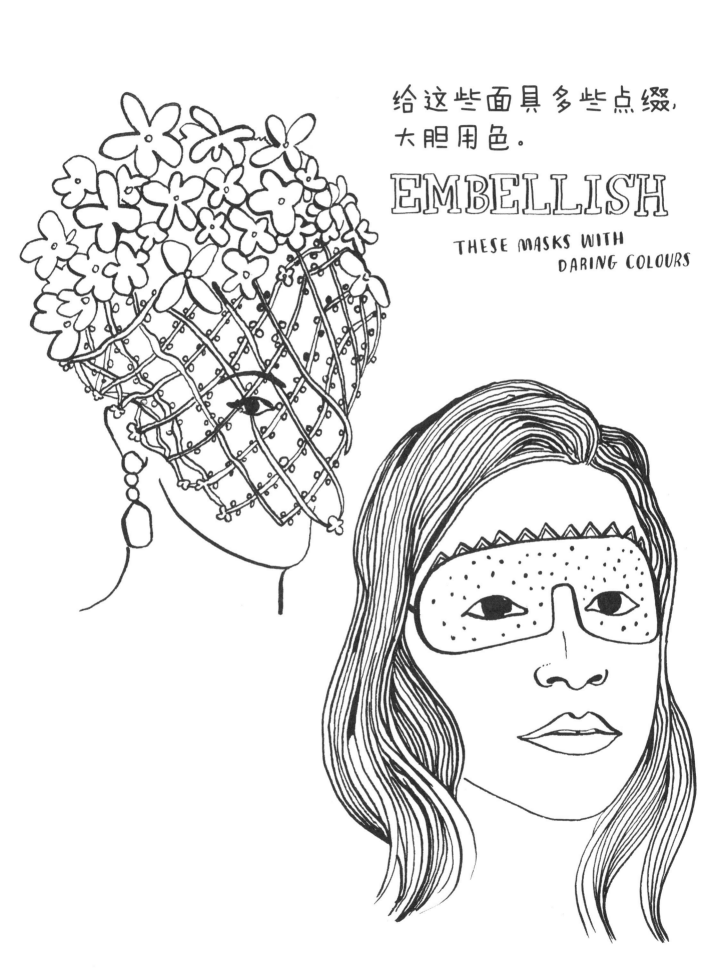

给这些面具多些点缀，
大胆用色。

EMBELLISH

THESE MASKS WITH
DARING COLOURS

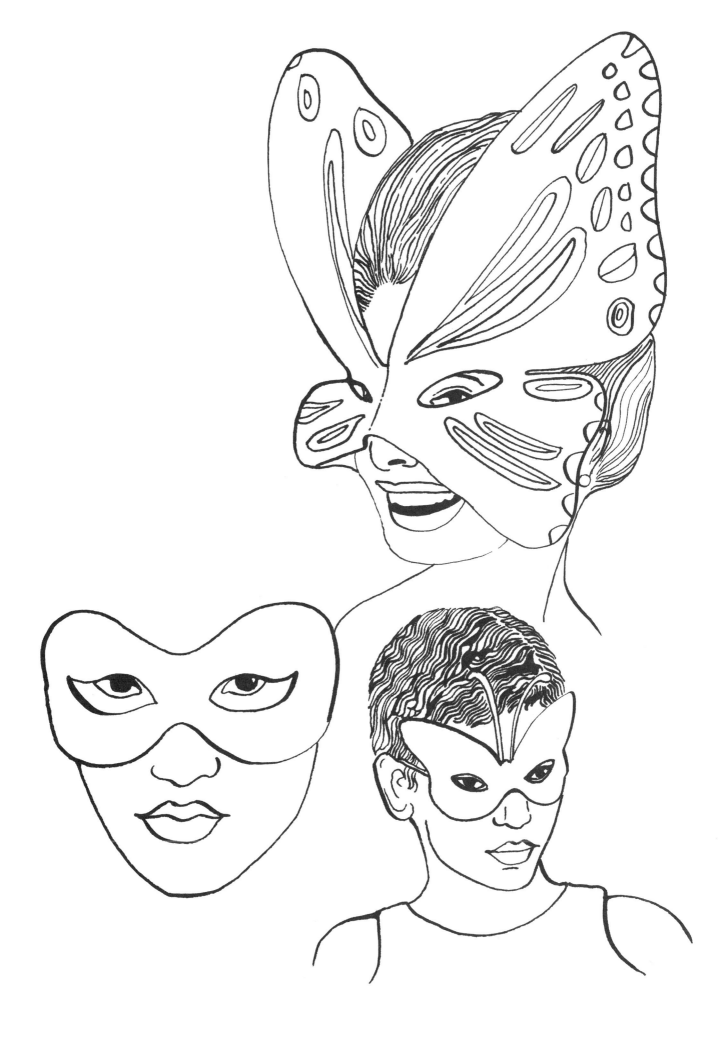

在装饰面具时，
可以选择亮片、
金粉、 EMBELLISH
羽毛等一切 THESE MASKS WITH
MORE FEATHERS,
MORE SEQUINS,
MORE GLITTER...
MORE EVERYTHING!
你能想到的材料。

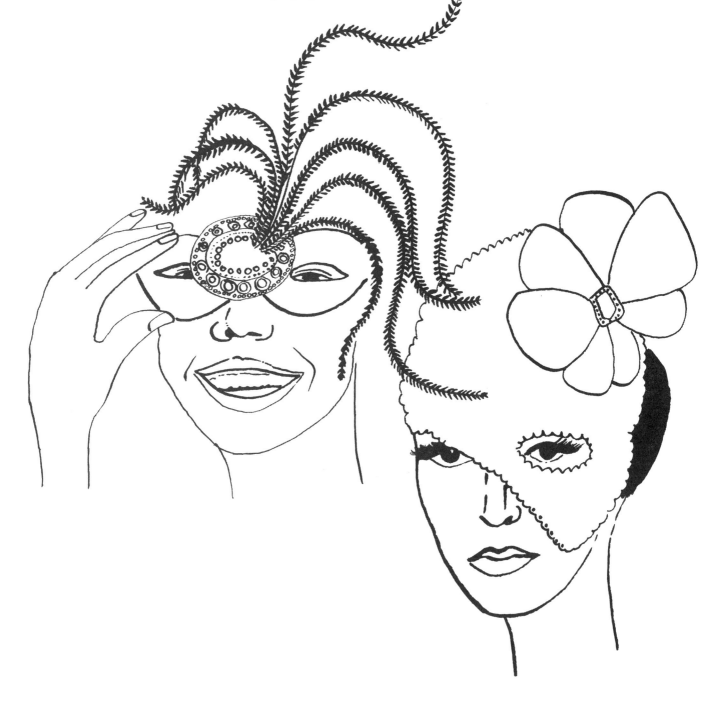

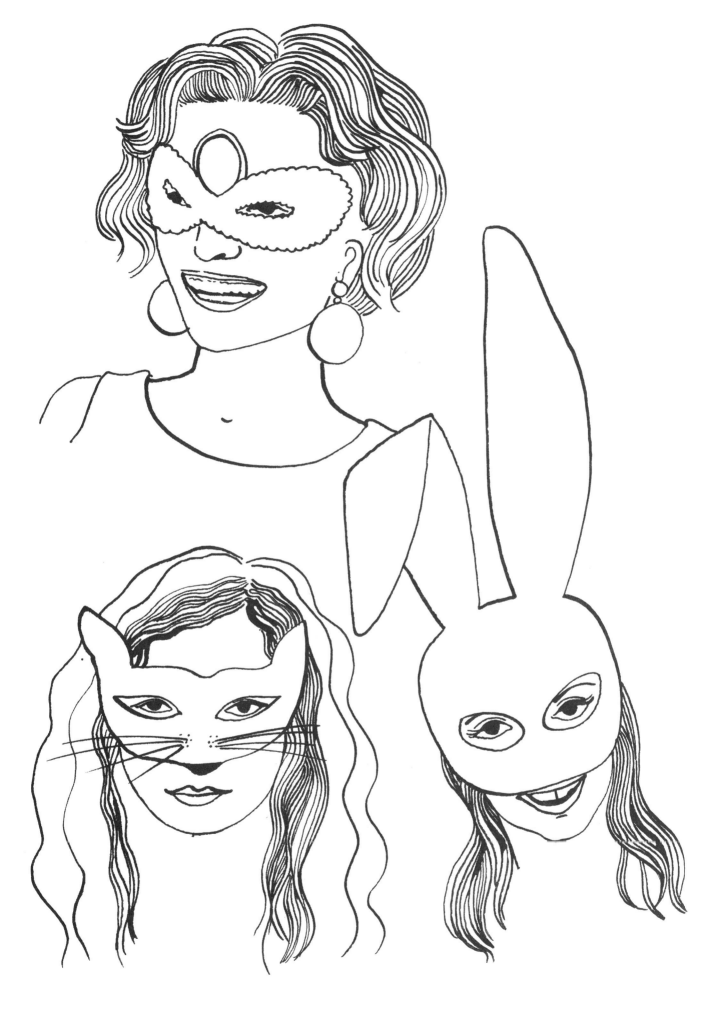

使用亮片、小卵石
或是珠子等材料来
装饰这件马甲。

EMBELLISH

THIS WAISTCOAT WITH

PRETTY PEBBLES, SEQUINS and BEADS

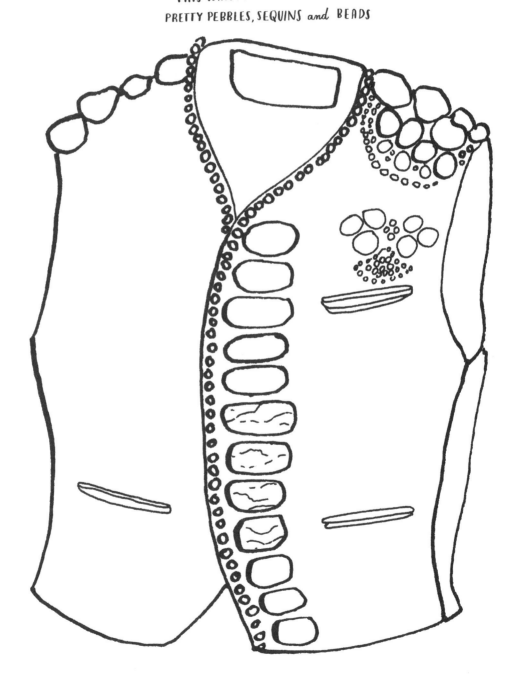

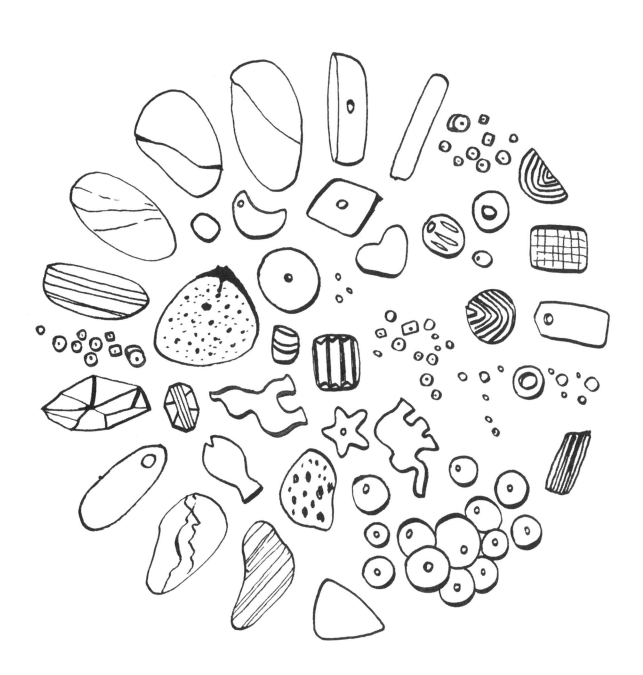

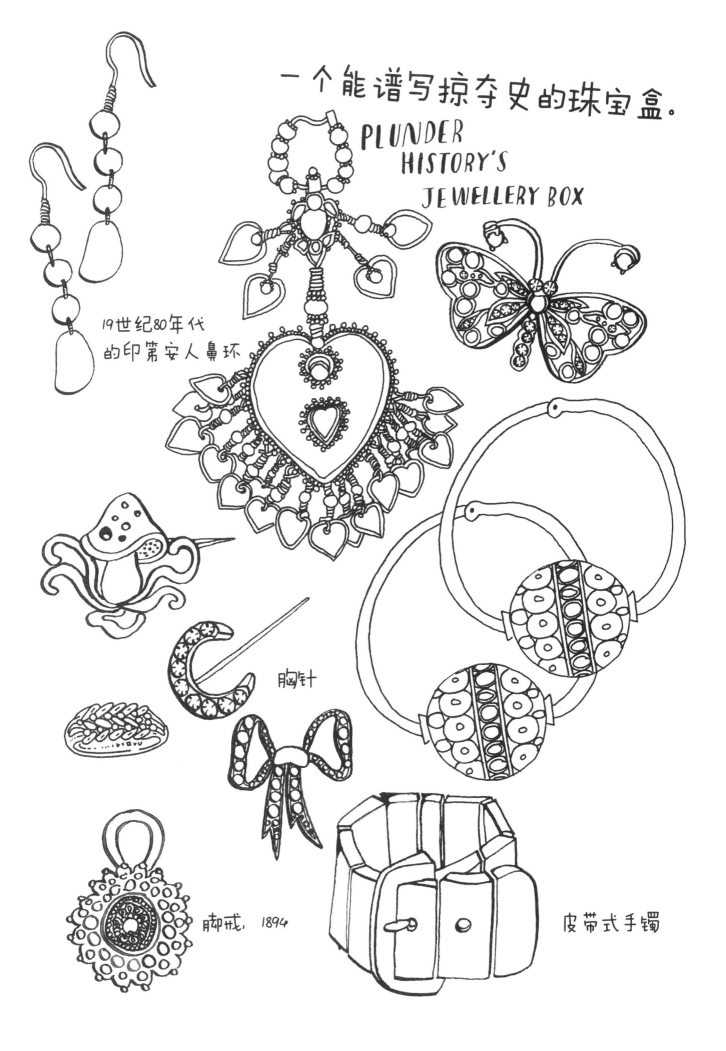

一个能谱写掠夺史的珠宝盒。

PLUNDER
HISTORY'S
JEWELLERY BOX

19世纪80年代
的印第安人鼻环

胸针

脚戒，1894

皮带式手镯

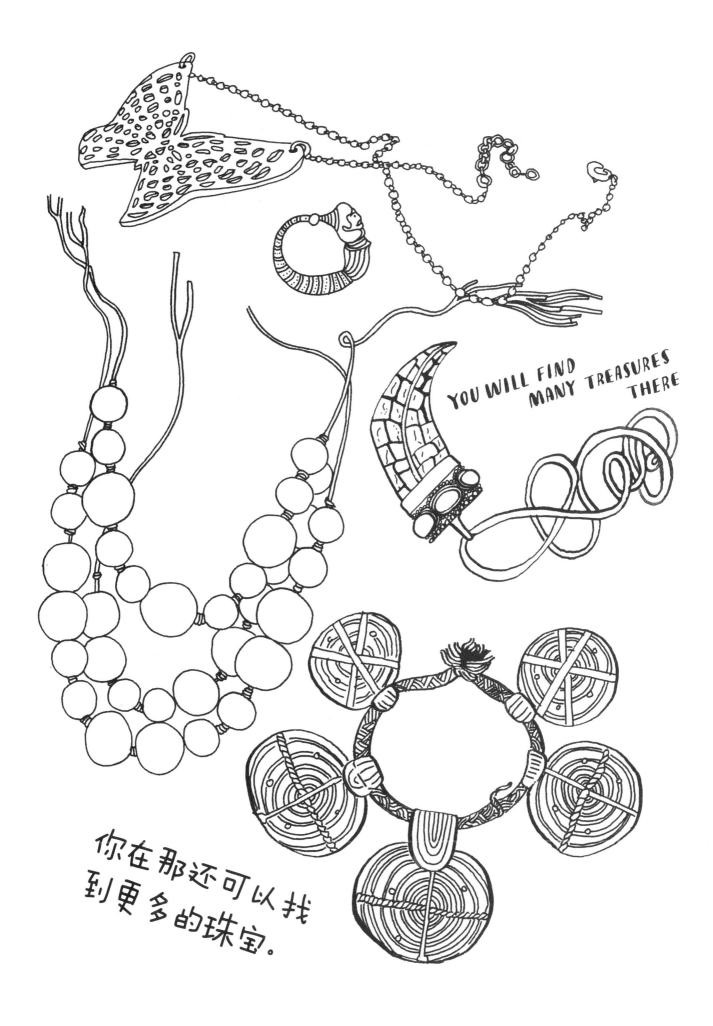

YOU WILL FIND MANY TREASURES THERE

你在那还可以找到更多的珠宝。

Azumi和David设计的一款聪明耳环。

CLEVER EARRINGS BY DESIGNERS
AZUMI and DAVID
(A'N'D)

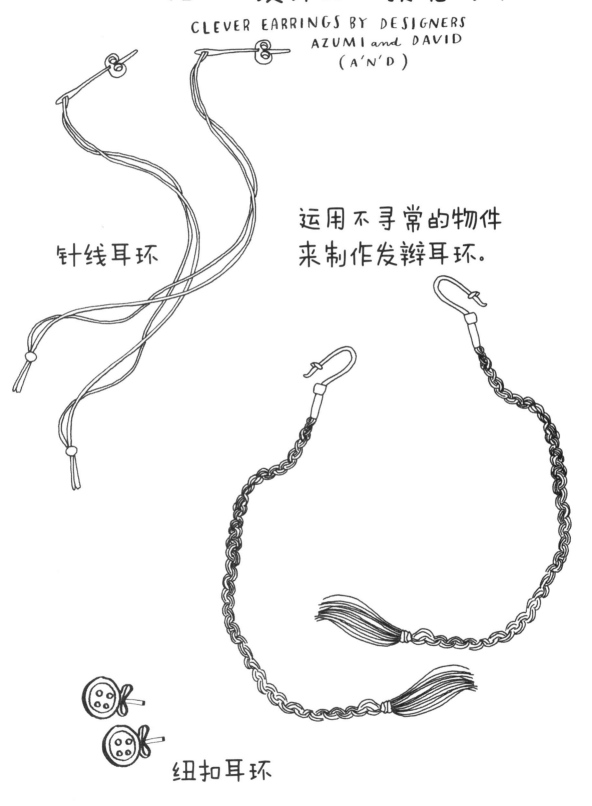

针线耳环

运用不寻常的物件
来制作发辫耳环。

纽扣耳环

除此之外
你还能想到什么
不寻常的
材料用来制作耳环吗？

CAN YOU...

THINK OF SOME UNUSUAL
OBJECTS THAT CAN BE MADE
INTO
EARRINGS ?

NOW YOU'VE
THOUGHT OF THEM...

将你想到的画出来吧！　　draw THEM!

如何使用
别针
来制作一条
别具一格的手链。

HOW TO

MAKE A SAFETY PIN CHARM BRACELET

你需要：

有个性的小饰品、小玩意儿，还有可以悬摆的小东西。

别针　设法找那种金色的。

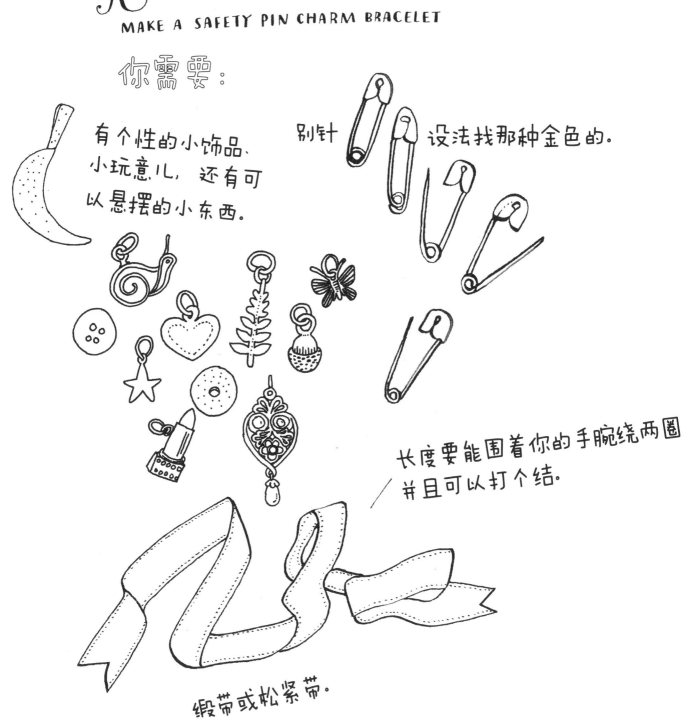

长度要能围着你的手腕绕两圈并且可以打个结。

缎带或松紧带。

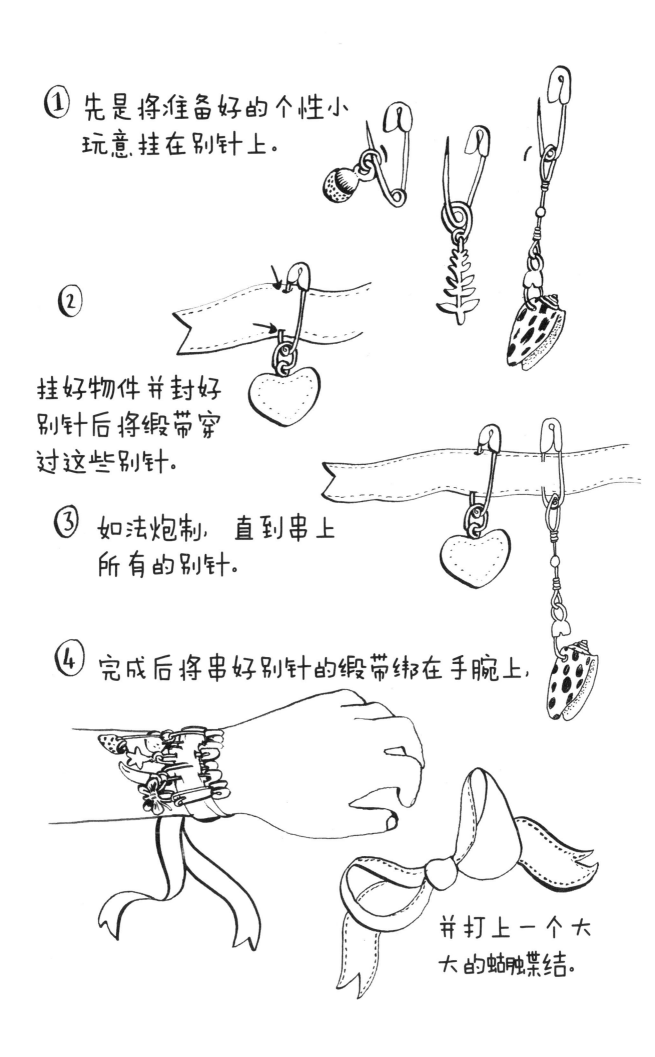

① 先是将准备好的个性小
 玩意挂在别针上。

② 挂好物件并封好
 别针后将缎带穿
 过这些别针。

③ 如法炮制，直到串上
 所有的别针。

④ 完成后将串好别针的缎带绑在手腕上，

并打上一个大
大的蝴蝶结。

试着给这副手套绘制图案。

DESIGN A BEAUTIFUL PATTERN FOR THESE EXTRA-LONG GLOVES

也为这条紧身裤
绘上图案吧。

draw...A BEAUTEOUS PATTERN FOR THESE TIGHTS

第一次尝试给保温绑腿腿绘制图案吧!

Create

A PATTERN FOR THESE
LEGWARMERS

画出你最
喜爱的一
双袜子。DRAW
YOUR FAVOURITE
PAIR OF SOCKS

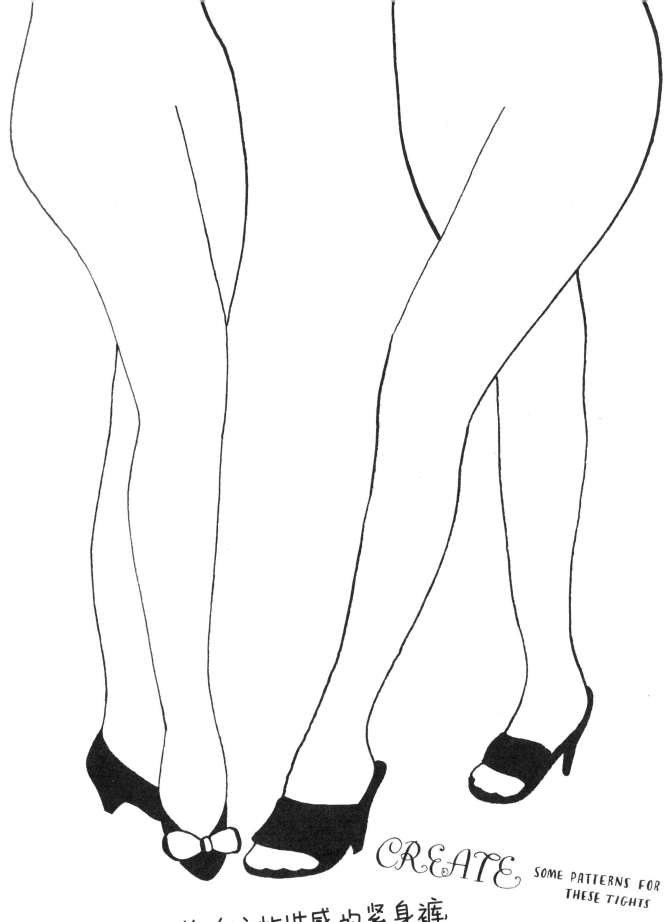

CREATE SOME PATTERNS FOR THESE TIGHTS

试着给这些性感的紧身裤

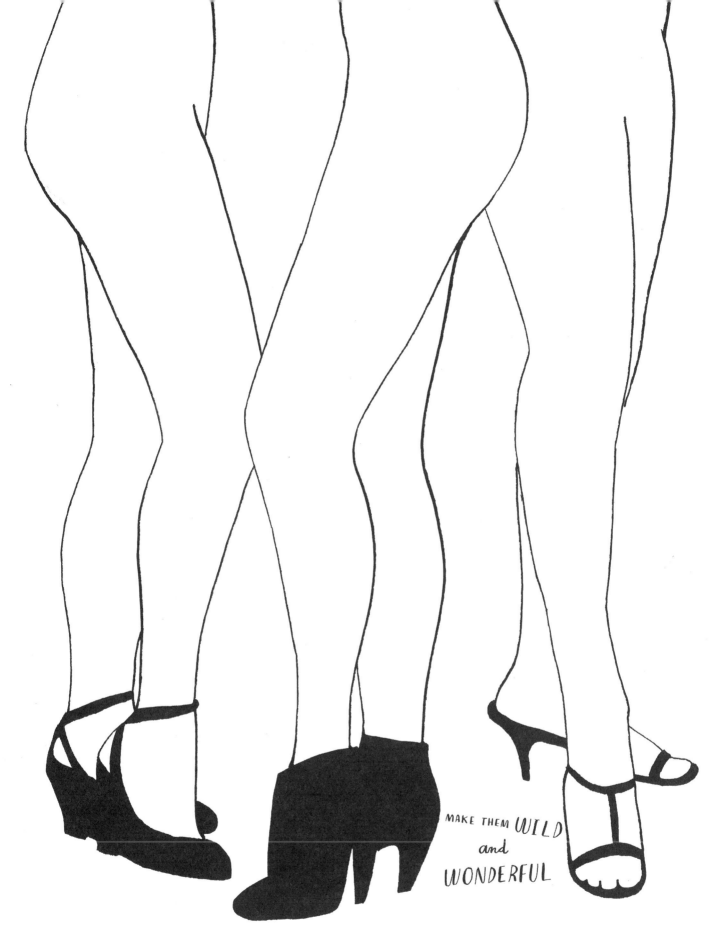

MAKE THEM WILD and WONDERFUL

绘制令人惊叹的图案吧!

DESIGN

A GARMENT YOU CAN WEAR
IN SUMMER *and* IN WINTER

设计
一件在夏天和冬天
都能穿的时装。

DESIGN
YOUR OWN
ITSY BITSY
TEENY WEENY
RATHER BEAUTIFUL
BIKINI

设计一套适合你自己的，
看着可爱且小巧美丽的比基尼。

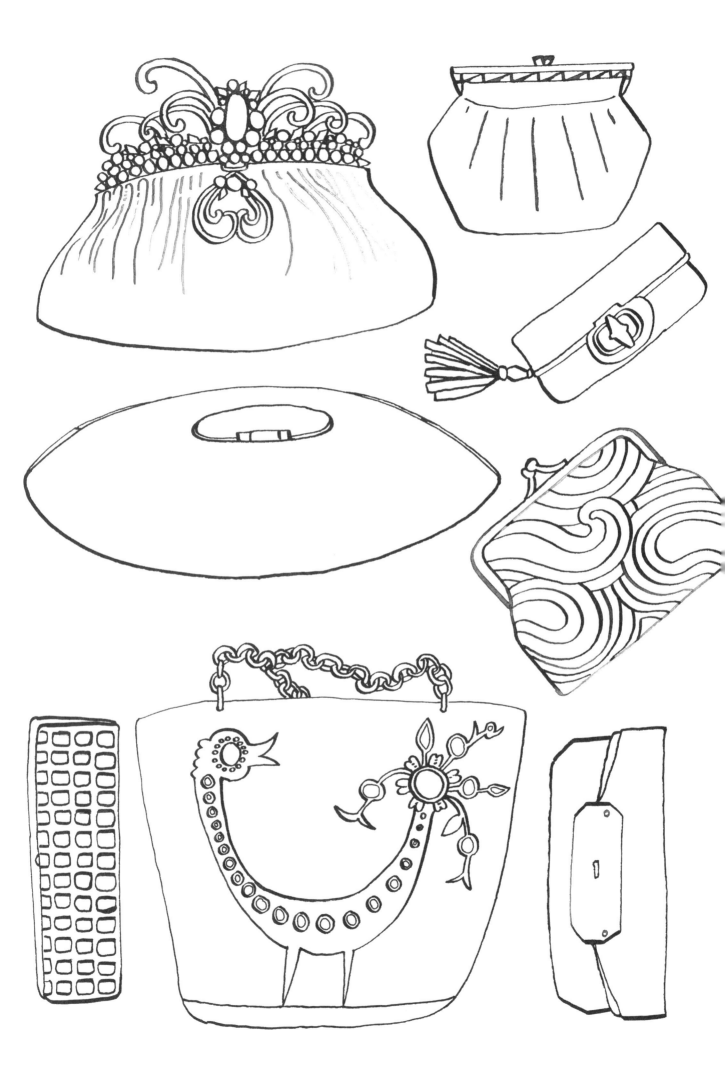

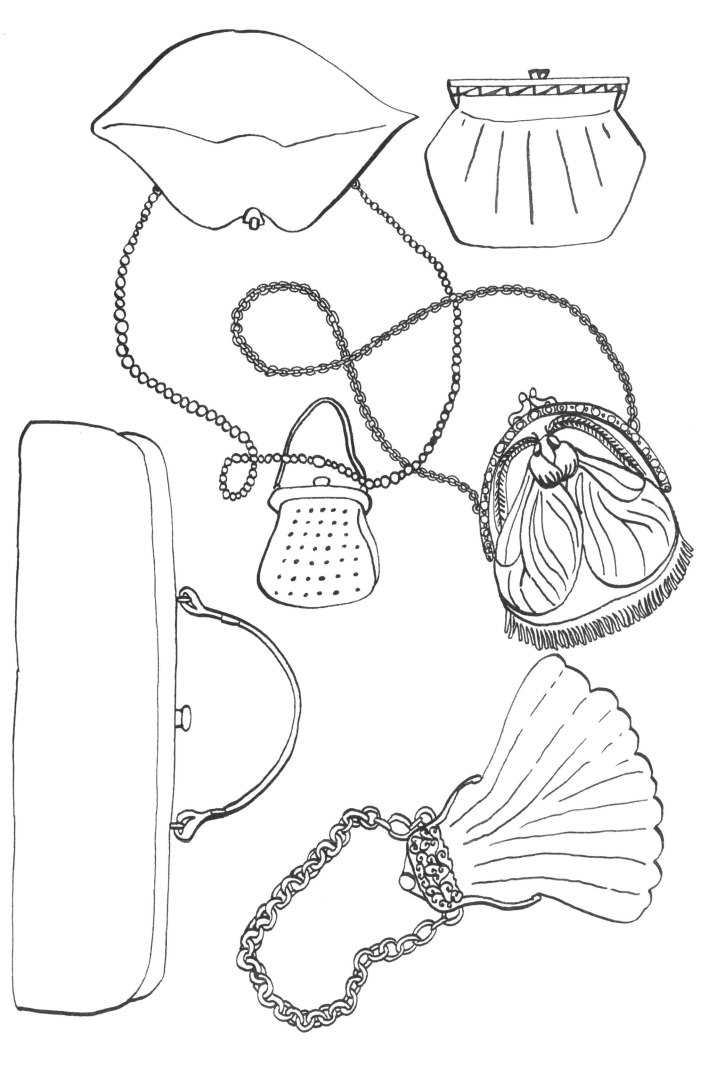

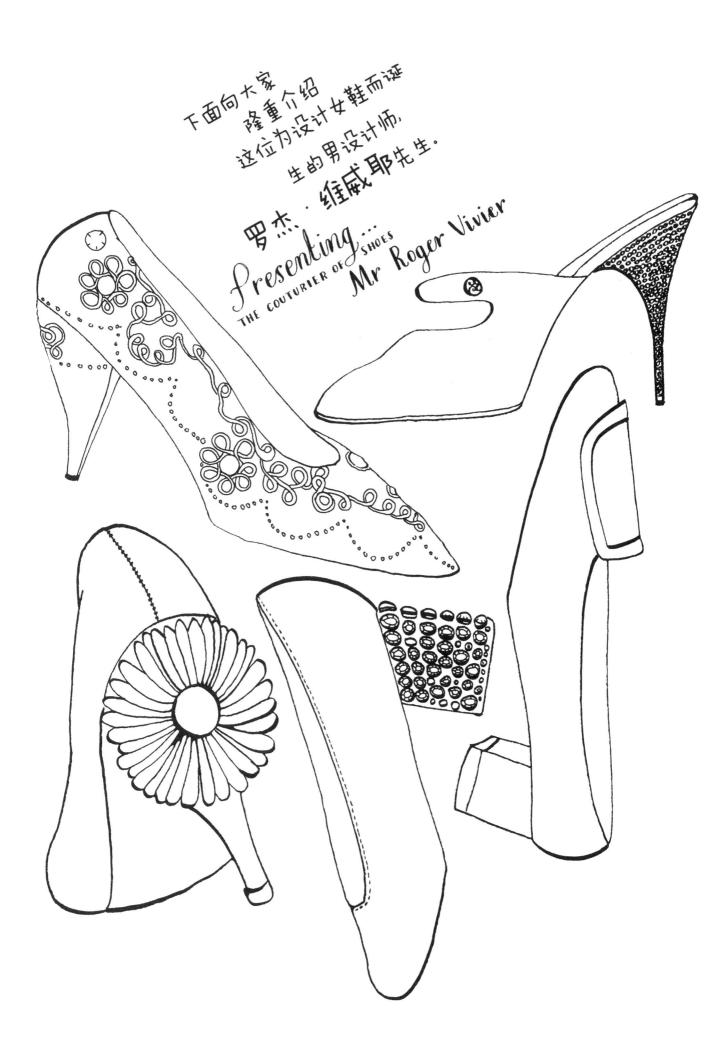

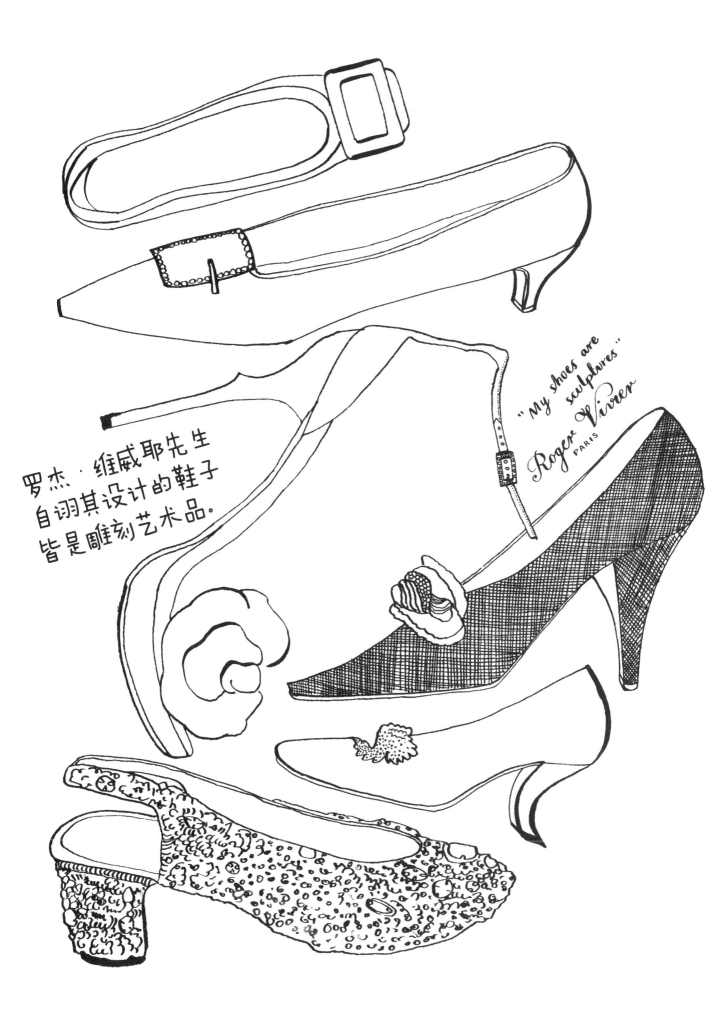

"My shoes are sculptures" Roger Vivier PARIS

罗杰·维威耶先生
自诩其设计的鞋子
皆是雕刻艺术品。

出自史蒂夫·米勒的作品鞋子的X光照片
是影响艺术的时尚的典型案例。

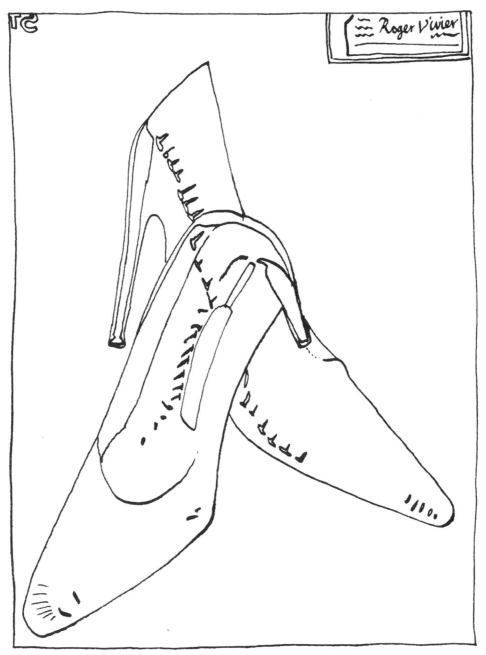

"I NEVER SAW ANYTHING SO BEAUTIFUL.
THEY LOOKED LIKE BLACK FERRARIS, SO I TOOK
THEM TO THE HOSPITAL AND HAD THEM X-RAYED."

"可以说这是我见过最为美丽动人的作品，它可以和黑色的法
拉利媲美。于是我便不自觉地将其带到了医院，为它拍摄了X
光照片。"

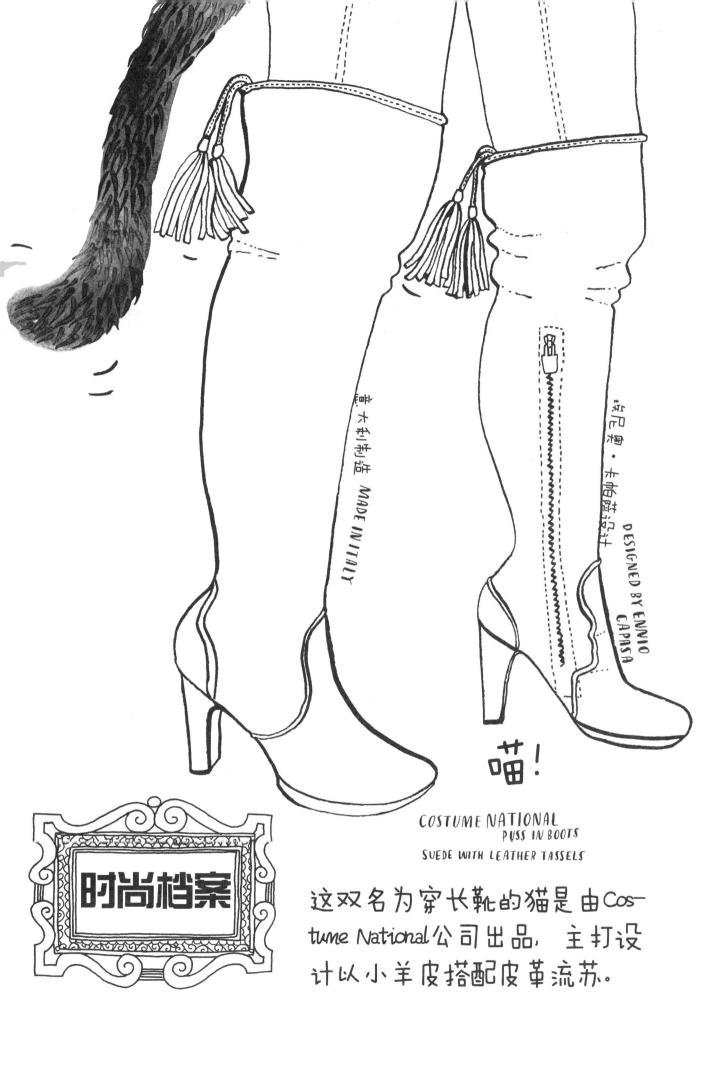

MADE IN ITALY
意大利制造

埃尼奥·卡帕莎设计
DESIGNED BY ENNIO CAPASA

喵!

COSTUME NATIONAL
PUSS IN BOOTS
SUEDE WITH LEATHER TASSELS

时尚档案

这双名为穿长靴的猫是由Costume National公司出品，主打设计以小羊皮搭配皮革流苏。

时尚档案

ELSA SCHIAPARELLI BOOTS, 1938
艾尔莎·夏帕瑞丽1938年设计的短靴。

试着为鞋店设计
一款手提袋。

DESIGN

A BAG FOR A SHOE STORE

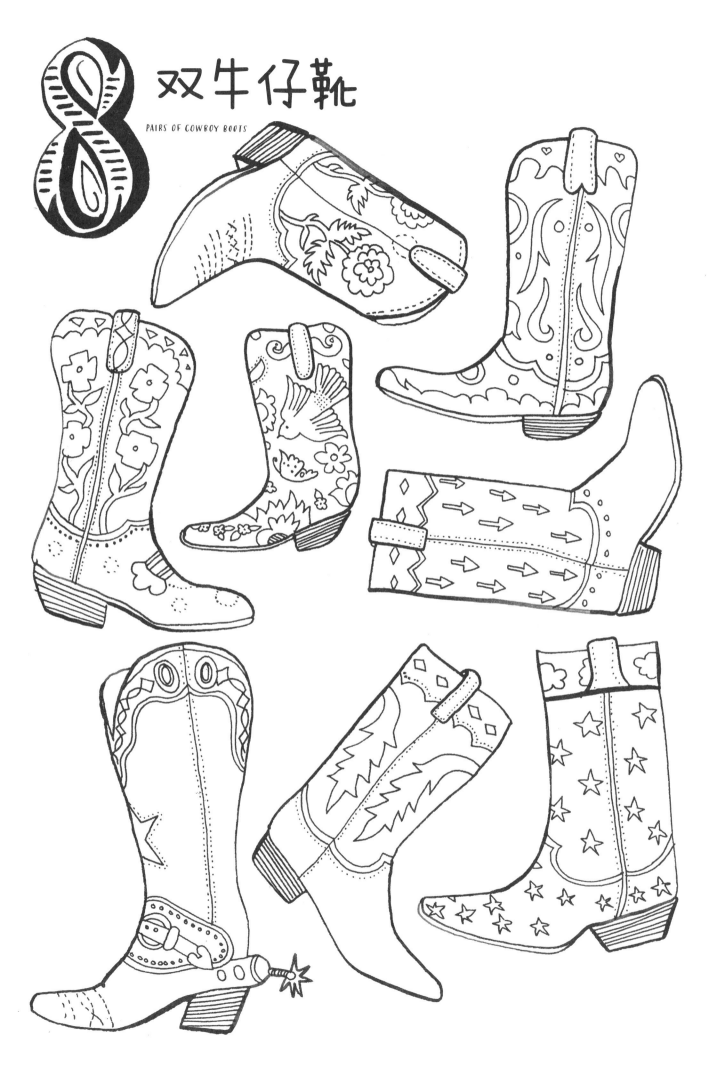

8 双牛仔靴

PAIRS OF COWBOY BOOTS

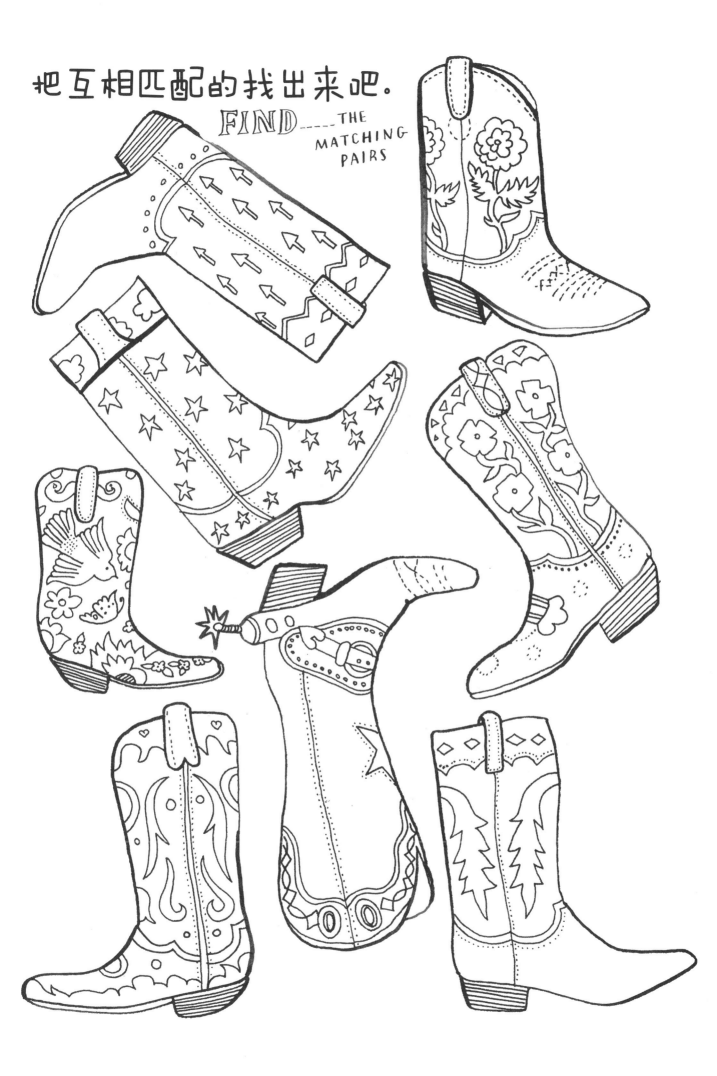

把互相匹配的找出来吧。
FIND----THE MATCHING PAIRS

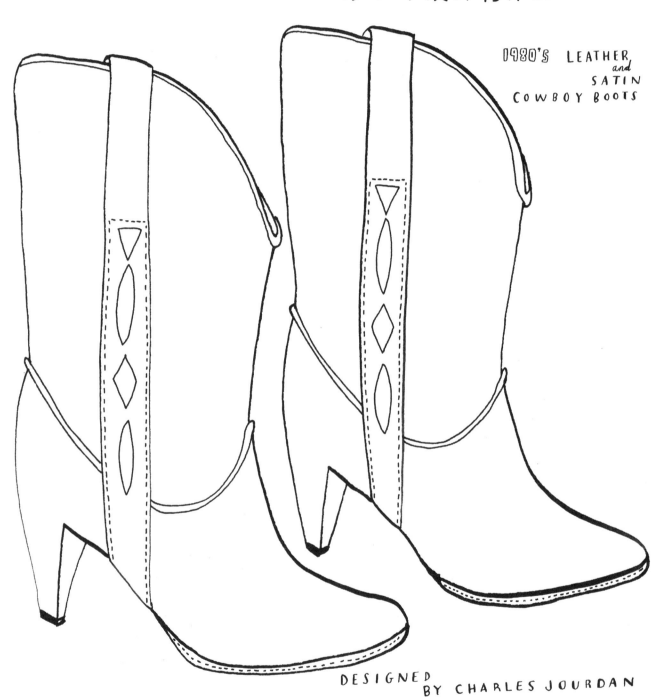

时尚档案

这是一款来自20世纪80年代的牛仔靴，是由查尔斯·佐丹使用皮革搭配沙丁布设计制作的。

1980'S LEATHER and SATIN COWBOY BOOTS

DESIGNED BY CHARLES JOURDAN

查尔斯·佐丹设计

为这条窄脚裤
绘制一款令人叹服的图案。

DESIGN
AN ASTOUNDING
PATTERN FOR THESE
LEGGINGS

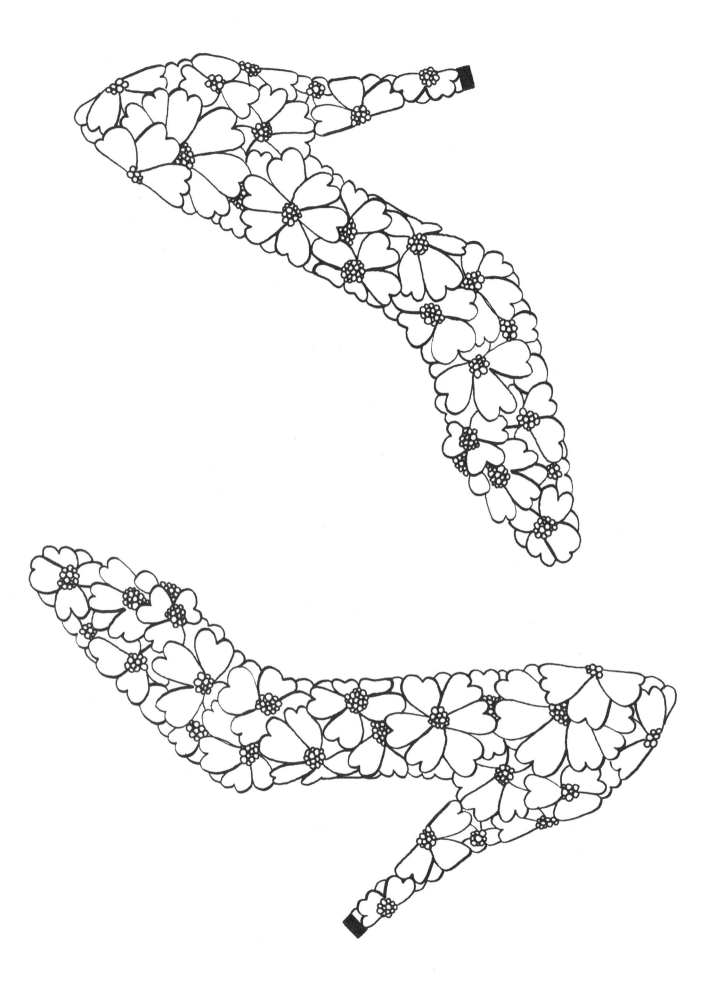

使用你喜爱的**花朵**
作为创作元素设计一款鞋。

Create a shoe...
FROM YOUR FAVOURITE FLOWER

看到
空隙了吗?
在空隙处画上
蚂蚱莱和
瓢虫。

SEE ANY GAPS?

...FILL IN THE SPACES WITH BUTTERFLIES and LADYBIRDS.

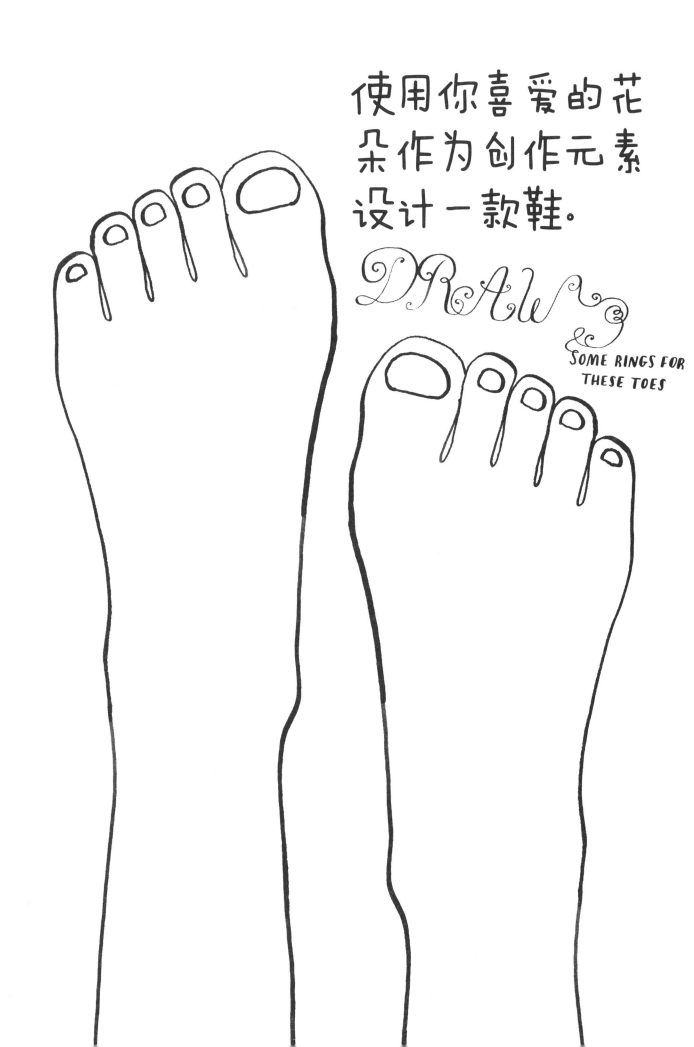

使用你喜爱的花
朵作为创作元素
设计一款鞋。

DRAW

SOME RINGS FOR
THESE TOES

夹脚鞋
THE TOE KNOB

MADE LONG AGO in THE 1800's

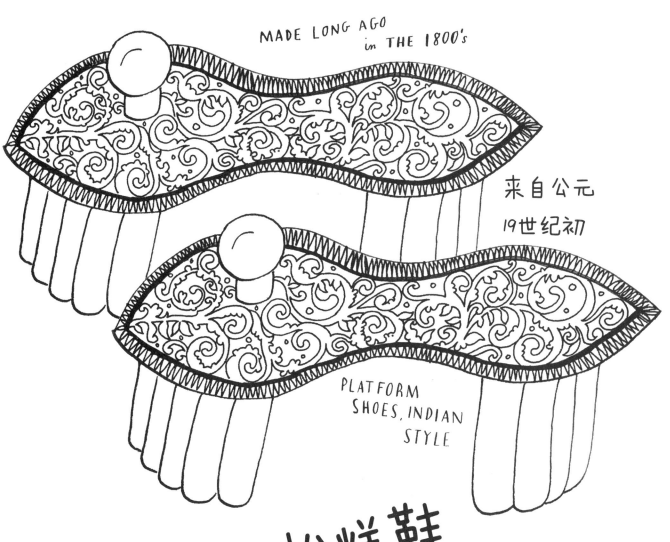

来自公元
19世纪初

PLATFORM
SHOES, INDIAN
STYLE

印度风格的松糕鞋

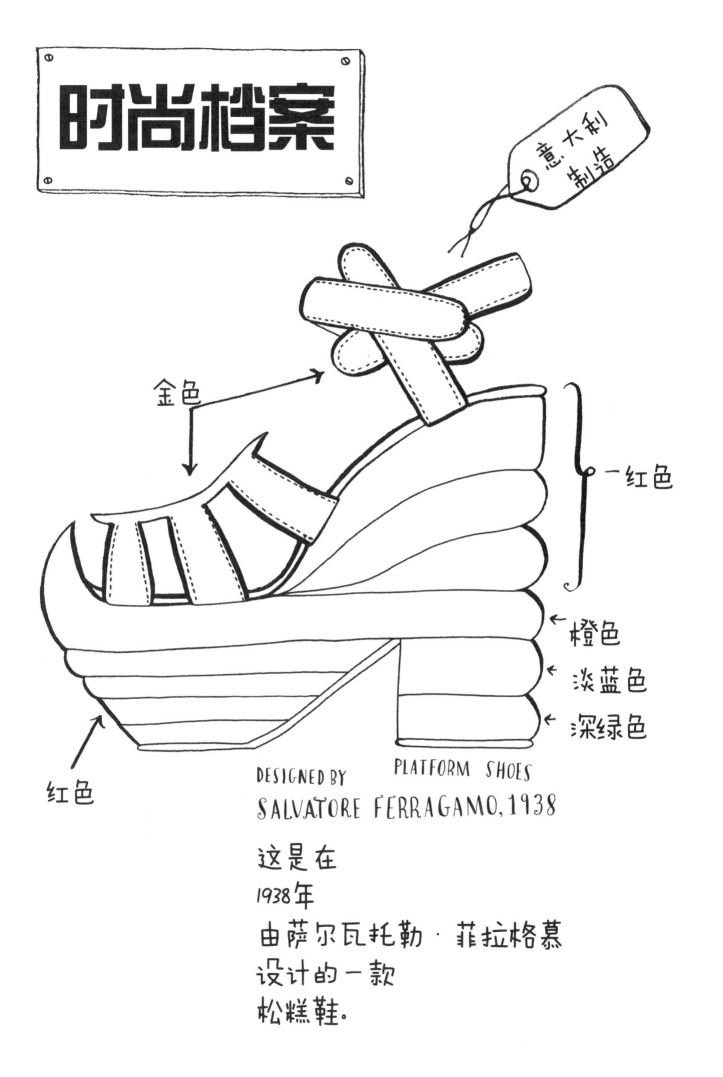

时尚档案

意大利制造

金色

一红色

橙色

淡蓝色

深绿色

红色

DESIGNED BY
SALVATORE FERRAGAMO, 1938

PLATFORM SHOES

这是在
1938年
由萨尔瓦托勒·菲拉格慕
设计的一款
松糕鞋。

DRAW

在此绘制这个世界上鞋底
最高的松糕鞋。

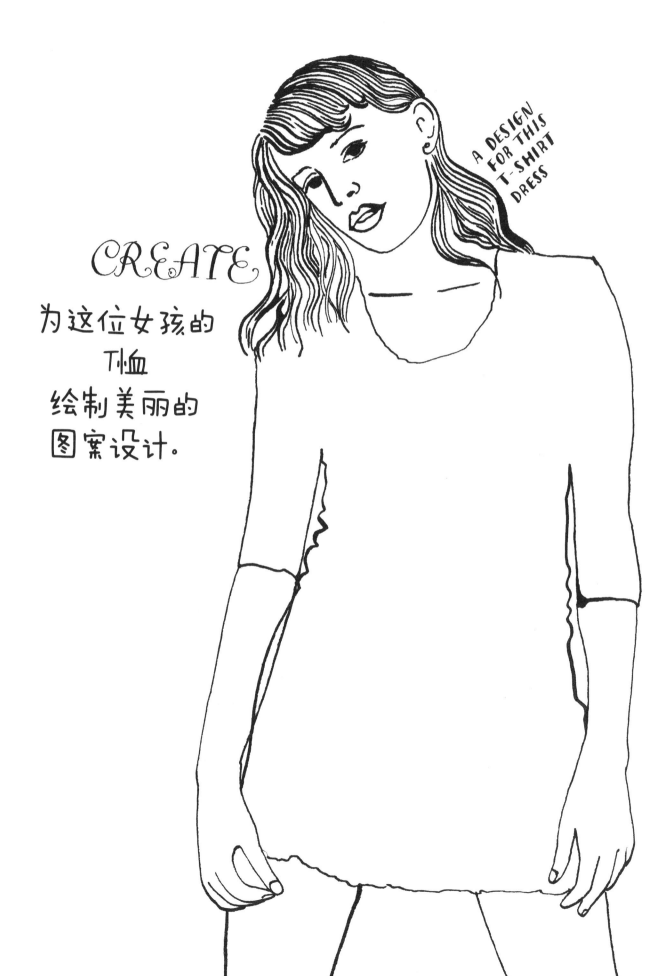

CREATE

为这位女孩的
T恤
绘制美丽的
图案设计。

A DESIGN
FOR THIS
T-SHIRT
DRESS

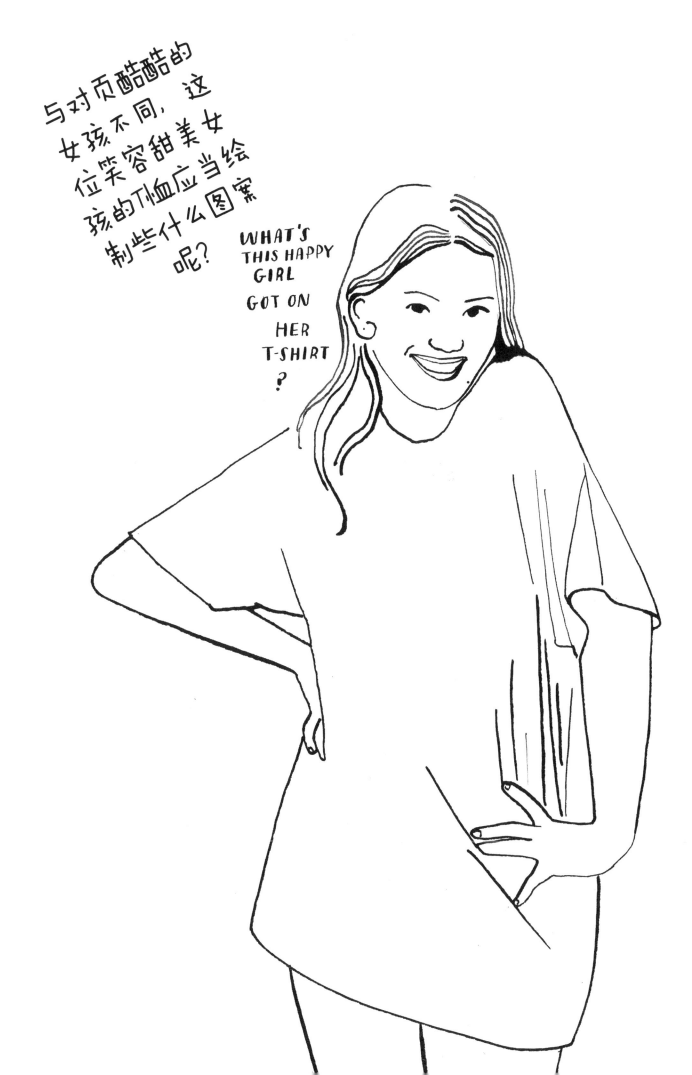

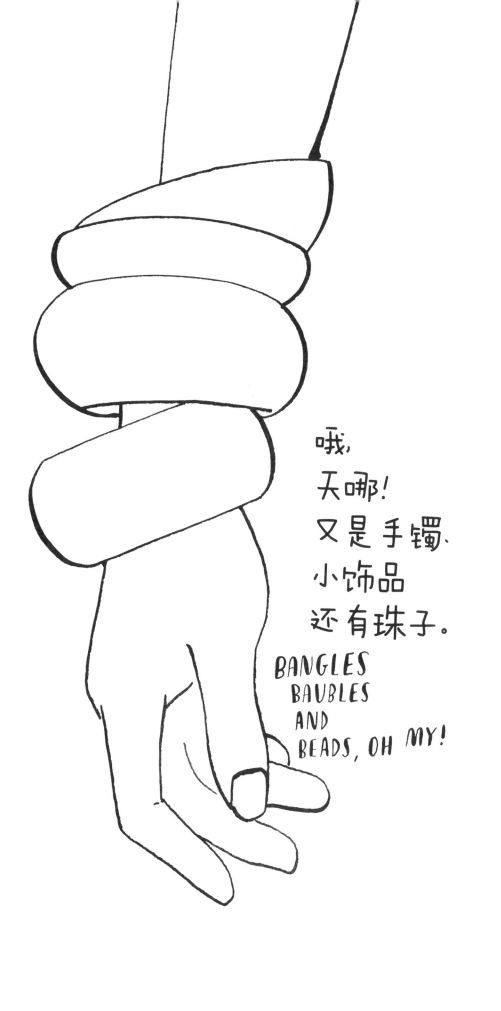

哦,
天哪!
又是手镯、
小饰品
还有珠子。

BANGLES
BAUBLES
AND
BEADS, OH MY!

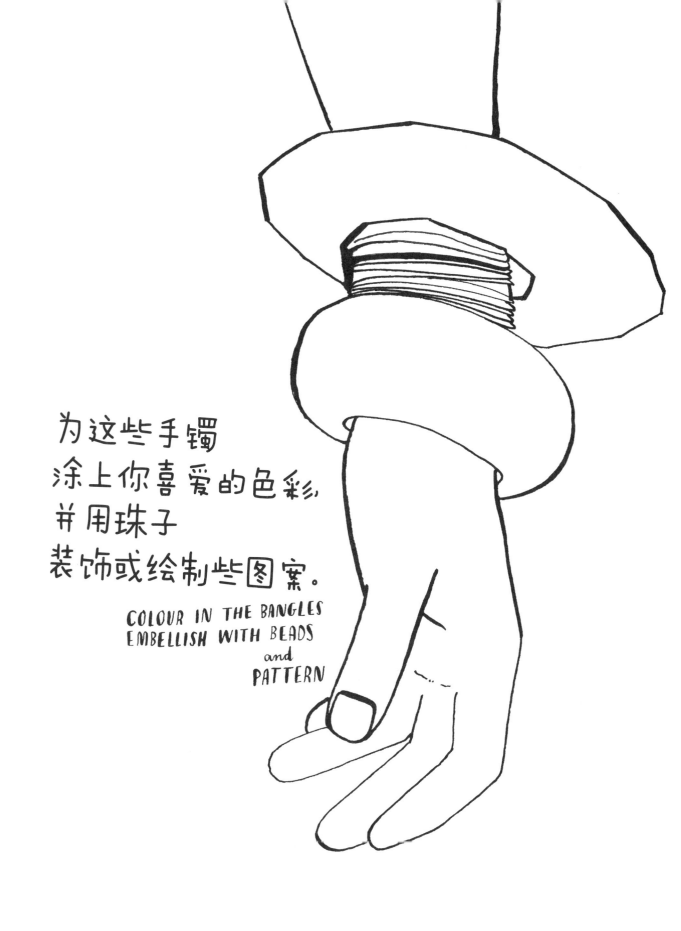

为这些手镯
涂上你喜爱的色彩，
并用珠子
装饰或绘制些图案。

COLOUR IN THE BANGLES
EMBELLISH WITH BEADS
and
PATTERN

draw...
A FACE TO FIT THESE DANGLY EARRINGS

什么样的脸蛋能与这对耳环搭
配呢？请画出来吧！

将收集的
纽扣
用针线
串在一起
制成一条手链。

MAKE
A BRACELET
FROM
STRINGING
BUTTONS
TOGETHER WITH
EMBROIDERY THREAD

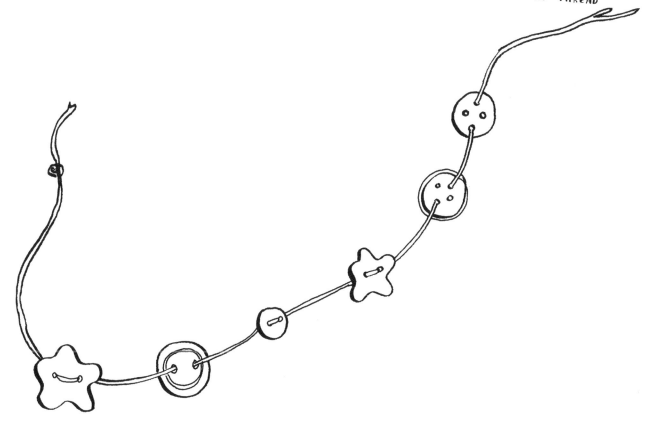

How to... 啪啦球的制作方法
MAKE A POM POM

①

先在硬纸板上剪出两个同样的圆形。

②

再在这两个同样的圆圈中剪出较小的圆洞。

③

将剪好圆洞的圆圈叠合，用毛线穿过圆环圆洞并围绕。

这时你将毛线事先串在针上会更加容易些。

④ 重复这种做法，
　　直到中间的
　　圆洞无法再穿针为止。

⑤ 完成后要沿着圆圈的外边缘剪开毛线。

⑥

这时再将剪开的
毛线分开，并在
两个圆圈中间打
上死结。

最后将圆圈剪开
扔掉。

一个完整的啦啦球
　　便算完成了，
可以将其绑在物品上作装饰。

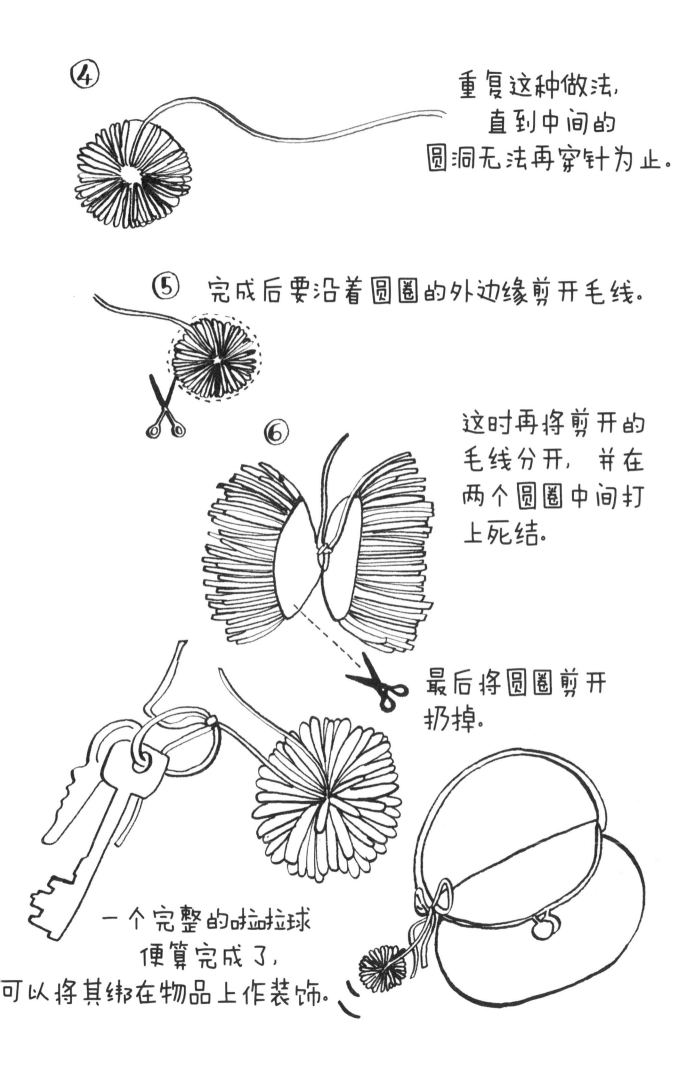

DRAW
A DRESS THAT IS MADE ENTIRELY FROM POM POMS

绘制一件都是
使用啦啦球制作的衣服。

为这双 **土耳其**拖鞋绘制图案。

CREATE

A PATTERN FOR THESE
TURKISH SLIPPERS

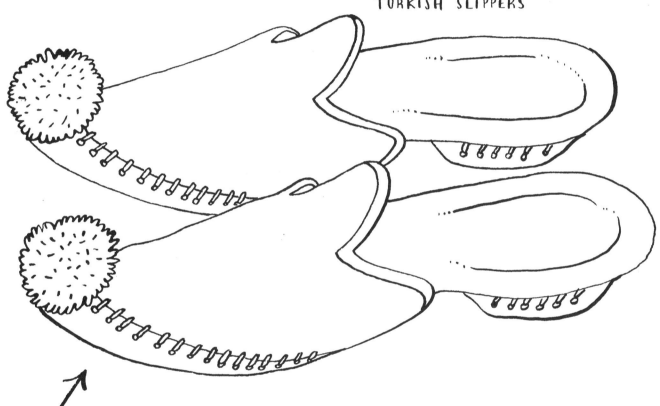

↑
ÇARIK IS THEIR TURKISH NAME.
They are characterized
by a raised tip

这双鞋的土耳其名字是Çarik，其因翘起的鞋尖而显得格外独特。

这两页需要你画满
闪闪亮亮的钻石。

FILL THESE TWO
PAGES WITH LOTS and
LOTS and LOTS OF
SPARKLING DIAMONDS

时尚档案

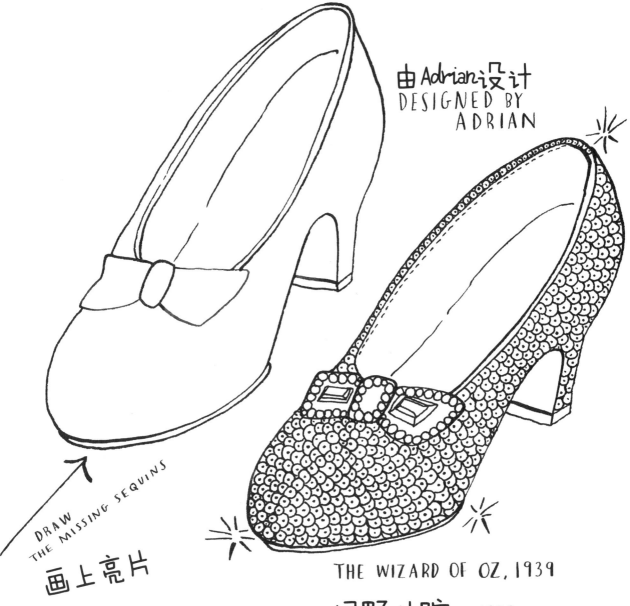

由 Adrian 设计
DESIGNED BY
ADRIAN

DRAW
THE MISSING SEQUINS

画上亮片

THE WIZARD OF OZ, 1939

绿野仙踪 1939
桃乐丝扮演者所穿。

DRAW A HAT THAT YOU
THINK a
A WICKED WITCH WOULD WEAR

绘制一顶
 你认为适合邪恶女巫戴的帽子。

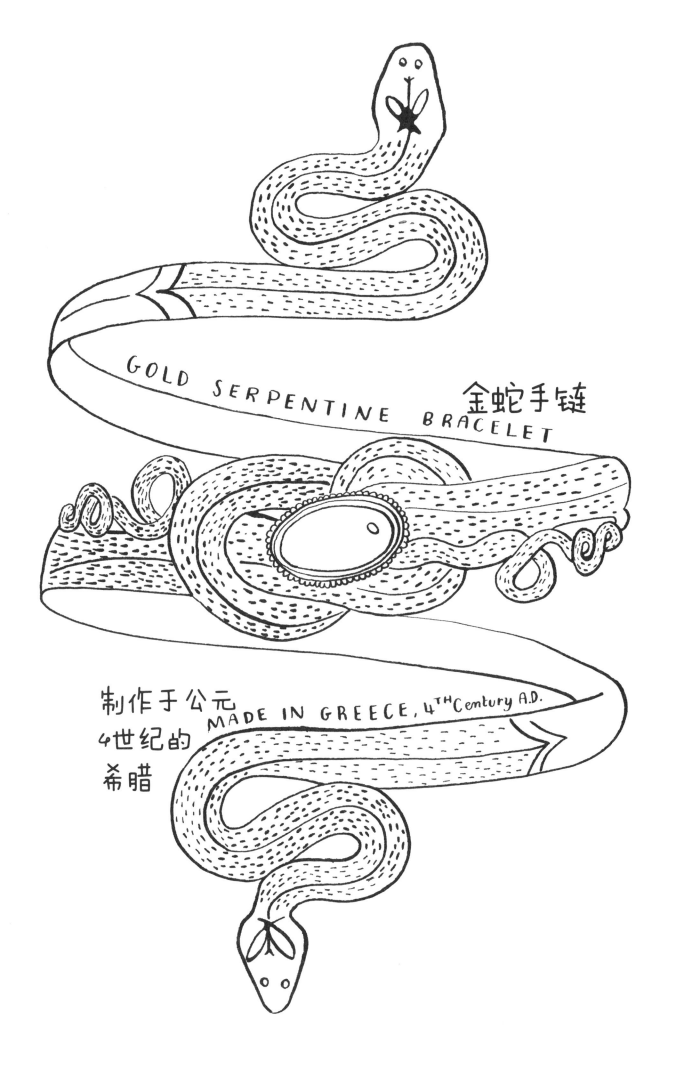

GOLD SERPENTINE BRACELET 金蛇手链

制作于公元 MADE IN GREECE, 4TH Century A.D.
4世纪的
希腊

先将自己的
脸画在
合适的位置。 DRAW
YOUR OWN
FACE IN
HERE

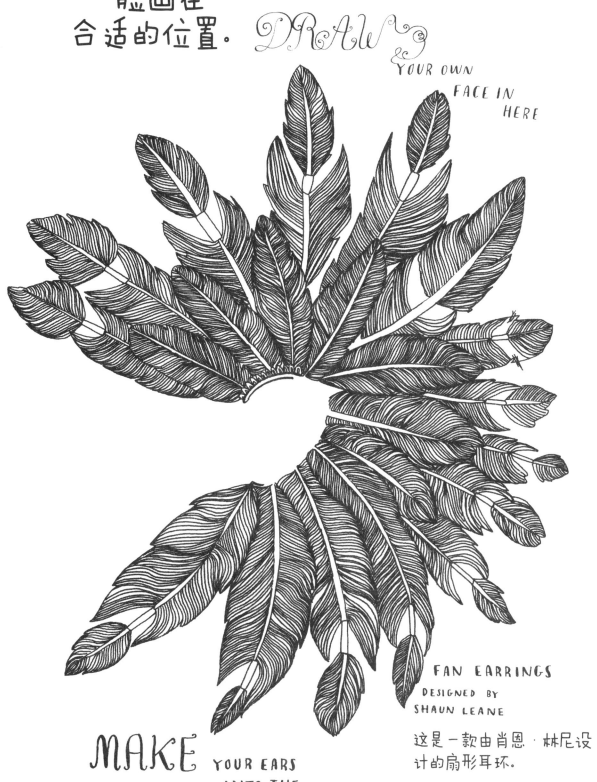

FAN EARRINGS
DESIGNED BY
SHAUN LEANE

这是一款由肖恩·林尼设
计的扇形耳环。

MAKE YOUR EARS
INTO THE
STAR ATTRACTION!

耳环能够让你的耳朵
也显得格外出众。

绘制一件都是使用羽毛
制作的 斗篷。

DRAW

A CLOAK MADE ENTIRELY
FROM FEATHERS

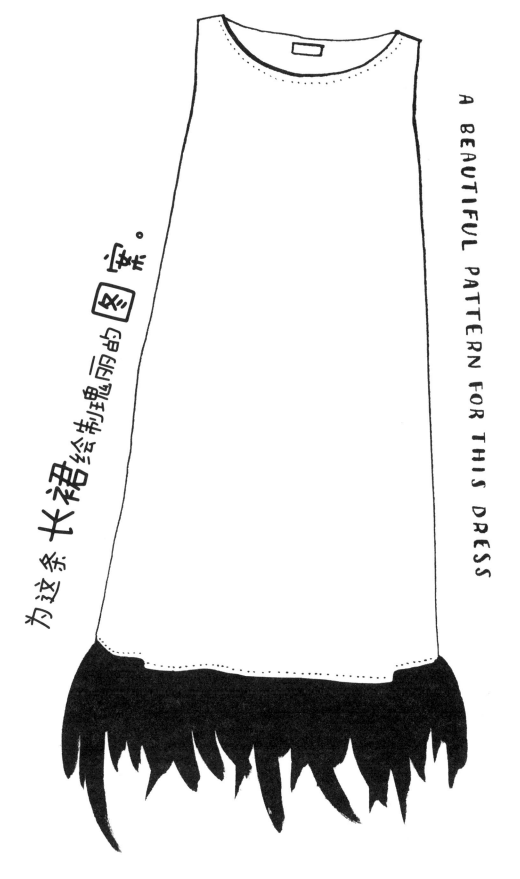

draw...

A BEAUTIFUL PATTERN FOR THIS DRESS

为这条长裙绘制出魅丽而田的图案。

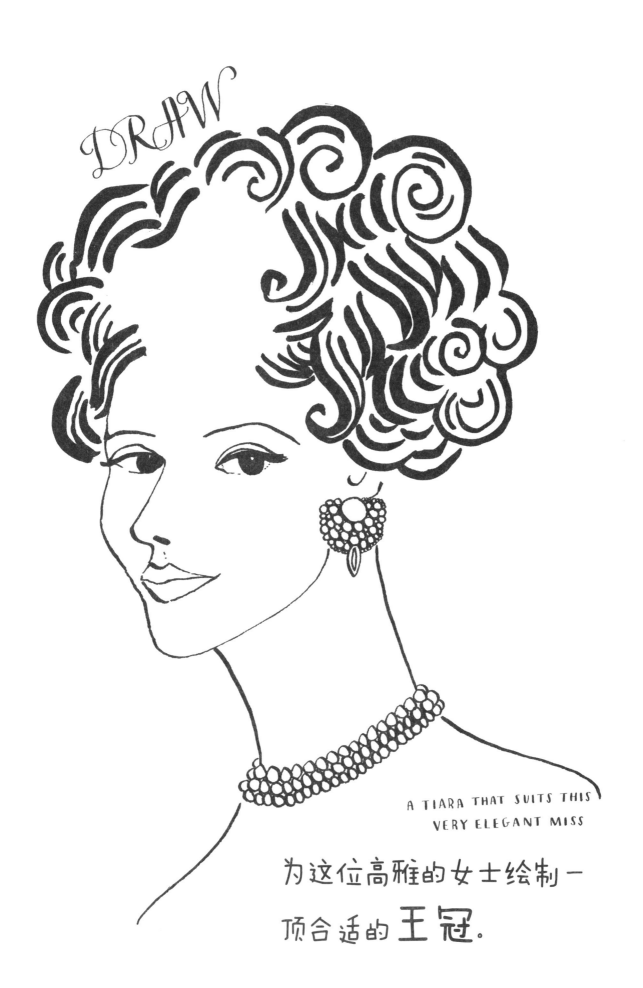

A TIARA THAT SUITS THIS
VERY ELEGANT MISS

为这位高雅的女士绘制一
顶合适的 王冠.

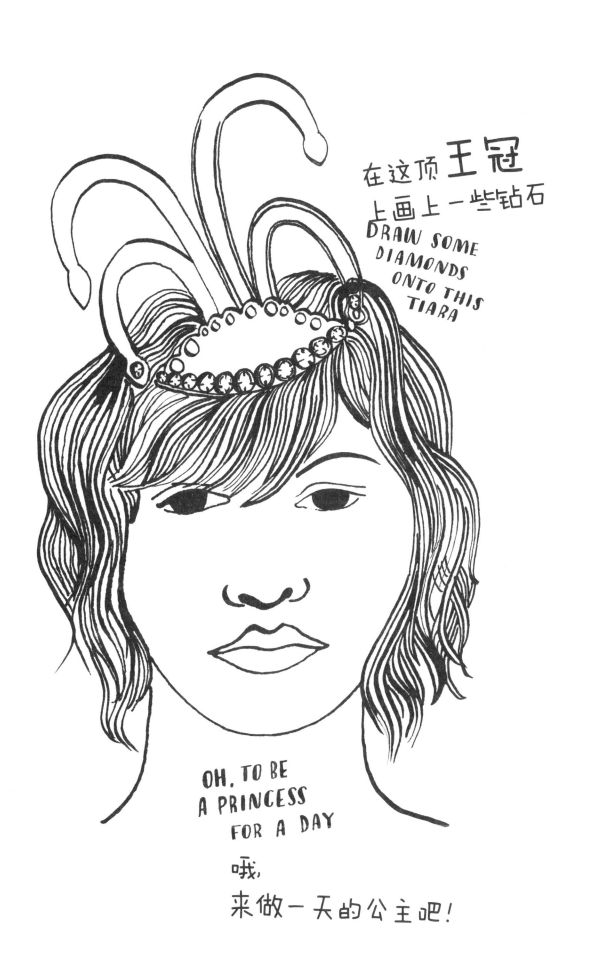

小树枝也可以被用来制作
王冠哦。

Make…

A TIARA FROM TWIGS

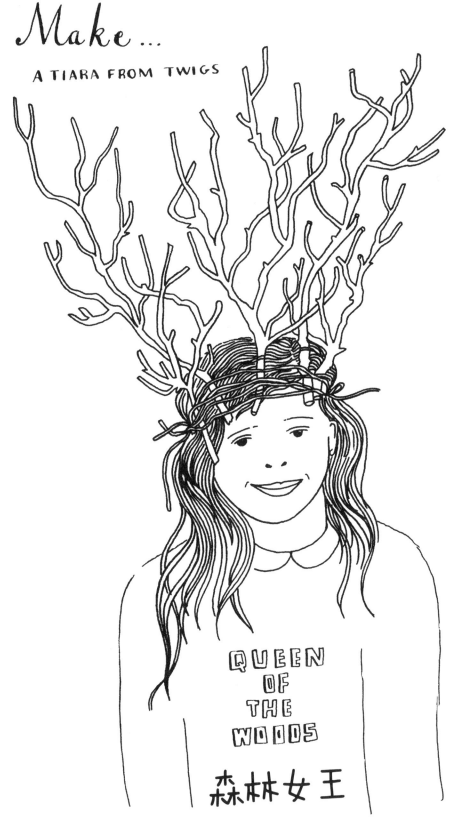

QUEEN
OF
THE
WOODS

森林女王

为这位精灵的翅膀
绘制奇妙玄幻的图案。

CREATE...A MAGICAL
PATTERN
FOR THESE
FAIRY WINGS

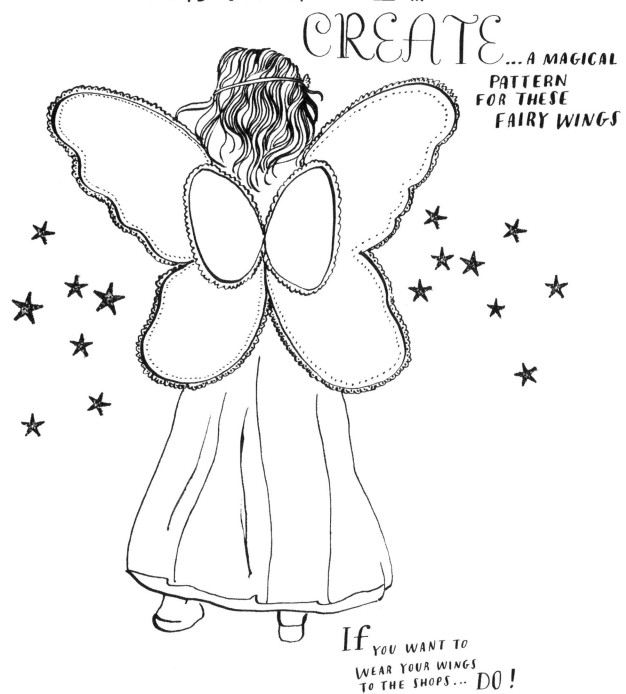

If YOU WANT TO
WEAR YOUR WINGS
TO THE SHOPS... DO !

倘若你想要带着这
双翅膀去逛街，何
乐而不为呢？

为了这位女孩快快上床睡觉，快为她的睡衣绘制奇妙的图案吧。

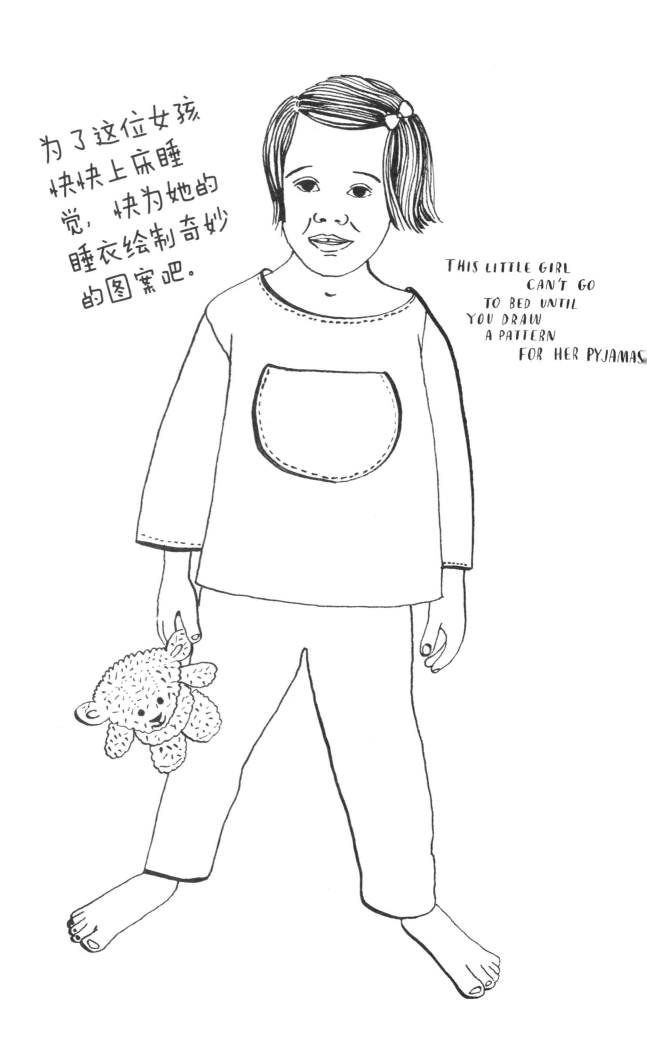

THIS LITTLE GIRL
CAN'T GO
TO BED UNTIL
YOU DRAW
A PATTERN
FOR HER PYJAMAS

DRAW...
YOUR FAVOURITE DRESS

在此绘制你最喜爱的衣服。

学习如何穿针引线
HOW TO THREAD A NEEDLE

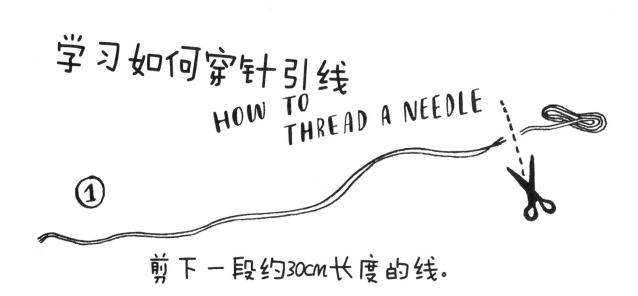

① 剪下一段约30cm长度的线。

② 为更容易穿线进针眼，可以舔一下线头。

针端有孔处便是针眼。

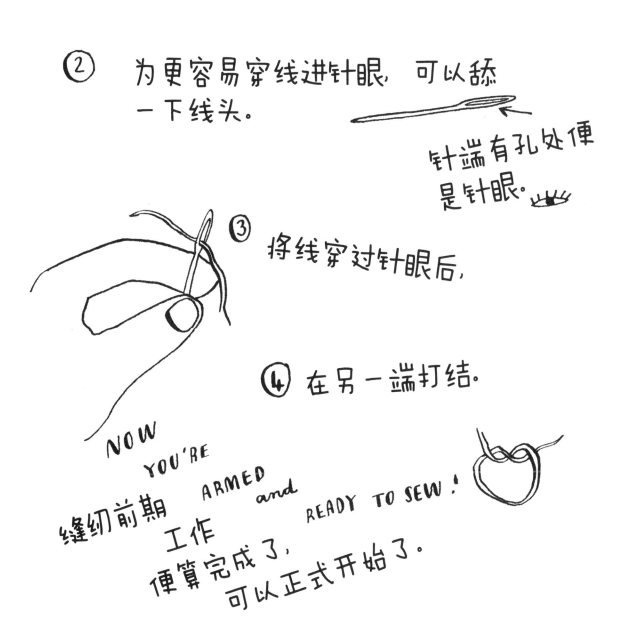

③ 将线穿过针眼后，

④ 在另一端打结。

NOW YOU'RE 缝纫前期 ARMED 工作 and 便算完成了， READY TO SEW！ 可以正式开始了。

针法有多种，以下是一些示范。

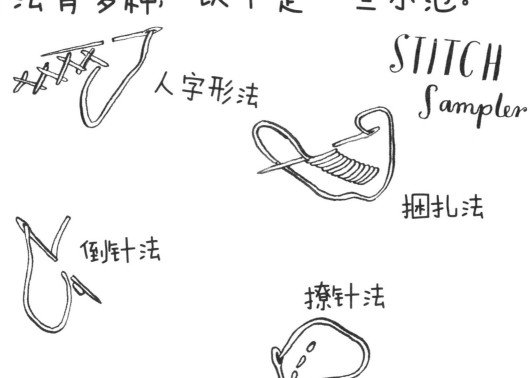

人字形法

STITCH
Sampler

捆扎法

倒针法

撩针法

锁针法

剑式法

链式法

辫式法

十字绣法

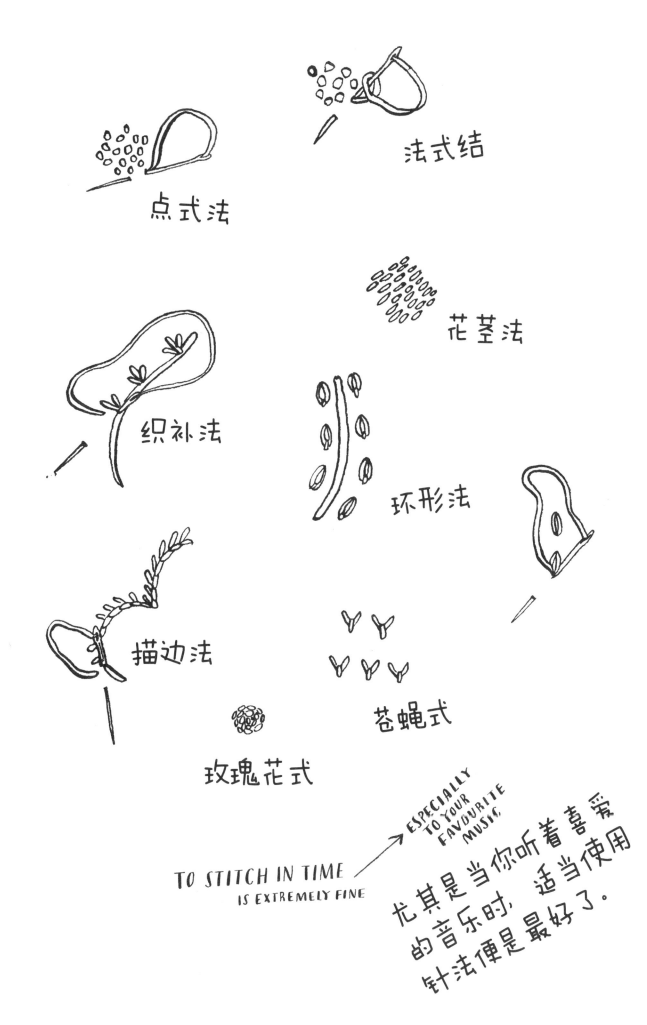

点式法

法式结

织补法

花茎法

环形法

描边法

苍蝇式

玫瑰花式

TO STITCH IN TIME → ESPECIALLY TO YOUR FAVOURITE MUSIC
IS EXTREMELY FINE

尤其是当你听着喜爱的音乐时，适当使用针法便是最好了。

时尚是个轮回，平时多
留意过去的女装设计。

Look OUT FOR OLD
DRESSMAKING
PATTERNS

Style

BUST SIZE
38

1764
Gt. Britain
4/-
5/9 Overseas

B

A

会发现许多服装要比现在
还要有意思得多。

OFTEN THEY CAN BE
MORE INTERESTING THAN NEW ONES

35p
inc. P.T.

NEW
Sizing

MULTI
PATTERN

le-roy
WELDONS

9380
FOUR SIZES IN ONE

A

B

Printed Pattern

"HOT
PANTS"

为下面每一枚
纽扣绘制
出挑的图案。

CREATE...

MAKE 让每一个纽扣都成为杰作。

EACH ONE A MINI MASTERPIECE

EVERYTHING THAT IS IN YOUR POCKET

将你现在口袋中的所有东西画出来。

DRAW
YOUR FAVOURITE PAIR OF GLOVES

绘制一副你最喜
爱的手套。

我想我要给你戴上它。
I THINK
I GLOVE YOU

为它们涂上精致多样的色彩。

COLOUR THEM IN EXQUISITELY

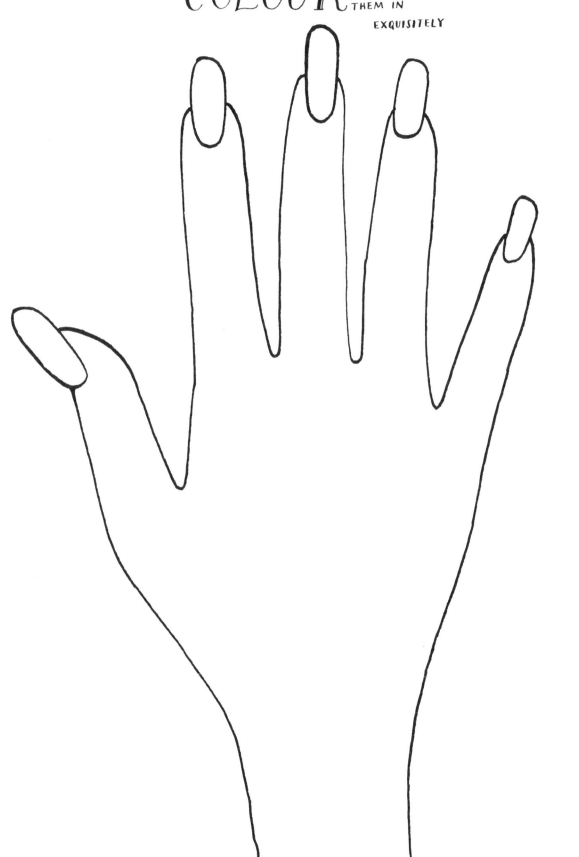

为它们涂上精致多样的色彩。

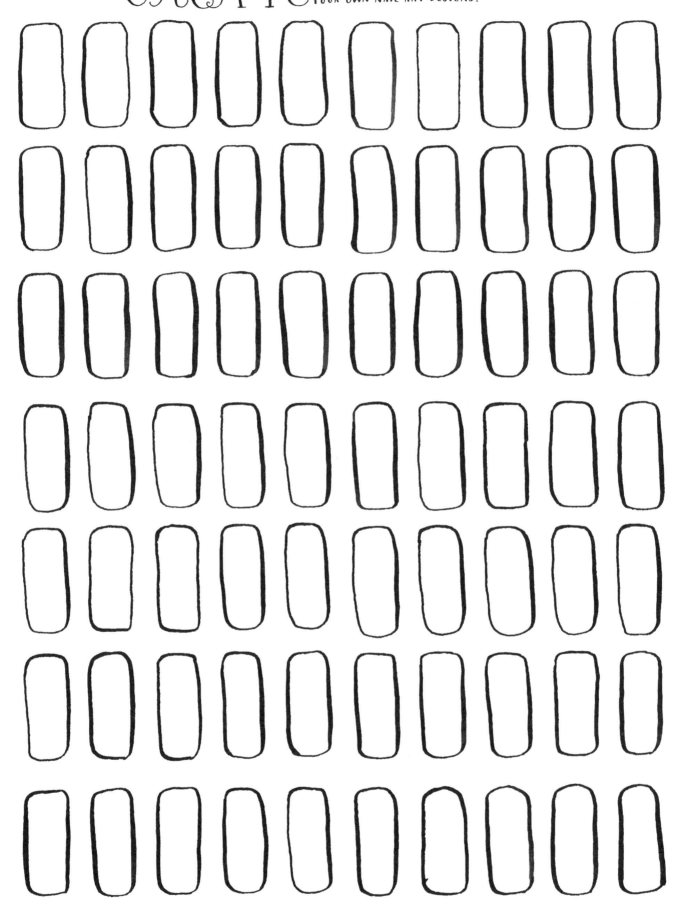

CREATE YOUR OWN NAIL ART DESIGNS!

在空白指甲上绘制属于你自己的美甲图案，

Make 使得每一个指甲都超凡脱俗。
EACH ONE A MINUTE WONDER

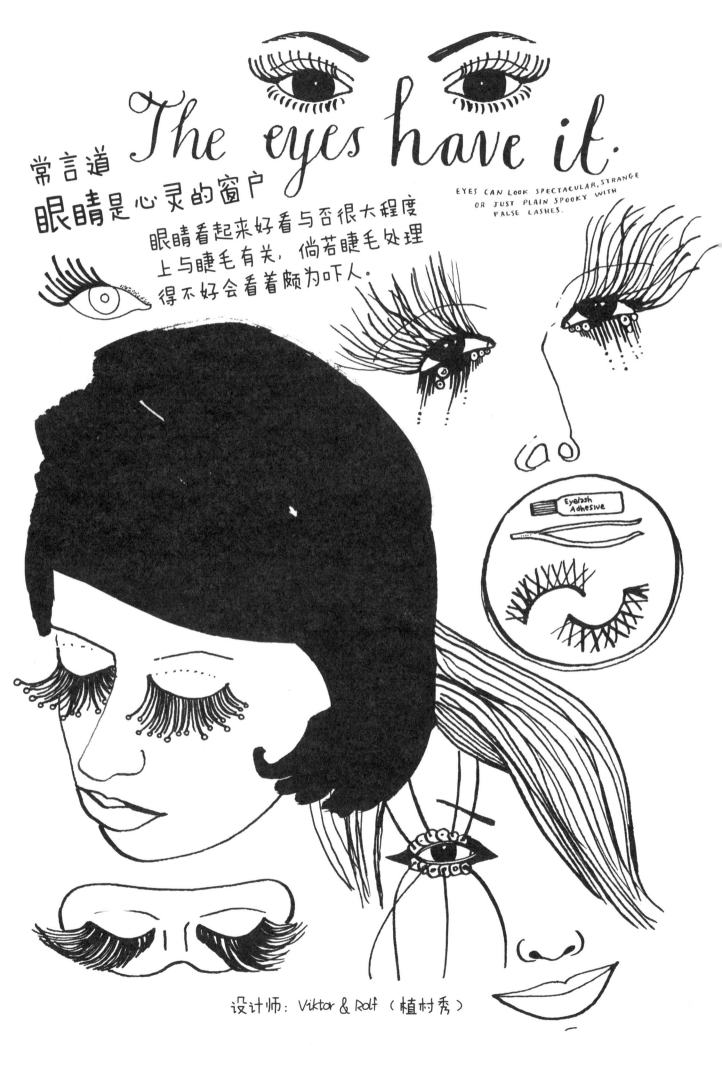

常言道
眼睛是心灵的窗户

The eyes have it.

EYES CAN LOOK SPECTACULAR, STRANGE OR JUST PLAIN SPOOKY WITH FALSE LASHES.

眼睛看起来好看与否很大程度
上与睫毛有关，倘若睫毛处理
得不好会看着颇为吓人。

Eyelash Adhesive

设计师: Viktor & Rolf（植村秀）

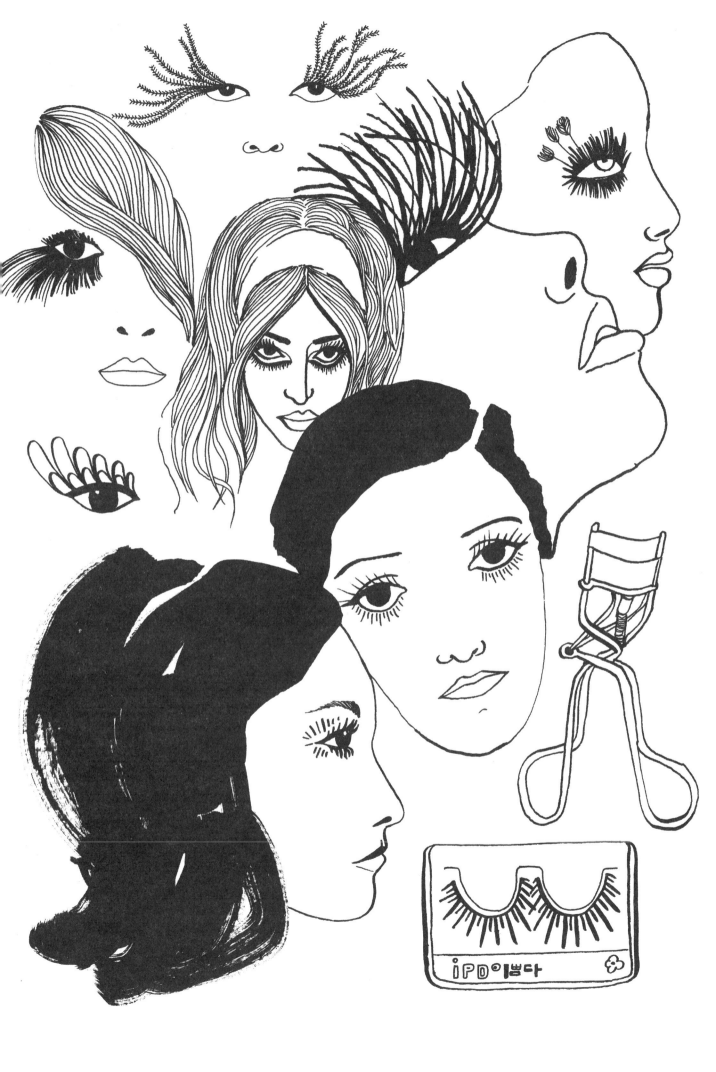

她们的**睫毛**都去哪了？
快给她们画上漂亮的睫毛。
LASH OUT !

DRAW SOME THEATRICAL LASHES
ONTO THESE EYES

孔雀毛甚是漂亮，
戴在你的头上看看。

PUT A PEACOCK
FEATHER IN YOUR
HAIR...

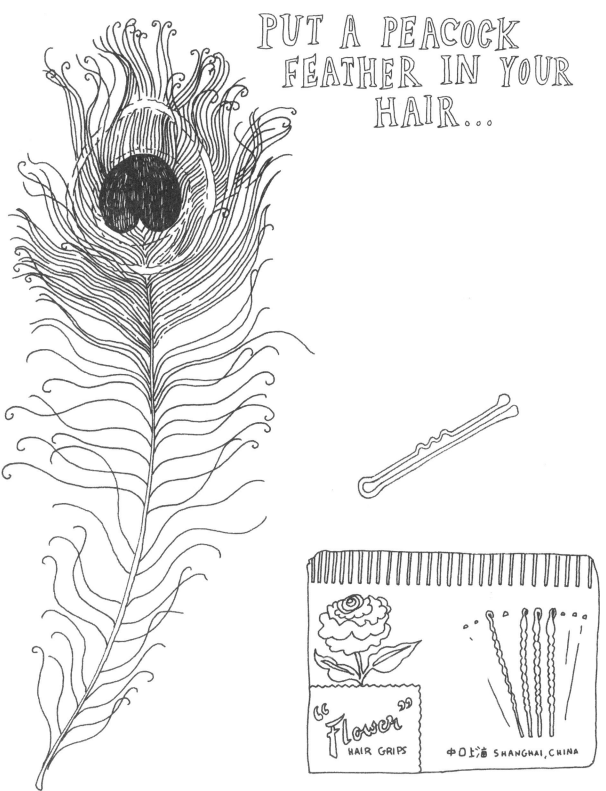

"Flower"
HAIR GRIPS
中日上海 SHANGHAI, CHINA

非洲**卷发**有着独特的魅力。
I ♡ MY FRO

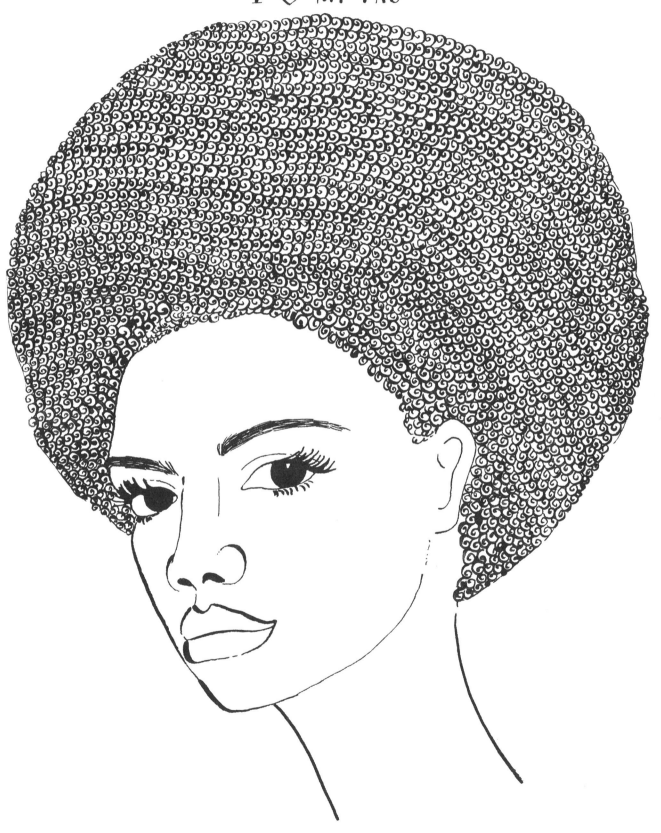

在此剪下你喜欢的图形并绘上图案，贴在对页的卷发上。

欣赏一些非洲
手工梳子。

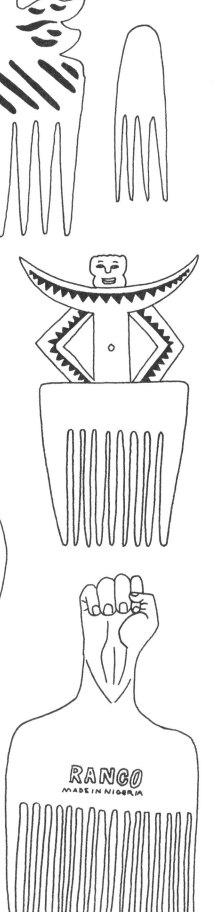

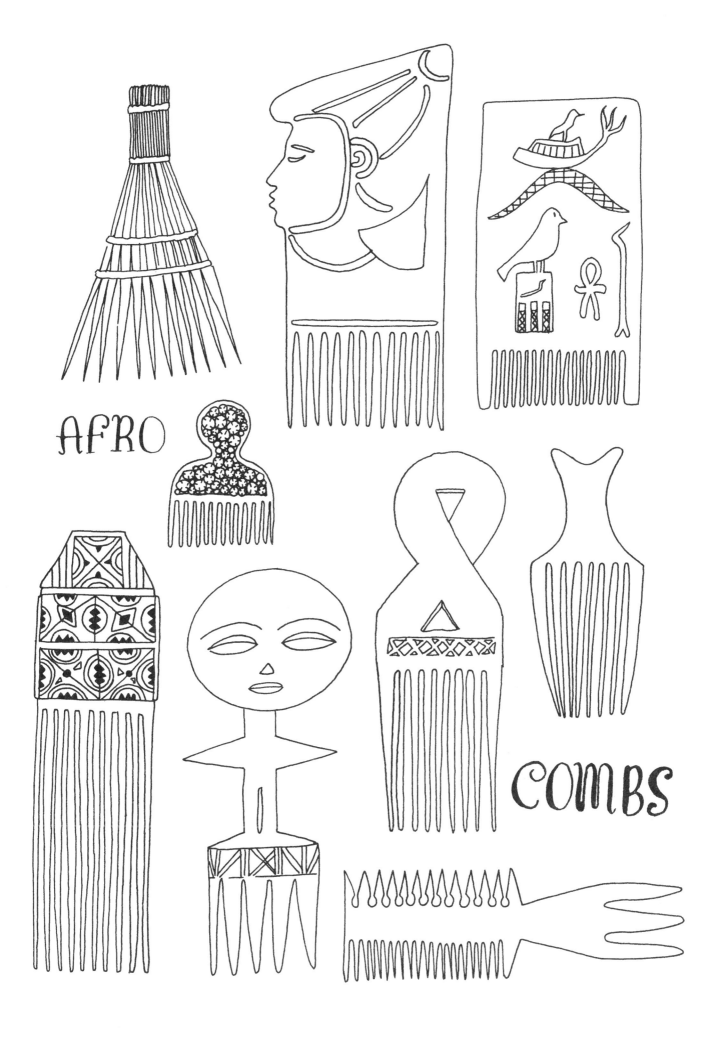

AFRO

COMBS

在此剪下你喜欢的图
形并绘上图案，贴在
对页的卷发上。

倘若你拥有一头非洲**卷发**会是怎样呢?
WHAT WOULD YOU LOOK LIKE WITH AN AFRO?

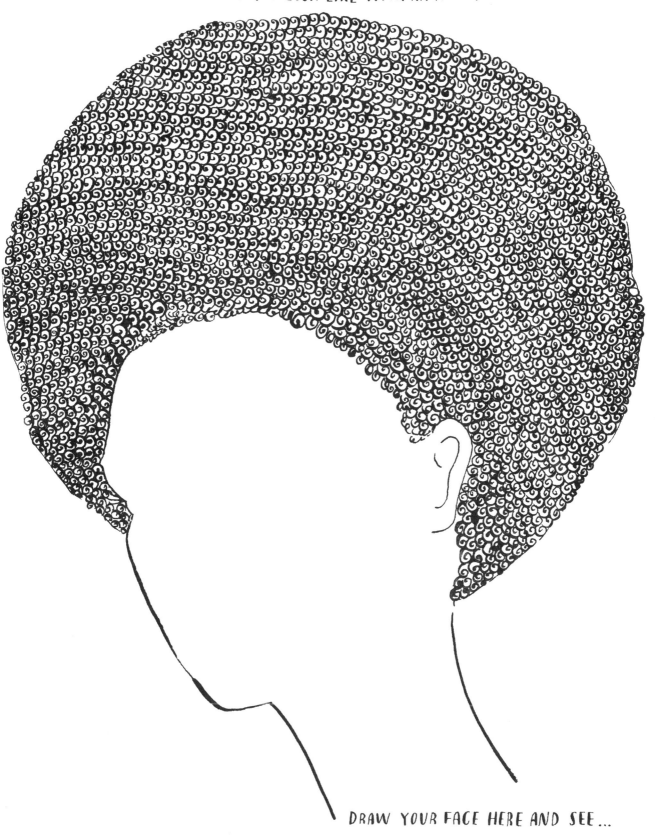

DRAW YOUR FACE HERE AND SEE...

将你的脸庞画在此处便知晓了。

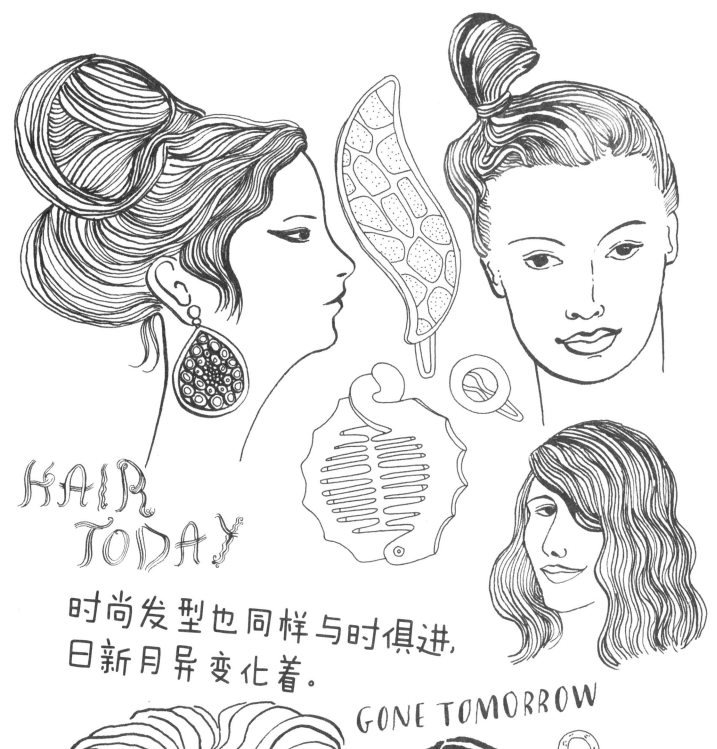

HAIR
TODAY

时尚发型也同样与时俱进，
日新月异变化着。

GONE TOMORROW

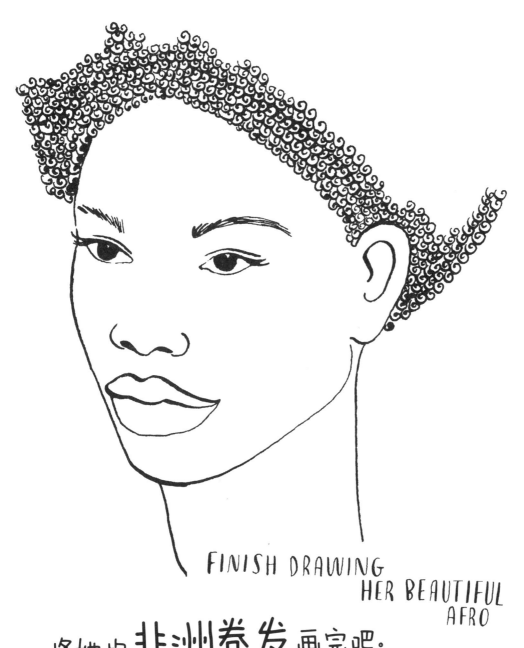

FINISH DRAWING
HER BEAUTIFUL
AFRO

将她的 非洲卷发 画完吧。

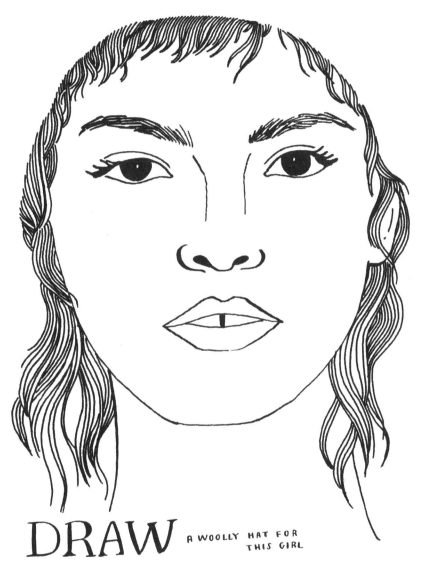

DRAW A WOOLLY HAT FOR
THIS GIRL

MAYBE THERE IS A
HUGE BOBBLE ON TOP OR MAYBE NOT

以及为这位女士绘制
一顶带有毛球的羊毛帽,
当然毛球也可以选择不要。

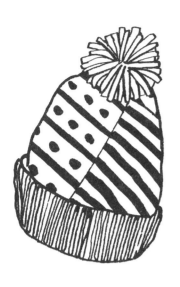
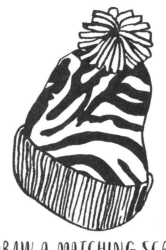
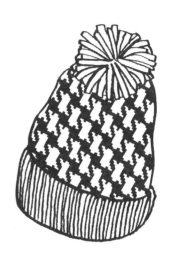

DRAW A MATCHING SCARF

为这里的每一顶羊毛帽绘制与之搭配的围巾。

画一条与之搭配的围巾。

FOR EACH WOOLLY HAT

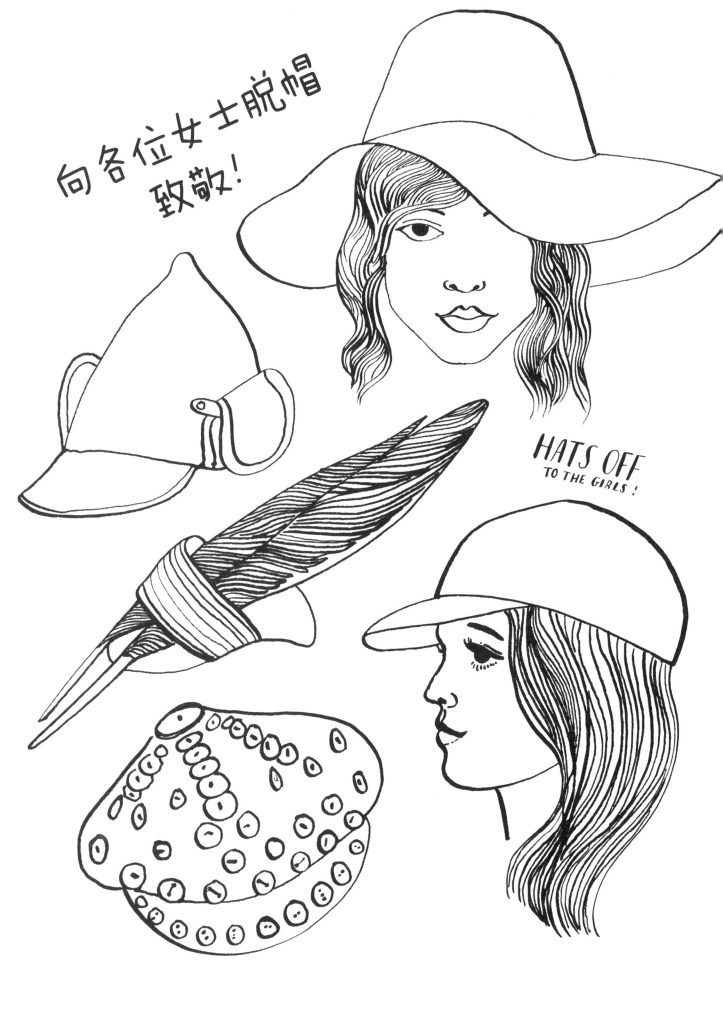

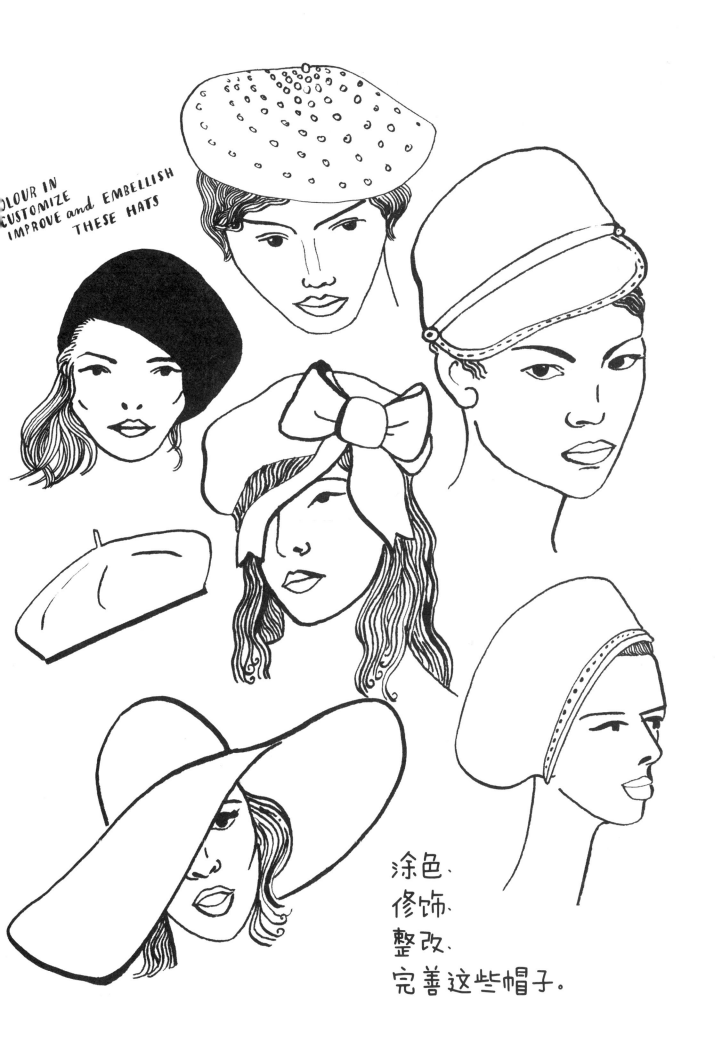

COLOUR IN CUSTOMIZE IMPROVE and EMBELLISH THESE HATS

涂色、
修饰、
整改、
完善这些帽子。

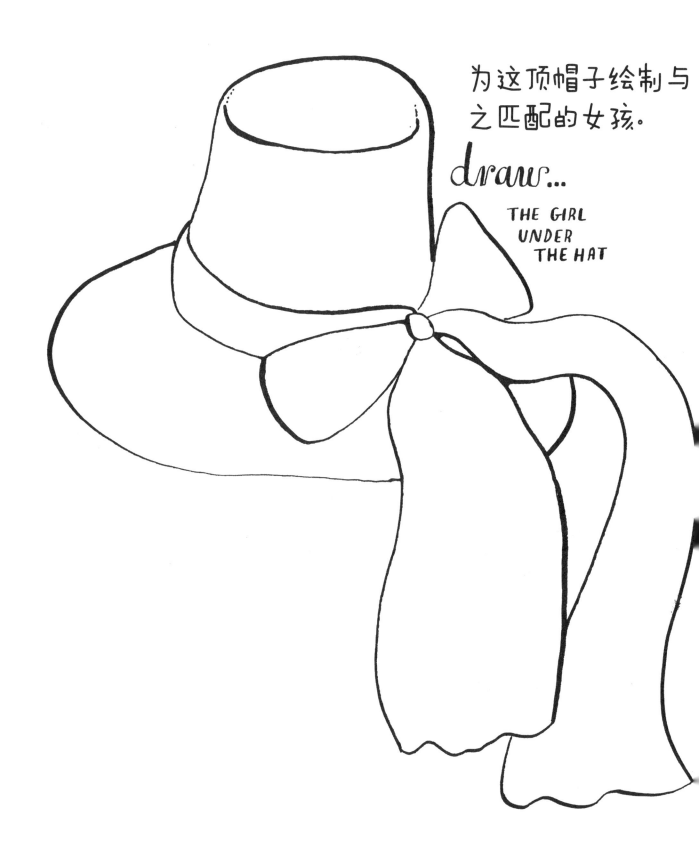

为这顶帽子绘制与
之匹配的女孩。

draw...

THE GIRL
UNDER
THE HAT

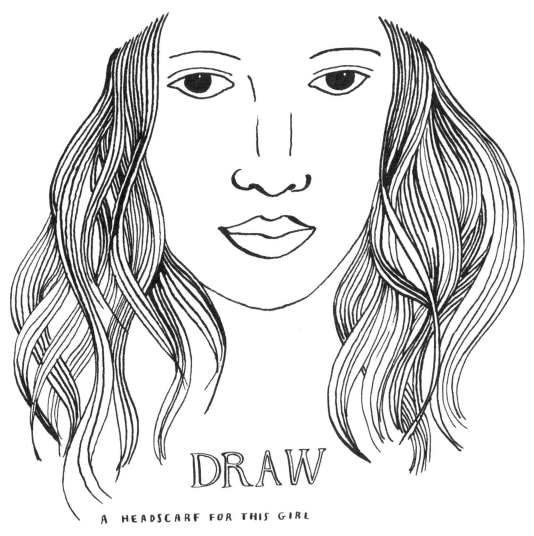

DRAW

A HEADSCARF FOR THIS GIRL

为这位女士绘制头巾。

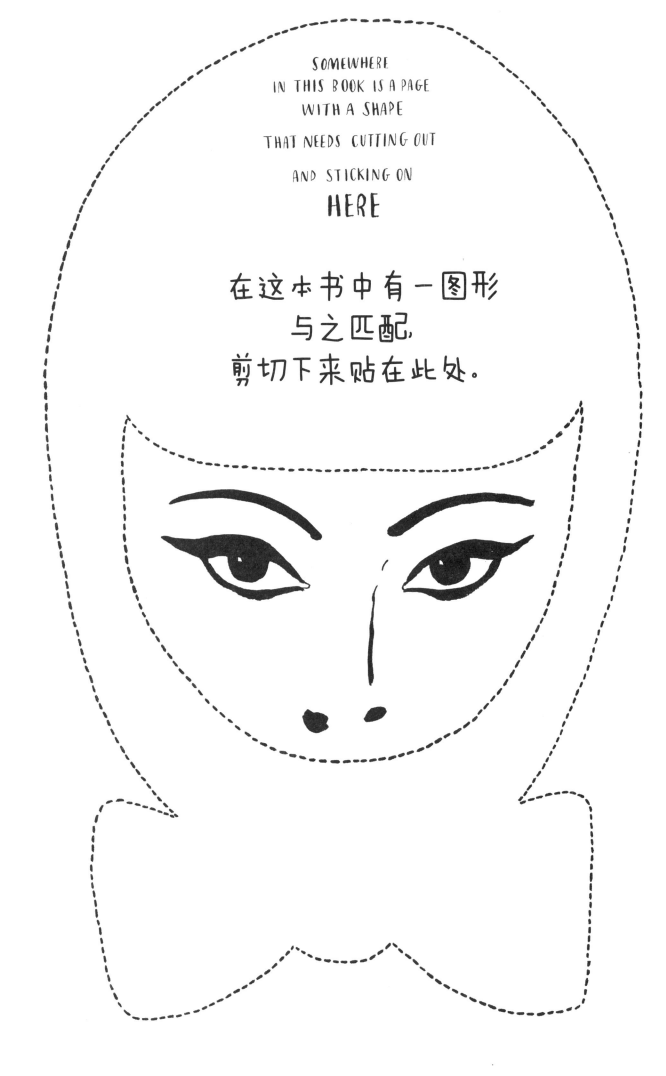

DRAW...

YOUR FAVOURITE HAT

绘制一顶你最喜爱
的帽子。

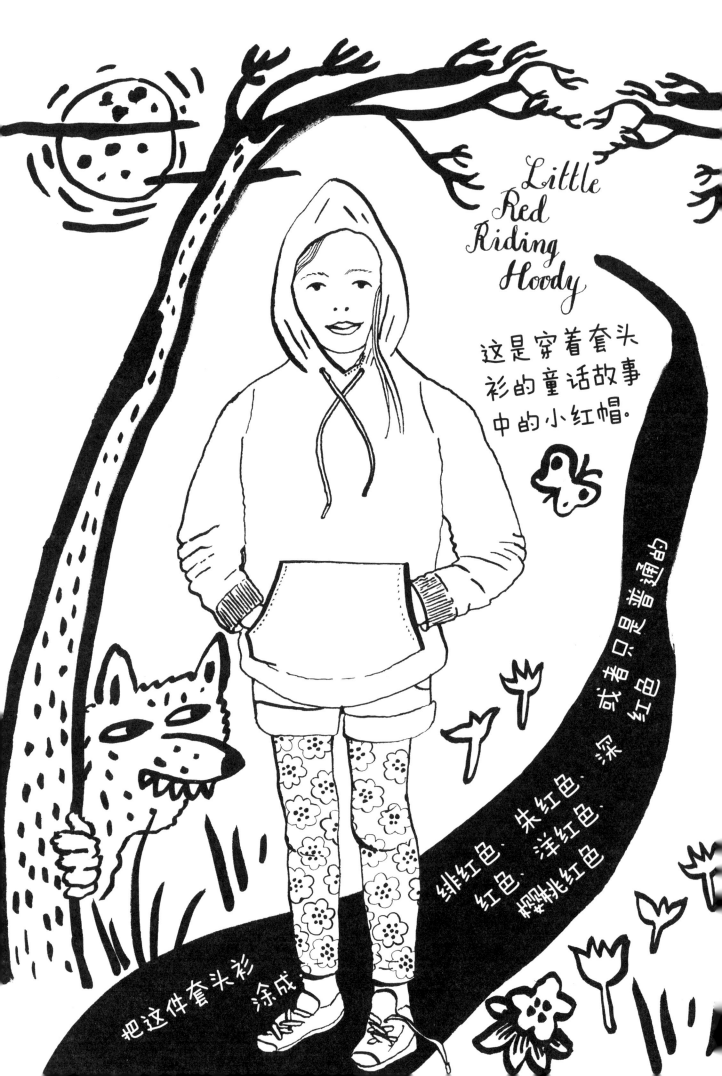

Little
Red
Riding
Hoody

这是穿着套头
衫的童话故事
中的小红帽。

把这件套头衫 涂成.

绯红色·朱红色·深 或者只是普通的红色
红色·洋红色·
樱桃红色

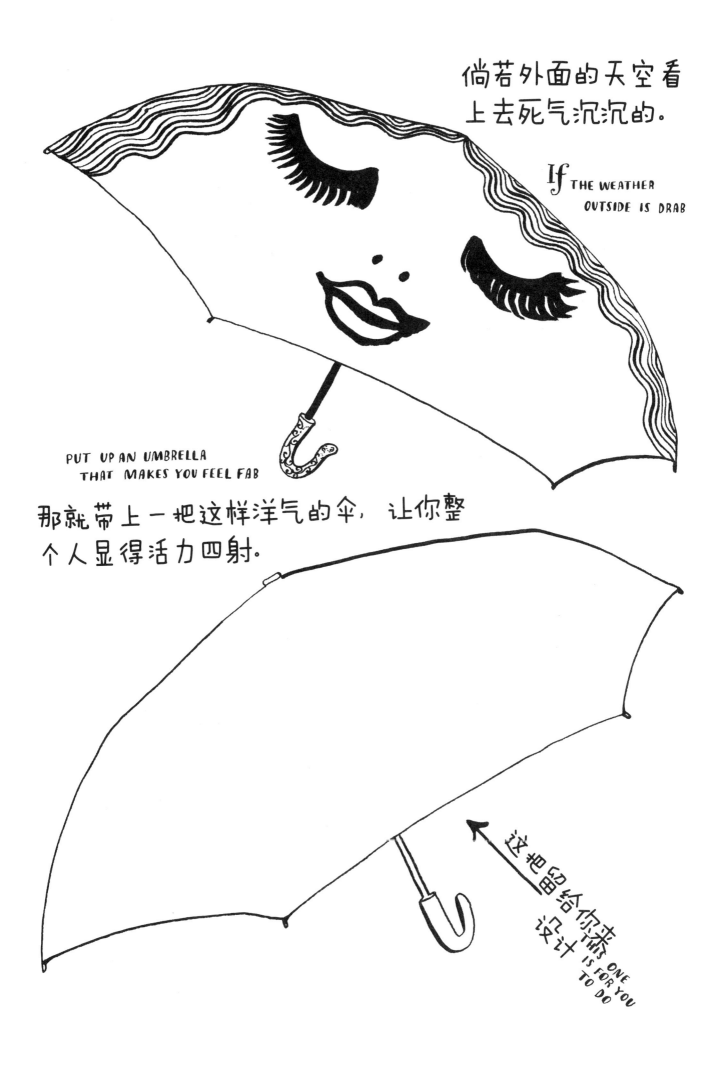

RAIN, RAIN
YOU CAN STAY
I'M GOING TO HAVE
A NICE DAY ANYWAY!

大雨大雨尽管下
我今天的心情不会差。

SPLISH SPLOSH! 一起来玩水! PAINT SOME MORE RAINDROPS ON THIS PAGE 在这页空白处绘制更多的雨点。

总之女孩子 JUST REMEMBER
要牢记这一点。 ONE THING GIRLS...

如果这个东西让你觉得不错，就想
方设法将其设计在身上。

Credits
(IN ORDER OF APPEARANCE)

（按书中出现的先后顺序）

ELSA SCHIAPARELLI — www.schiaparelli.com

MARIMEKKO — www.marimekko.fi/eng

MARC JACOBS — www.marcjacobs.com

VIVIENNE WESTWOOD — www.viviennewestwood.com

HUSSEIN CHALAYAN — www.husseinchalayan.com

STEVE MILLER — www.stevemiller.com

TOKIO KUMAGAÏ

MILENA SILVANO — www.at-the-treehouse.com

A'N'D — www.azumianddavid.com

ROGER VIVIER — www.rogervivier.com

COSTUME NATIONAL — www.costumenational.com

CHARLES JOURDAN

SALVATORE FERRAGAMO — www.salvatoreferragamo.it

ADRIAN

SHAUN LEANE — www.shaunleane.com

SHU UEMURA — www.shuuemura-usa.com

VIKTOR & ROLF — www.viktor-rolf.com

THANK YOU!

感谢

LAURENCE KING, JO LIGHTFOOT, ANGUS HYLAND,
CHRISTINA BORSI, WOOD MCGRATH, ANDY OSMAN,
GIOVANNA CELLINI, MELANIE CARVALHO,
CLARE PRICE, CLARE SHILLAND,
BETH FENTON, ELLEN LOFTSDÓTTIR,
LAURA CARLIN, LUKE PENDRELL, LIZZIE FINN,
CHRISTINA CHRISTOFOROU
SAFIYA CHAKRABARTI and
BEN BRANAGAN.

劳伦斯·金、乔·莱特福特、安格斯·海兰德、克里斯蒂娜·博尔西、伍德·麦格拉思、安迪·奥斯曼、乔瓦娜·切利尼、梅兰妮·卡瓦略、克莱尔·普莱斯、克莱尔·希兰、贝丝·芬顿、艾伦·洛夫茨多蒂尔、劳拉·卡林、卢克·彭德雷尔、莉齐·芬恩、克里斯蒂娜·克里斯托弗·萨菲亚·查克拉巴蒂和本·布拉纳根。